THE ART OF
GOTHIC LIVING

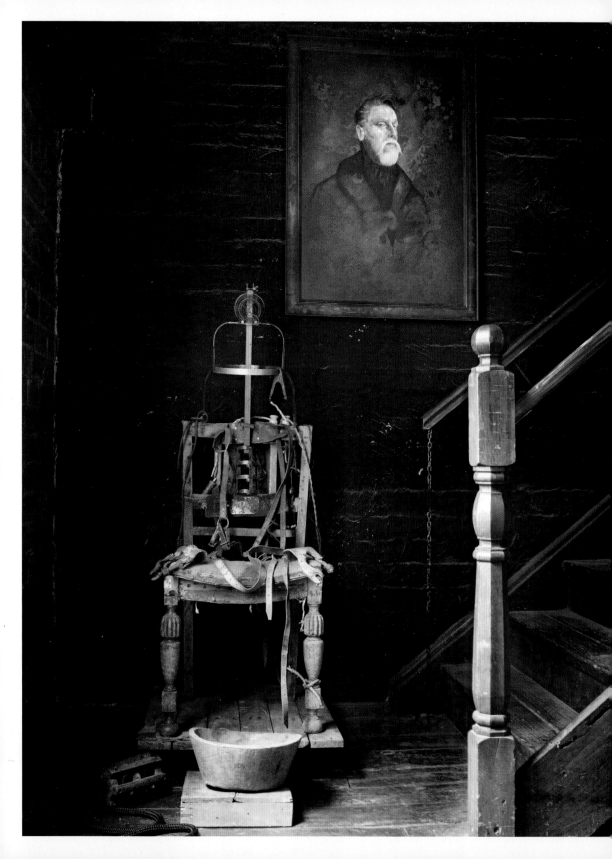

THE ART OF GOTHIC LIVING

❖

DARK DECOR FOR
THE MODERN MACABRE

PAUL GAMBINO

UNION SQUARE & CO.

NEW YORK

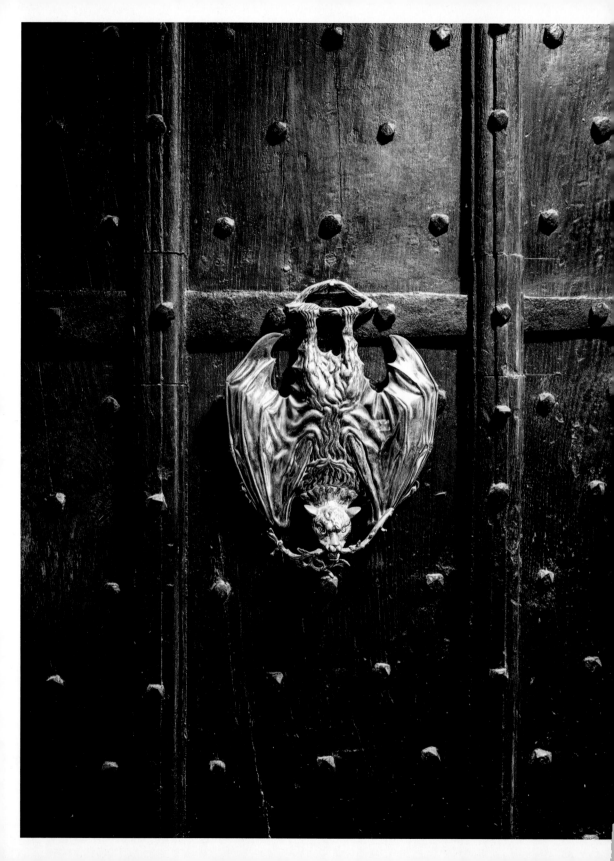

❖

THIS BOOK IS DEDICATED TO ALL
THE HOMEOWNERS WHO ALLOWED
ME AND THE PHOTOGRAPHERS TO
ENTER THEIR SACRED DOMAINS
AND SHARE THEIR WONDERFUL
HOMES WITH THE WORLD. AND TO
MY MOM, WHO SADLY PASSED AWAY
WHILE I WAS WRITING THIS BOOK.

LEFT: A doorknocker, circa 1890, from
the home of Alison and David McKinley.
PREVIOUS SPREAD: An antique electric chair
in the home of Andrew Delaney. FOLLOWING
SPREAD: A collection of skulls in the home of
Richard Marini.

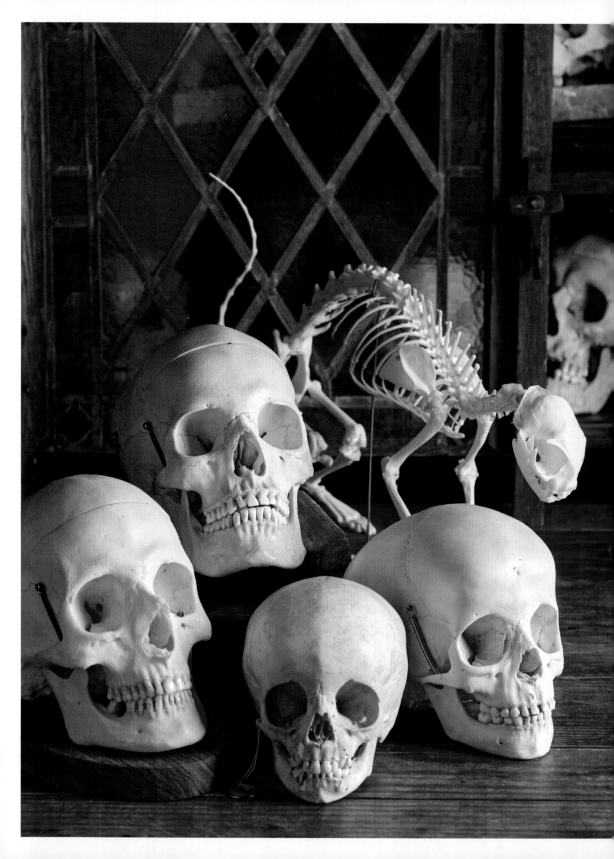

CONTENTS

INTRODUCTION

"This house has good bones." Never could you take that expression as literally as when stepping inside the wonderful homes of the fascinating people showcased between the covers of this book. *The Art of Gothic Living* will inspire you to add one (or one hundred) more Gothic pieces to your home decor or to trade in that generic 2010 table lamp for a late-nineteenth-century candelabra. From inspiration to aspiration, the homes beyond this introduction run the Gothic gamut from over-the-top macabre maximalism to the devilishly understated. But before we go any further, let's define *Modern Gothic*.

The original Gothic period was from the twelfth century to the sixteenth century, with architecture characterized by symmetry, stained glass, archways, spires, and religious iconography. The furniture ranged from crude wooden benches and tables to hulking, carved cabinetry, velvet-covered couches, and heavy drapery. These high-end pieces, mainly referred to as examples of High Gothic and Early English, were found primarily in churches and monasteries, whose exterior architecture was graced with pointed arches, trefoils, quatrefoils, roses, grape leaves, and vines.

The wealthy secular faction of society also owned ornate furniture with the unique characteristic of being "mobile"—tables with removable tops, folding chairs, and collapsible bed frames.

By the end of the sixteenth century, known as the Late Gothic period, artisans embraced a style that is now more widely equated to Gothic design—the carvings became more intricate. The themes included relief work of

saints, royalty, mystical beings, and creatures. There was also a shift to functionality: cabinets, armoires, dining tables, and chairs became all the rage among royalty.

In England and the Americas during the late 1800s and early 1900s, coinciding with the Victorian era, we see the return of a Gothic influence in painting, furniture, and home decor. This is referred to as the Gothic Revival period. Some believe it was during this time that the most exceptional pieces were created, and when scouring the auction houses, it is pieces from this era that are most likely to be available today.

So, who and what is Modern Gothic? The mindset of a "Goth" has existed for generations. Images of the original Bauhaus art students in Germany circa 1927 could be easily mistaken for a photo taken on London's King's Road in 1981.

For the next two decades, the music produced from this scene echoed the sobering thought that life is fragile, that sadness always wins over happiness, and that being in physical and mental anguish is an unescapable factor of life—and yet despite this grim outlook, life is worth living because your favorite band is playing this weekend. This cauldron of despair spawned countless hours of amazing music and a fashion scene that pushed the limits of extreme style and redefined the concept of beauty. Many of these homeowners are children of that past Goth era, and we're happy to say Goth's not dead.

Modern Gothic decor is the physical manifestation of the Goth ideology. It's an infusion of vintage religious iconography, antique human and animal osteology, Victorian taxidermy, antiquated medical devices, early 1900s

i.

ii.

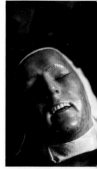

iii.

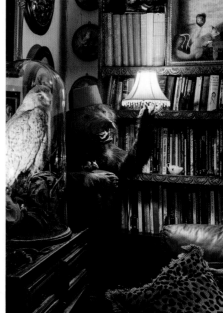

iv.

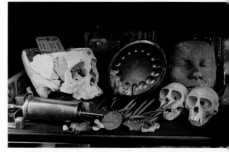

v.

✥

i. Rosie peacefully lies in repose, bathed in the blue light of the stained glass and flanked by just a pair of the lush plants found throughout the home. Rosie was found in a large duffel bag in the attic of an Independent Order of Odd Fellows lodge. It was customary during the early part of the twentieth century for each Odd Fellows lodge to have its own real human skeleton. It symbolized mortality and was used in some of their more sacred ceremonies. (See "The Enchanted Church," page 109.) ii. An antique Victorian velvet tufted chair with intricately carved legs, arms, and backs. (See "Midwest American Gothic," page 189.) iii. A medical wax moulage head, circa 1900. (See "The Bourne House," page 129.) iv. A sloth bear by Rowland Ward, circa 1925. (See "The Bourne House," page 129.) v. Among the collection of macabre on this shelf are an antique partial medical skull, a pair of monkey skulls, and a death mask. (See "A Home for the Haunted," page 161.)

funeria . . . if it's old, odd, authentic, macabre, and has an interesting history, it more than likely can find a home in the home of the Modern Gothic.

The Art of Gothic Living is an invitation from the owners of some of the most interesting homes on three continents to step across their threshold, make yourself comfortable, and take a peek behind the veil. Despite the fact that all of this aesthetic falls under the black lace umbrella of Modern Gothic, each of these homeowners has a distinctive approach and a unique interpretation. Many of these homes have never been photographed before and are being seen for the first time.

The decor of these homes includes some of the most unique items to be found in a private residence, and our approach to documenting these homes is equally as unique. Unlike many home decor books, instead of standing at the entrance of each room, we step "into the rooms." We give you literal close-ups of the fascinating items these individuals have collected from all over the world. You'll sit in the owner's favorite chair and see the room just the way they enjoy it, and marvel at the artifacts they have curated. You will sink into a century-old Chesterfield couch with a brandy in your hand, gazing into the eye sockets of a 200-year-old skull sitting on a shelf across the candle-lit parlor.

Accompanying these highly curated photos are informative and compelling captions providing background on the homes, the history of the highlighted pieces, the conceptualization of the rooms, the theme of the house, and the exciting sagas on how these relics came to be in the possession of these homeowners.

After you visit with *The Art of Gothic Living*, you will leave with twenty-three new friends who will help guide you down the shadowy path of your love for Gothic decor.

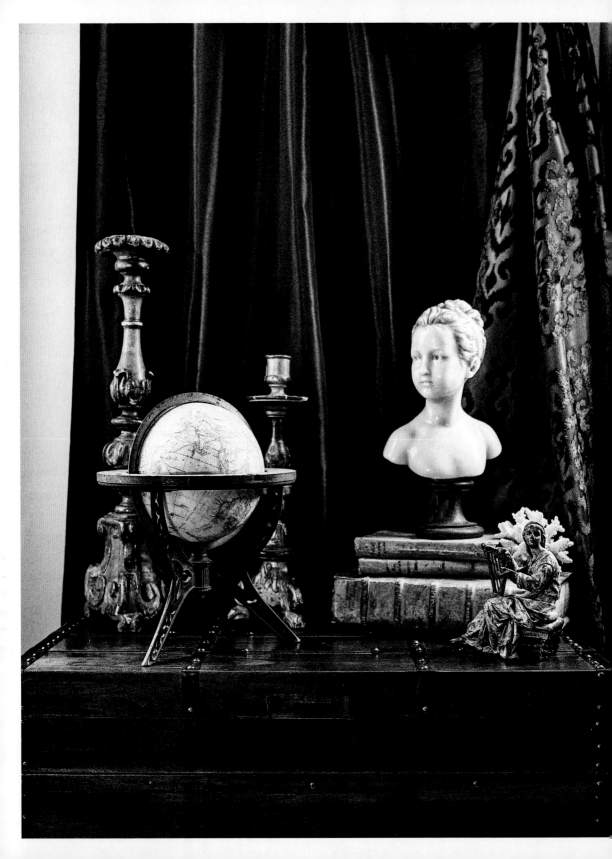

Calm before the storm? A quiet
display of antiques holds court in
the Bashians' bedroom.

✣

ADAM + LAURA BASHIAN
New Jersey, USA

THEATRE OF THE MACABRE

Adam and Laura Bashian have accomplished many things together, but one of the things they are most proud of is taking a living space that wouldn't be described as "unique" and creating a one-of-a-kind home through their design aesthetic. As a collector and dealer, Adam has always emphasized that building a cabinet of curiosities or embracing an antique style needn't be reserved for those with a grand home or unlimited budget. "Living in a simple apartment, we've surrounded ourselves with pieces steeped in history and meaning, starting small and growing over time into the home we love today."

Adam and Laura grew up three thousand miles apart, but both lived in homes best described as cozy. Adam's mother was a quilter, "so the most prominent decorative feature of the home was a lot of beautiful handmade quilts, hung on walls and draped over furniture. Classic farmhouse style."

1.

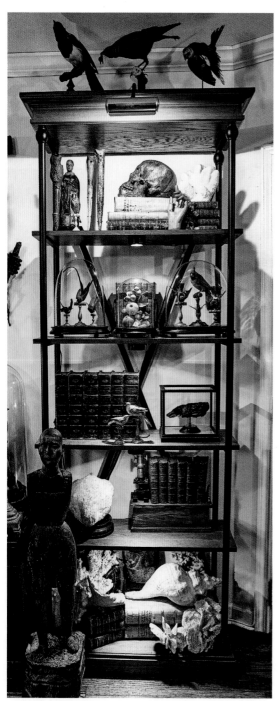

i.

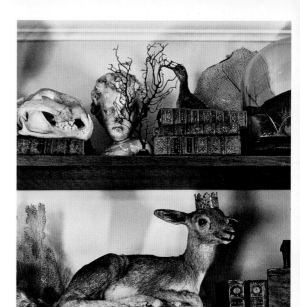

ii.

iii.

iv.

v.

i. Dramatic lighting highlights the artifacts in this living room étagère. One of the many highlights of this shelf unit is the ancient Egyptian mummy hand displayed in a glass box. ii. Adam refers to this bedroom assembly as one with a gentler feel. "There are lovely birds and natural history books. In that treasure chest, we have all of the cards we got from our wedding." iii. St. Rosalia is from the 1700s and comes to this New Jersey home via Spain; she keeps watch over the living room. iv. A Manus Island ancestor skull. This skull would have been in a ceremonial bowl and consulted on family or village matters. To the right of the skull is an antique artist's wooden hand. v. This kitchen shelf contains hunting trophies from the late nineteenth century, a wax half-face, rare antique books, and taxidermy birds. "We like to mix live plants in our assemblages," says Adam. "They add a pop of brightness . . . and a touch of life."

I ADAPTED THE TENETS OF THE AUTHENTIC *WUNDERKAMMERS* TO FIT THE NEEDS AND FUNCTIONALITY OF MY LIVING SPACES.

Laura had a penchant for visiting her grandmother's home as a child. "They built a classic mid-century California ranch-style house, and I remember how they filled the home with art, mementos from their travels, and the ubiquitous display wall of encyclopedias and old books."

One would think that growing up amongst this conventional home decor would not have led Adam and Laura down a path of the macabre. However, Adam's exposure to Victorian style and design was a by-product of his interest in classic film and being a bona fide '90s Goth kid. Music was a driving force in his aesthetic development, and he was drawn to the Goth scene of the '80s and the "nu metal" movement of the '90s, and with that came the requisite nod to Victorian Gothic

Revival style. As Adam matured, so did his aesthetics, and over time, "I adapted the tenets of the authentic *Wunderkammers* to fit the needs and functionality of my living spaces."

Laura's interest in antiques came from her love of and involvement in theatre and opera. Performing in period pieces exposed her to the vintage and historical fashion that she fell in love with. "I became fascinated with the artistry and craftsmanship of the past and began to blend elements of the antique into my unique style, both in fashion and home decor. I love to explore the juxtaposition between modern and antique style, and I would say that, in some ways, this provides a balance to Adam's pure Victorian maximalism."

Living in or near New York City for the last fifteen years, Laura and Adam have made the adjustment from sprawling homes to big-city apartments. The apartment they share now was a blank beige slate when they moved in. "The building

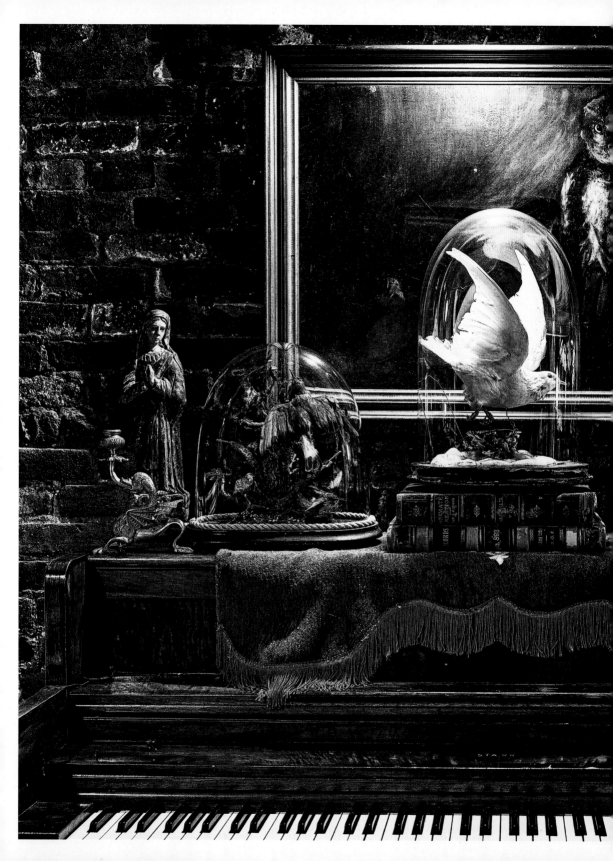

A nineteenth-century French piano
in excellent condition; Adam and
Laura play it often. Perched on the
piano lid are two beautiful Spanish
religious figures circa the early
1800s and wonderful taxidermy
birds under period-appropriate
domes—a stunning display.

dates back to 1900, so it has a brick
facade, but the prewar apartment
has been updated multiple times
over the years. Thankfully, some
features that suited our design
styles were left, such as a bay win-
dow, dark wood kitchen cabinets,
and two walls of original exposed
brick, which we have used to
anchor our antique aesthetic."

"Editing!" When asked what is
the most challenging aspect of inte-
rior home design, that was Adam's
immediate response. "The space is
beautiful now, but with our collec-
tion and storing some of the inven-
tory we sell on Dark Interiors—our
Instagram auction account—we are
extremely limited for space. Our
decor constantly evolves as new
pieces come in, and tough decisions
must be made about what stays.
The beauty of this design style is
that our space is a living, changing
environment where there is always
something new to appreciate.

"Bringing character back to the
apartment has been a big part of
our design journey. We added an

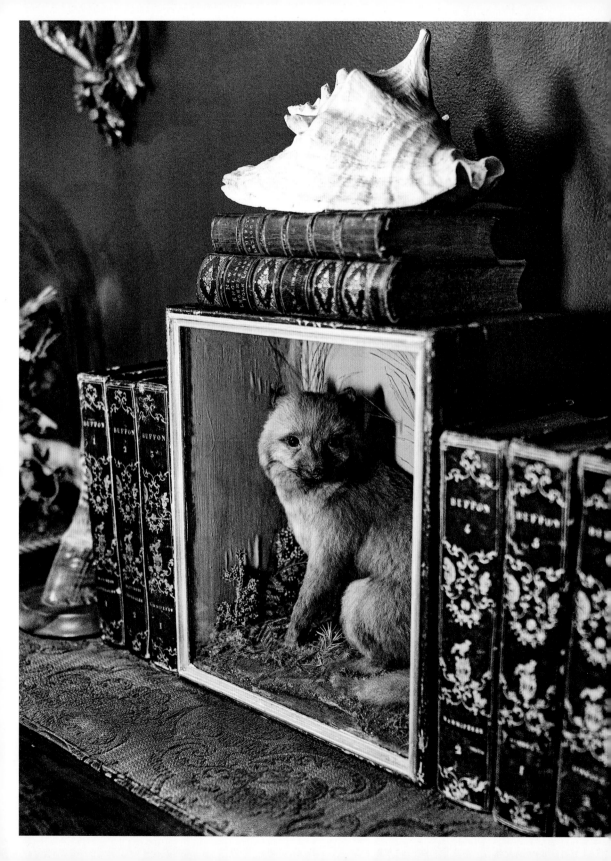

A beautiful Victorian kit (baby fox) diorama flanked by a complete set of very rare natural history books authored by the naturalist Buffon.

area of brick facade that hadn't been there originally and treated it to match the old brick, which was a fun DIY project. It was Laura's idea, and it really tied in the existing brick areas beautifully. Adding simple crown molding throughout the apartment, installing chair rails to some walls, refinishing and staining the wood floors, and choosing bold paint colors where appropriate helped restore a little turn-of-the-century style. Lighting a space makes all the difference, so instead of relying on modern, and often harsh, overhead lights, we brought in refurbished antique floor and table lamps to add a historic ambiance."

That lighting effect is best illustrated in the main living room, which Adam and Laura feel is the heart of their home. It is lit warmly by the vintage Tiffany "skull cabinet" and refurbished lamps, which makes it very cozy and dramatic at the same time. "We display some of our favorite pieces in open shelving and antique domes. It is the first

room guests enter, setting the tone for our whole space."

Living on the top floor of a three-story walk-up does pose some logistical issues. "The steps are very narrow and steep, so lugging boxes of delicate antiques up and down three flights of stairs is challenging. Getting our antique upright piano into the apartment was the biggest challenge—there are no plans to move her out again."

The piano is something that they both love, but neither Adam nor Laura could come up with a definitive piece that encapsulates the style of their home. "It is tough to choose a 'favorite piece.' We select items that complement each other and are all beautiful in vastly different ways." The solemn grace of an eighteenth-century wooden sculpture of Saint Rosalia, "La Santuzza," stands in contrast to the fierce and imposing Klebit Bok shield from Borneo, adorned with real human hair from head-hunted enemies.

"Looking around the house, we see the objective beauty of

i. Victor, the family cat, cuddles up with a full-size vintage taxidermy goat draped in Odd Fellows regalia. Here is another example of how the Bashians use majestic colors, like dark reds and blues, to accentuate the grandeur of the items. ii. A nineteenth-century taxidermy of a toucan that Adam mounted on a Victorian specimen branch. iii. A sloth bear rug, an uncommon bear to be found as a rug or taxidermy. "It was prepared by a taxidermy firm, the Jonas Brothers, circa the mid-twentieth century. The sloth bear has a 'goofy' look with enormous ears; however, they are the most aggressive bear species in the world," explains Adam. iv. An authentic human shrunken head, circa the 1930s. For decades, she was kept in a safety deposit box because the owner's family disapproved of the item, which wasn't discovered until he passed away. Adam comments, "She's in perfect condition. I got it about five years ago. They are now extremely hard to come by and easily go for upward of \$30,000." v. "This is our only contemporary taxidermy piece," says Adam. "'Oh, cockatoo can play at that game! Oh, toucan?'" Being able to voice that quip was one of the reasons he bought the cockatoo. vi. Adam and Laura's wedding photo.

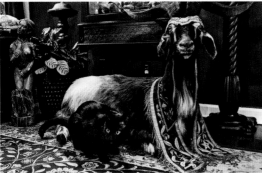

i.

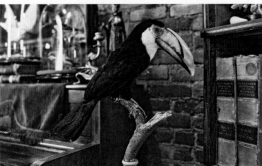

ii.

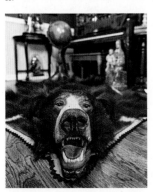

iii.

iv.

v.

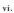

vi.

✥

our pieces and the personal jour-
ney that led us to them. Among
our favorites is a 'mated pair' of
now-extinct passenger pigeons,
acquired separately but displayed
together; one was found collect-
ing dust in the basement of a used
bookstore Adam happened upon
while touring the country as an
actor in *The Phantom of the Opera*.
He searched high and low for a
mate, and now they have been
beautifully restored and given the
respect they deserve as some of the
last specimens of their kind."

The "disease" of the collector
is the unending quest for the next
great piece, and Adam and Laura
are not immune. "While there are
pieces we'd love in the future, and
presently eighteenth-century hang-
ing tapestries come to mind, we
don't have our sights set on a single
item. There are pieces we have
in storage that we would love to
display now, such as a collection of
seventeenth- to nineteenth-century
oil paintings, some of which are too
large to fit through the door of our

apartment; a full mount antique
taxidermy lion; a prehistoric woolly
rhinoceros skull that came to us
straight from the Siberian perma-
frost; a collection of antique Fijian
weapons; and hundreds of books,
among many other treasures.

"We are both lucky enough
to have passions that double as
careers. In addition to running Dark
Interiors, we are both professional
actors. We met doing theater, made
our Broadway debuts the same
year, and still work in the theater,
film, and TV. Granted, it makes
for a busy life, and sometimes that
means we are away from our home
more than we like, but that makes
the effort we put into making this
place our cozy Gothic refuge all the
more worth it. We feel very com-
fortable surrounded by this decor."

This toile-design wallpaper appears to be a classic hunting pattern, but when you look closely, you realize the motif is that of animals retaliating against the hunters.

✥

REGINA + RYAN COHN
Connecticut, USA

CURATED BY THE COHNS

In the 2000s, Regina was a mover-and-shaker on New York City's underground fashion scene, and Ryan garnered a reputation at the same time as the "Professor of Oddities." When the pair decided to become partners in crime—romantically and as a power couple in the high-end oddities community in 2012—the union started with Regina moving into Ryan's already maxed-out *maximalist* Brooklyn apartment. There was a quick lay-over in a Brooklyn townhouse, but

then in 2020, the couple decided to pack it all up for a second time in less than a year and, this time, head north to the suburbs of Connecticut. The packing included three floors of the Brooklyn town-house as well as the contents of four large storage units. Ultimately, that resulted in two full trailer trucks, not to mention the countless trips the Cohns made to transport ultra-fragile items personally.

"In 2020, there wasn't a lot of inventory out here. The pandemic

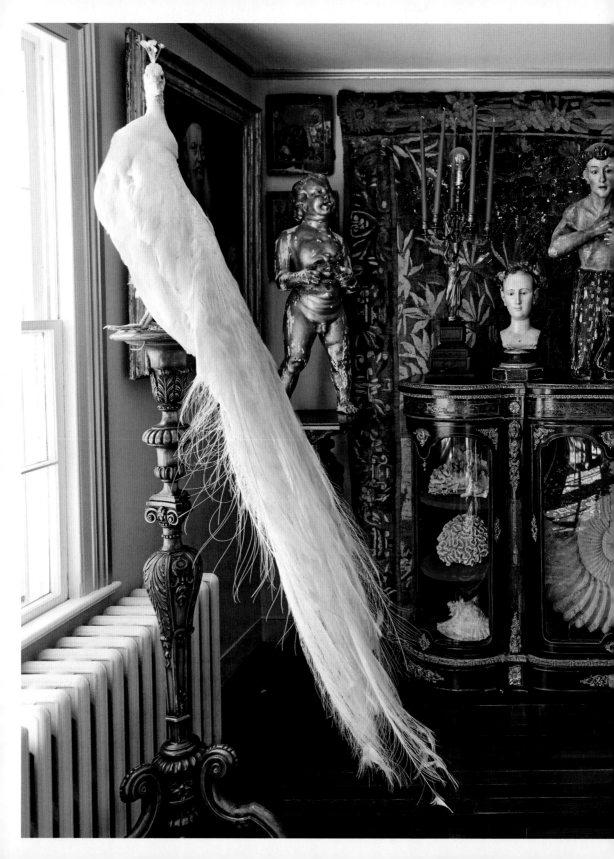

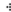

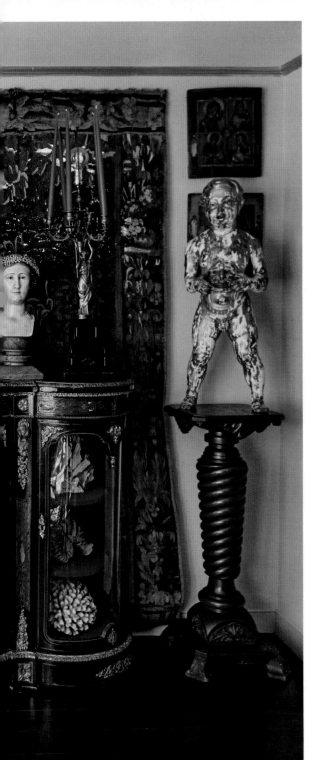

was in full swing, and people were
fleeing the city. However, we looked
at many houses but kept gravitating
back to this one. I believe it was on
the market for an extended period
because the kitchen is small, and
this is a very family-oriented town.
But that factor didn't matter to us."

Kitchen size wasn't an issue
for the Cohns, but room size was.
Having an extensive premier col-
lection that took decades to curate
and consisting of some of the rarest
and most sought-after pieces in the
oddities community, they wanted
a home where these treasures
could be properly displayed and
incorporated into their everyday
lives. "We looked at a lot of old
houses in the area, and what was so
different about this house was how
large the rooms were. Most houses
built in this era in these towns,
although large in square footage,
are usually broken up into multi-
ple smaller rooms with very low
ceilings. Surprisingly, this house
was constructed with an open floor
plan. It also has very high ceilings,

This room was originally Regina's office, with a Louis XV–inspired antique desk found at a Connecticut auction house as her workstation. However, the desk became a fitting locale to display a series of religious artifacts, and the room has since surrendered to becoming a second parlor.

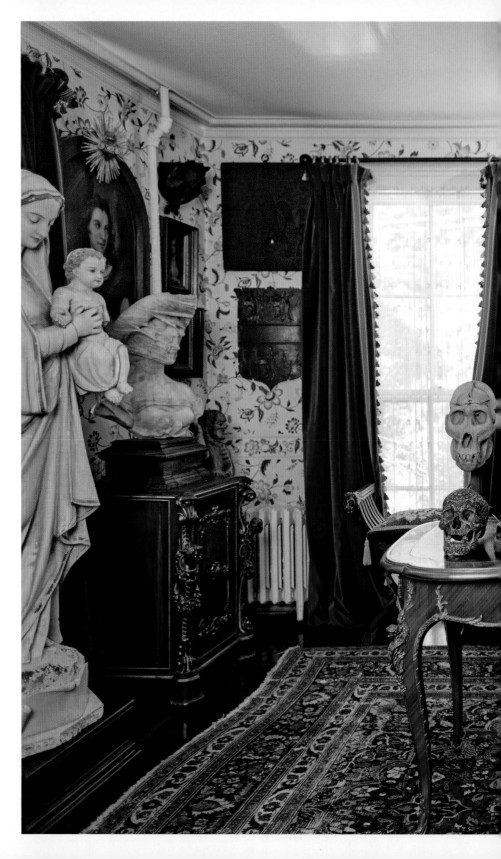

A fantastic collection of curiosities focusing on animal skulls, taxidermy, insect mountings, ceremonial shrunken heads, and human osteology.

which are important because, over the years, I have acquired a lot of beautiful, very tall Gothic cabinetry, and I needed them to fit."

Overall, the house was in pretty good shape. Any modernizations that were done did not involve compromising or destroying the original architectural design either inside or out, and the "skeleton" of the house was structurally sound. However, as imagined, a house built in the late 1800s may have a few surprises.

"Well, first of all, we didn't even realize there was that hidden stairway from the second floor to the top floor. In these older homes, hidden stairways, which were narrow stairways running at the back of the house (usually from the kitchen up to the servant's bedrooms) were relatively common; however, this one was from the master bathroom to the third floor, which was very odd. We did our walkthrough at the height of Covid; the realtors rushed us through and just wanted us out as quickly as possible. I saw

"DISAPPOINTMENT ROOMS" WERE FOUND IN ATTICS, BASEMENTS, OR SPECIALLY CONSTRUCTED ROOMS TO KEEP PHYSICALLY OR MENTALLY CHALLENGED FAMILY MEMBERS OUT OF PUBLIC VIEW.

the door but assumed it was a little linen closet. So, it was a big surprise when we moved in, and there was this small hidden staircase on the second floor.

"Then there was a gun safe in what's now my boudoir, and it weighed about six hundred pounds; the realtors never had the keys to open that room, so we didn't know what was going on in there. It was inside a room that can be best described as a 'disappointment room.' There is debate on how common these rooms were; however, even if only a few existed, it would be a sad commentary on life in pre–Civil War United States.

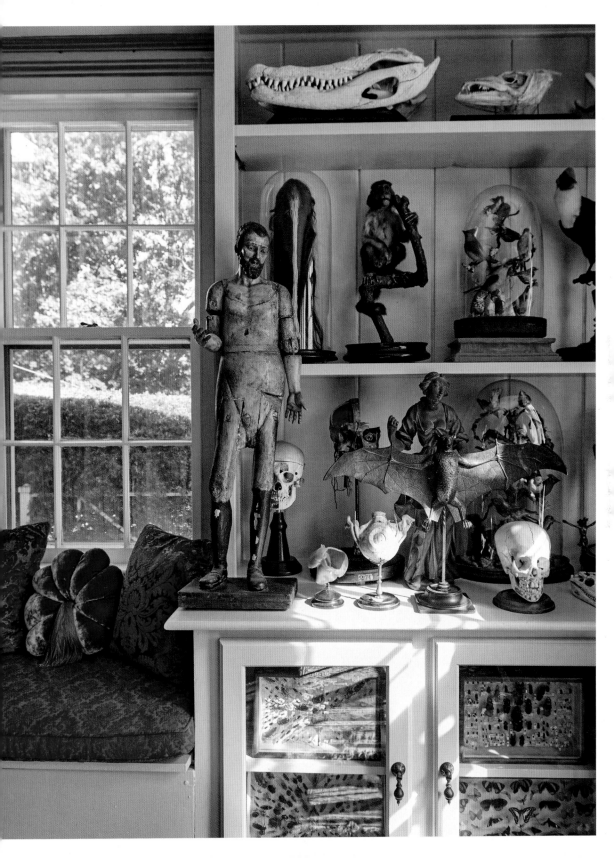

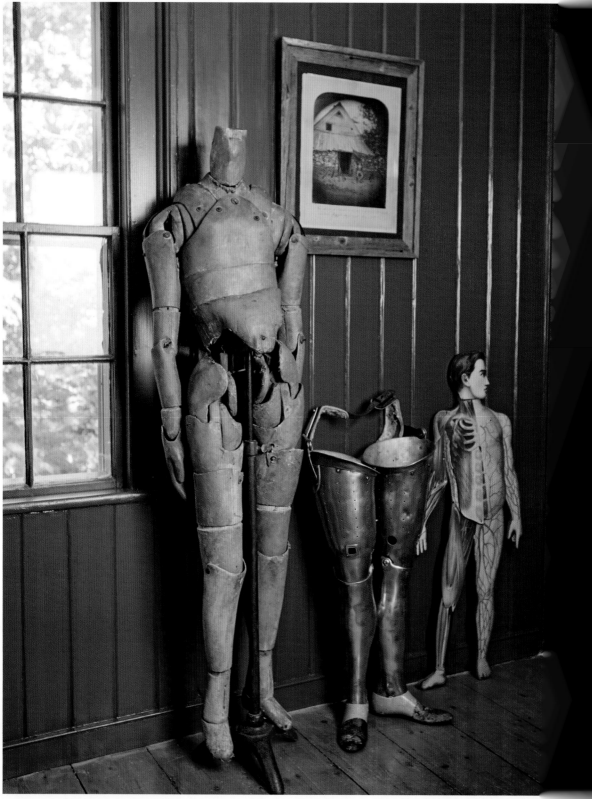

✛

i. An eighteenth-century life-size artist figure sans its head stands beside an aluminum prosthetic for a double amputee severed at the knee. ii. One of a pair of eighteenth-century wood and polychrome figures that Ryan had out in the yard. "We had these two sitting outside for two years until a European collector friend visited and told us how valuable these were, and we quickly brought them in. So, I had to dry them up. Then I realized I had the arms in my studio, and when I put them back together, I thought, *wow, you have some excellent detail mixed in here.* Unfortunately, one is missing its head." iii. Ryan Matthew Cohn standing beside a nineteenth-century anatomical wax figure three times the size of a normal human being. It would have been used in a medical school anatomical theater while teaching the curriculum. "I have to point out that the color scheme of the wax model is the same as the wallpaper, which is original to the house." iv. A nineteenth-century suit of armor surrounded by South American battle instruments.

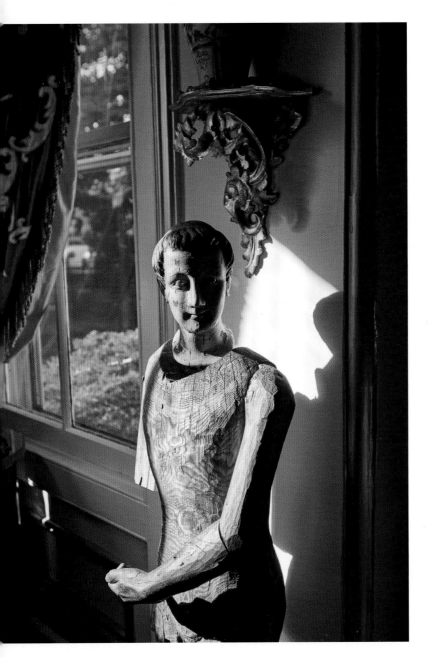

iii.

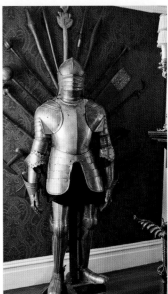

iv.

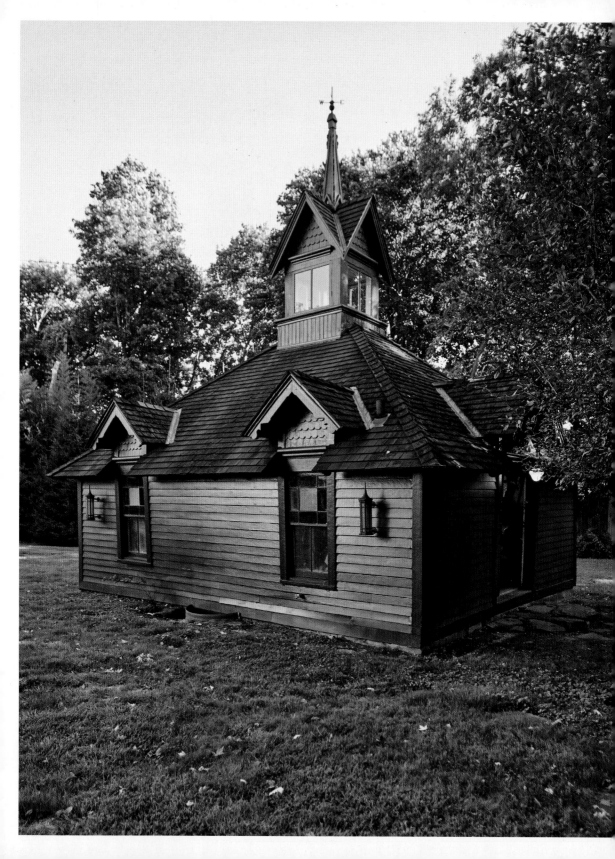

⁜

The chapel was steeple-less and white when the Cohns bought the house; they had the chapel painted black and added the steeple. Presently the chapel serves as storage for pieces that have yet to find a buyer or a place in the Cohns' home.

A DEACON LIVED IN THIS HOUSE IN THE LATE 1940S. HE PURCHASED THE CHAPEL AND HAD IT PLACED HERE ON THE PROPERTY.

These rooms were found in attics, basements, or specially constructed rooms to keep physically or mentally challenged family members out of public view."

In addition to the layout, one of the most unique features of this home is not inside the house but on the sprawling grounds surrounding it. "Apparently, a deacon lived in this house in the late 1940s, and a small chapel in town was slated to be demolished to make room for a parking lot. Well, the deacon purchased the chapel and had it placed here on the property. I suppose he may have given services here."

When the Cohns took possession of the property, a tire was hanging from a rope tied to one of the chapel rafters. "Of course, we thought it was weird that this tire swing was in the chapel. Then we noticed a signature inside the tire as if it were a piece of artwork. The signature looked very much like 'SAMO,' which was Jean Michele Basquiat's alternate signature, and for the longest time, we thought we might have an original Basquiat piece. However, I showed it to an expert in Basquiat paintings, and he said it was not the priceless artwork we were hoping it would be. This summer, we intend to hang it from one of the trees on the property and have it be a tire swing."

"When we bought the house, the chapel didn't have a steeple. We recently purchased a vast collection from the estate of a deceased collector, and believe it or not, this steeple was actually in his Brooklyn apartment."

Despite the Cohns' selling off a considerable amount of their massive inventory over the last couple of years, unfortunately, the chapel is still primarily being used for storage. Although when asked

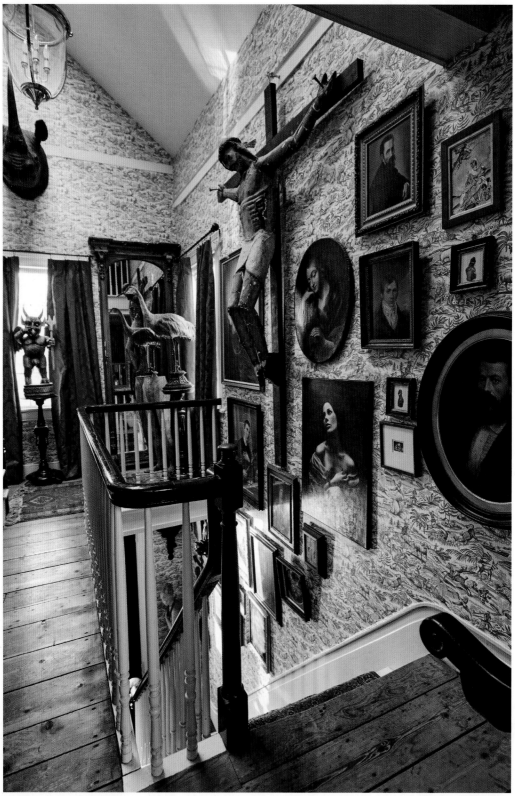

✥

i. A life-size eighteenth-century Santos Crucifix. This piece comes from Spain, and in addition to its size, it also has glass eyes and an exposed rib cage, which was created from real human ribs. ii. An amazing example of a Victorian-era fetus skeleton once on exhibit in a European medical college. iii. This painting is an eighteenth-century version of *Cleopatra Bitten by the Asp*, which was originally painted by Guido Reni in the seventeenth century. Ryan had the painting restored. A pair of cast iron Parisian gargoyles stand guard on either end of an assemblage of heads, including that of an eighteenth century saint. iv. A pristine antique cherub head. v. An antique clock with a hand-painted face. When it chimes twelve, the eyes go back and forth. vi. A particularly odd-looking taxidermy of a cat.

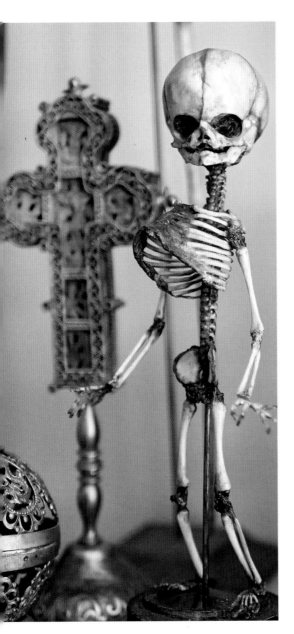

iii.

iv.

v.

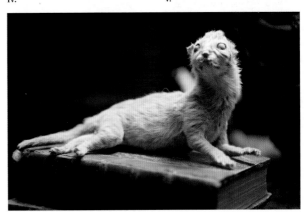

vi.

✤

Shelves of antiquarian books. "It's mostly occult and natural history, with many other things mixed in. But they're all rare," explains Ryan. "I think it started as a decorative collection in Brooklyn years ago. Over the years, I've picked up a rare book here and a rare book there, and I've developed a pretty extensive collection."

about future renovations for the house, Ryan cites the chapel as the one feature he has his eye on. "Now that the chapel has been painted and repaired, there were some leaks that needed to be addressed; I am contemplating turning the chapel into a little banquet room with a huge twenty-foot table running down the center of the building."

After being surrounded by antiques for over a decade now, Regina has some unique thoughts about what to do with a room presently empty on the third floor. "I want something modern. I want it to have mirrored floors. I want something completely wacky, like when you open the door; it's just something you wouldn't expect. I still think it could be really cool to do a mixture of antique and modern."

When speaking to friends of the Cohns who have slept in the guest room, which also happens to be on the third floor, they have commented that the house is haunted. Ryan responds to their observations

IF IT WERE HAUNTED, I WOULDN'T MOVE; I WOULD CHARGE ADMISSION TO VISIT US.

like this: "Well, we don't know, but Regina and I feel very comfortable in this home. We feel safe here. I've heard some weird shit, but it's an old house, and old houses make weird sounds. But hell, if it were haunted, I wouldn't move; I would charge admission to visit us."

✤

i. Regina Cohn residing on a
bed originally owned by Andy
Warhol. ii. A "demonic" looking
ram head is mounted on the mantel.
Regina comments, "I hate that
thing; it just gives me the creeps.
The eyes are too piercing." iii.
Angelic head. iv. The bed is from
the Andy Warhol estate. The
paneling at the base was salvaged
from a church that burned down in
Newark. The "marbling" is a result
of water damage from a fire.

i.

ii.

iii.

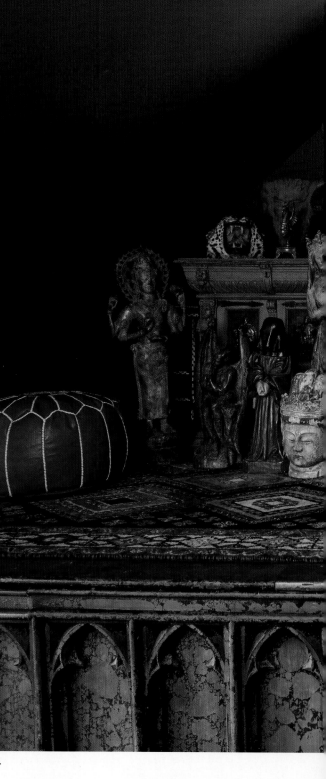

iv.

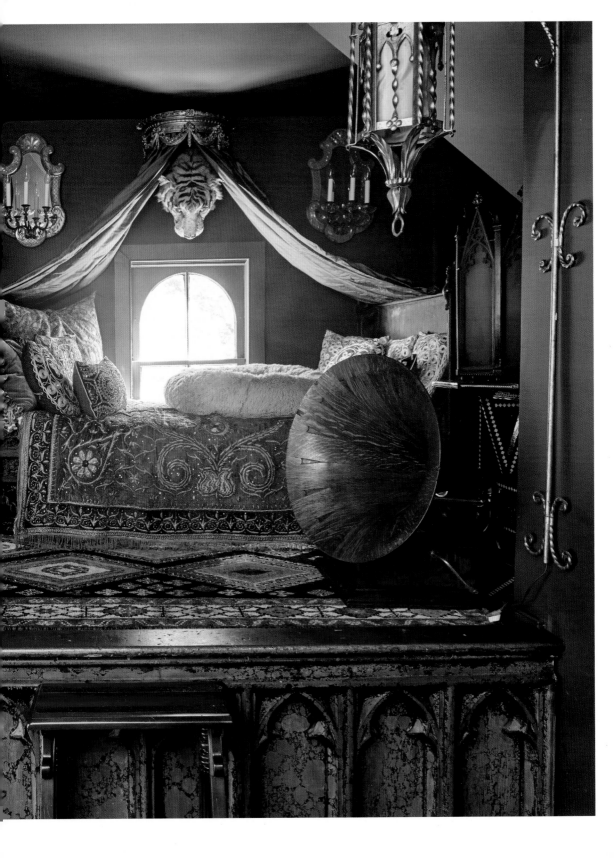

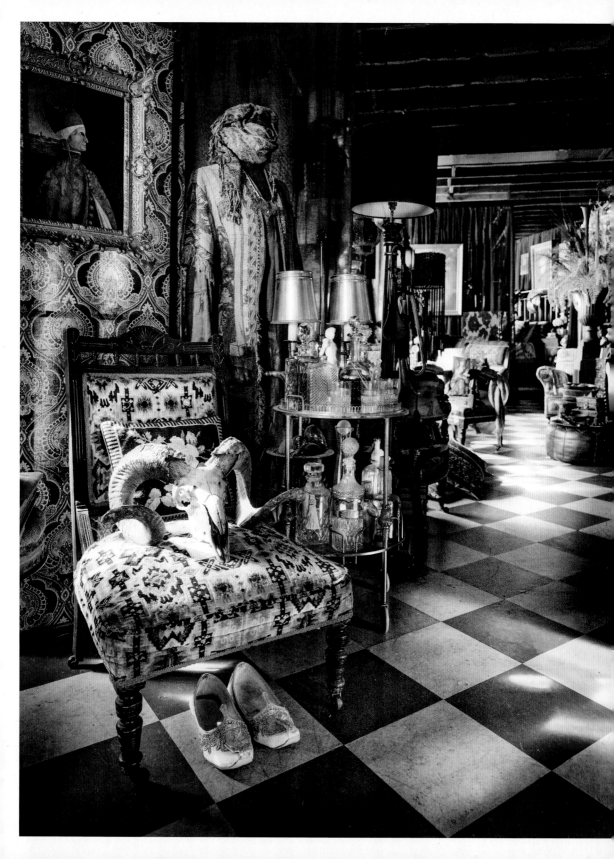

"I'll find a wall hanging, and it'll either get made into a cushion, a bed cover, or a mannequin costume. In the foreground rests a drink trolley and a velvet-covered chair with a fantastic ram skull."

✢

ANDREW DELANEY

Victoria, Australia

ANNO DOMINO

Over the past 150 years, the space Andrew presently calls home has seen plenty of iterations. "It was a Victorian storehouse for a department store that used to be connected via a wooden gantry. It's been a tattoo parlor, a tailor shop, a jeans shop, a music school, and a gamers' space. I believe when I took possession in 2014, that was the first time it's officially been a living space. Admittedly, the place had a weird vibe when I moved in. There was some serious teenage angst from the gaming business, and I had the place smudged. I have some great friends called the Muses of Mystery, and they went through and cleansed it. Now, if I ever sense something 'off,' I just have to pop an Air Wick, and it's all cool."

The unique location lends itself to plenty of privacy, something Andrew cherishes. "It is pretty hidden from the outside world, and it sits basically in a back alley behind some shops. The locals are probably the biggest thing to get

Below the counter of the kitchen are a hidden bar, fridge, stovetop, and microwave. There's a lightbox on the counter that lights up all the glassware, and there is a fair bit of counter space there, even though it doesn't look like it. Most of the collection sits toward the front. "It's all a mad scientist type of a feel, and then you see gold teacups, crystal glassware, and serving domes. So it's a kind of a real Victorian *shemozzle* of things with a bit of a greenhouse during the right season." The door against the back wall leads into a hidden second kitchen, which sits behind the Black Kitchen.

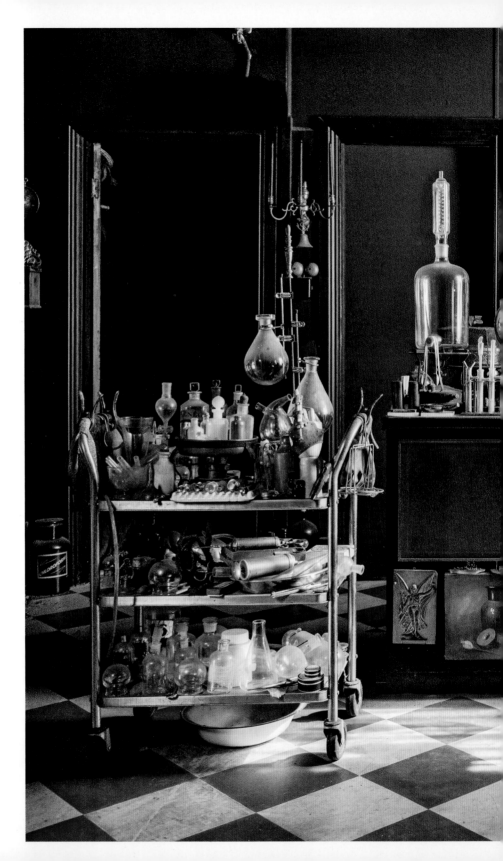

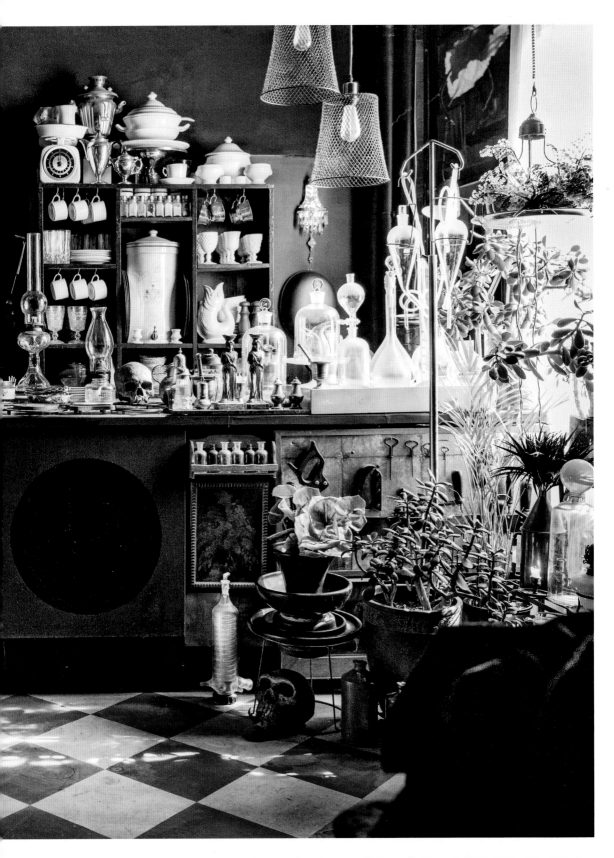

i. Opposite the hookah lounge. "It's rich and red, sumptuous and decadent. The couch is stuffed with soundproof foam, but it's quite comfortable. It's called a miner's bench; these were 'beds' that could easily be disassembled and moved to different rooms." ii. This little collection of artifacts sits in the Opium Den: a Nepalese bell; a stack of Indian boxes, including an Indian barber's box; a hookah pipe; a threatening-looking spiked ball; a pyramid; and a Middle Eastern flute. In the back, there's a Chinese chest.

used to down here; I don't socialize much, so it really is a sanctuary, and this was ever so true, especially during the Covid lockdown." This industrial area is a far cry from the setting of Andrew's youth. "I grew up in a hundred-year-old weatherboard house in the country. It was a very modest country middle-class home. Very practical. A lot of '70s kitsch. However, we were surrounded by lush gardens and a fruit orchard. Lots of plants and animals . . . and bones."

Andrew left that bucolic homesite when he was nineteen and headed to Melbourne to study. Since then, he's lived in a series of apartments. "I lived in a lot of art deco flats in my time, and the quirks of the spaces are what made them special. When I moved into this space, I changed very little. I still have the vinyl floor from the 1960s and the ceiling with all its exposed infrastructure. It has a natural feel of its own. The exposed brick really adds to the warmth and character. I painted the two end walls, the windowsills,

and some of the ceiling pipes black. That's pretty much it. I don't believe in ripping out functional bathrooms and kitchens for fashion's sake or just because it's expected."

Andrew is a full-time artist who works in paint, textiles, and assemblage. In addition, he is a set dresser and an event stylist, so his artistic inclinations and professional career naturally show up in his home decor. "Getting the space to where it is now was a gradual process, and it has a very 'layered' feel. I'm pretty patient when looking for what I feel is missing. One has to be if they are doing a lot of perusing through opp shops [thrift stores]. I have a keen eye for fabrics and see potential in many things, mostly really wonderful fabrics and printed velvets. Those get turned into cushions, throws, robes, and smoking jackets. If anything, it's starting to get crowded in here. I also have a penchant for the odd and curious . . . the creepier, the better. I am drawn to societal pieces devoted to mourning and death

THE ART OF GOTHIC LIVING

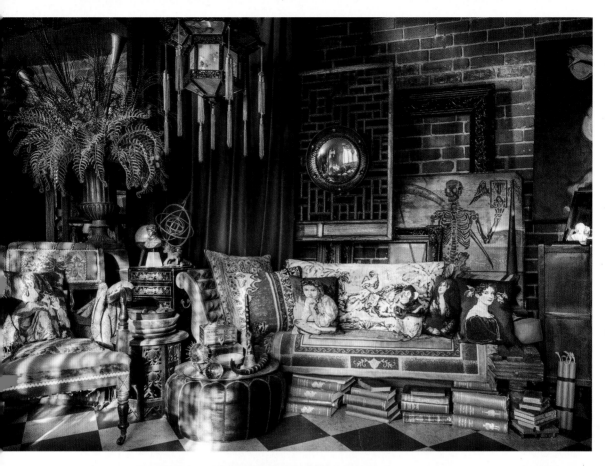

ii.

The Shisha Lounge, which sits dead center in the warehouse, is an Arabian-themed area. "This area is an illusion; it's a brick wall with a window that I've accented to create this little slice of dark paradise. I'll sit there and listen to music, and it gets incredible light through the day, so it's also a great place to read a book and chill out. And really, it could be anywhere in the world. Because it sits directly in the middle of the warehouse, it breaks up the length and again is divided by sheer black fabrics. Salame really sets the mood for this space. That's what I call the figure lying on the velvet love seat, which is part of an Edwardian parlor setting that I picked up at auction for the ridiculous price of eighty dollars. Note how short the legs are on the matching his-and-hers chairs. This was a thriving port area during the late 1800s. It was the Gold Rush era, and there was a lot of wealth here. Apparently, people aren't into dark woods and velvets, so you can still get real bargains. The Chesterfield couch is my most significant investment. The lanterns are also essential 'Middle Eastern' accents; every time I see one, I'll pick it up for a couple of bucks."

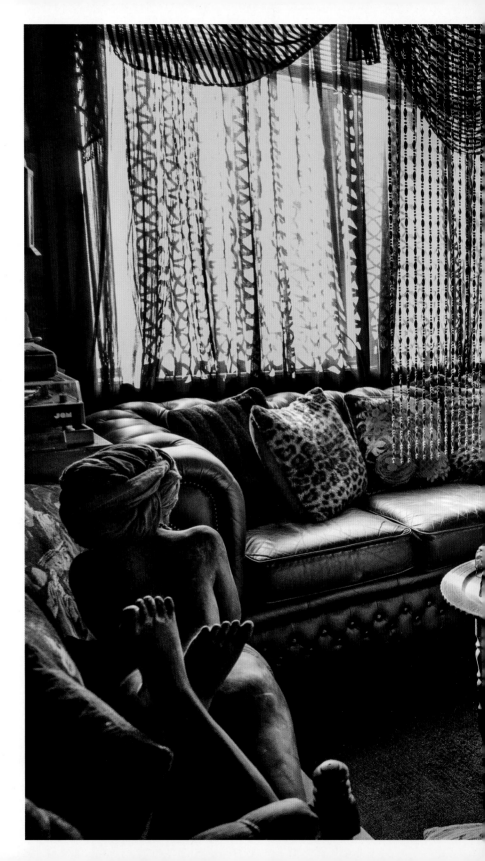

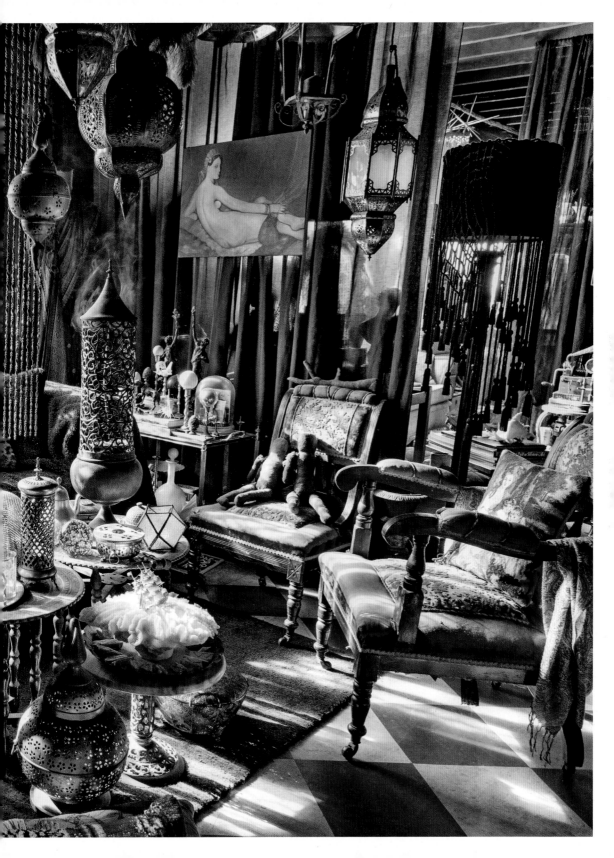

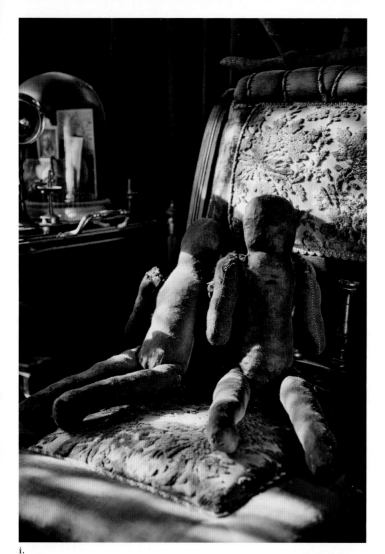

i.

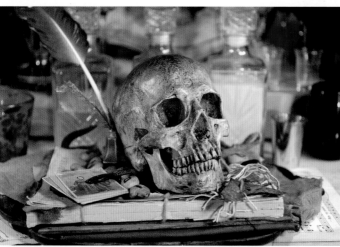

ii.

iii.

iv.

v.

vi.

i. These tourist dolls are from Kingston, Jamaica, and are stuffed with straw. "They're about as close to being a voodoo doll as I'd want to get without being a voodoo doll. They used to be dressed in colorful little Calypso costumes, but underneath were these fantastic, faded, sad little pair of bodies that just sat on the windowsill. And they're just the perfect level of dark and strange. Harmless is probably the best word." ii. An old replica skull sitting upon a manuscript of Darwin's *On the Origin of Species* (not the original) and antique candlesticks. iii. A reproduction skull draped in chainmail sits with a pair of motorcycle gloves atop a volume of one of the Goth world's favorite authors. iv., v., vi. Various figures and busts, including the *Vivisector* (v.), which Andrew made out of thirty-three pieces of sculpted body parts, all created out of textiles. This was made for an exhibition that included creations depicting baby vivisections, livers, spleens, body parts ravaged by cancer, and straitjackets. "People came and spoke about their health battles and, hopefully, triumphs. It was a positive turning point in my thoughts on illness."

customs. I am also fascinated with human anatomy–related items; however, I like brutal-looking vintage medical items more than genuine human body parts. I'm not sure why? It could be a juju thing. If the piece has an interesting history or can unnerve someone, it may find its way into my home.

"Although, if I were to live in a place that was haunted, it would depend on what kind of stuff was happening. I would be okay if the milk was going bad before its expiration date or things were moving around the home. But if it were being groped while sleeping or watching my face peel off in the bathroom mirror, that would be a different story."

The space is one continuous floor plan with challenges; however, Andrew has created multiple areas distinguished by drapery and screens. "I don't need or want to do any major renovations. The space is constantly evolving. I change it by redividing the area with the drapes and screens, changing the paintings,

and so on. My favorite room, apart from the bedroom, is the Middle Eastern–inspired *shisha* lounge. That area has a stereo and is a great spot to read. It is atmospheric and sensory. It's like a mini exotic destination within the home. Presently, that's what I am on the hunt for: Middle Eastern cutout screens and lanterns."

Andrew is no snob when it comes to seeking out his home furnishing; used furniture outlets, thrift stores, and oddities shops are where he finds his most cherished pieces. "I firmly believe that if I can't find what I'm looking for in a store, then I'll make it myself. Although, my favorite piece of furniture is probably the bed, which was a bit costly. The bed is a bit of luxuriousness, and one thing I can't make that I am looking to add to my decor is a burgundy Chesterfield club chair."

I asked Andrew if there was one place he could live, where would that be? Without missing a beat, he responded, "That's obvious, a Scottish castle."

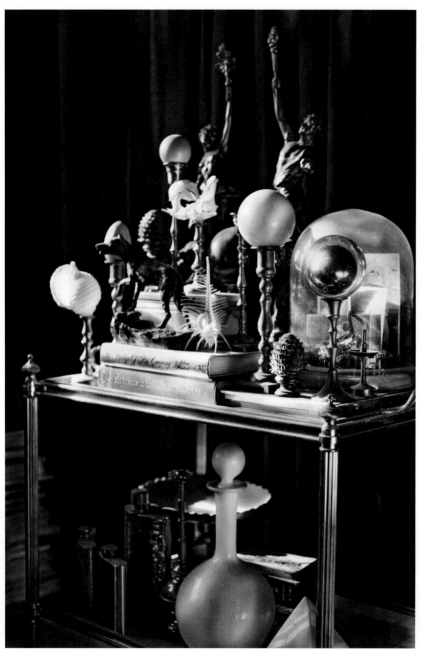

i.

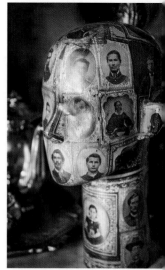

ii.

iii.

iv.

⚜

i. A small bar trolley displays a collection of natural shells, marble spheres, a little bronze dog, and a book on etiquette. ii. The cross-section of the head was created out of material from an old blanket. It's all in the original colors of the blanket and is approximately a half-inch thick. It pivots on a knitting needle that runs through the middle of it. iii. Because of where it sits in the home, the sundial only tells the correct time for about thirty minutes of the day. iv. A shipwreck sits on a large coral specimen—part of the Darwin exhibition. v. Vintage sunburst mirrors hang on the brick wall in front of "the slab" that two gilded eagles support. Highball glasses and barware share the stage with an old replica skull sitting upon a manuscript of Darwin's *On the Origin of Species* (not the original) and antique candlesticks. Below is a rare glass wine transport vessel. "It's an altar scenario where I mix drinks when guests come over."

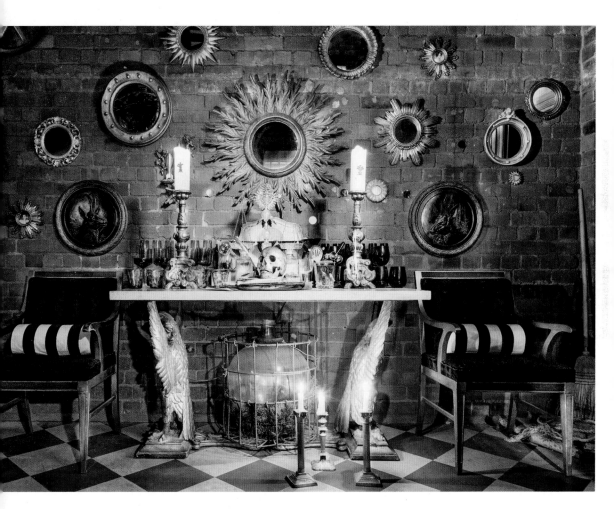

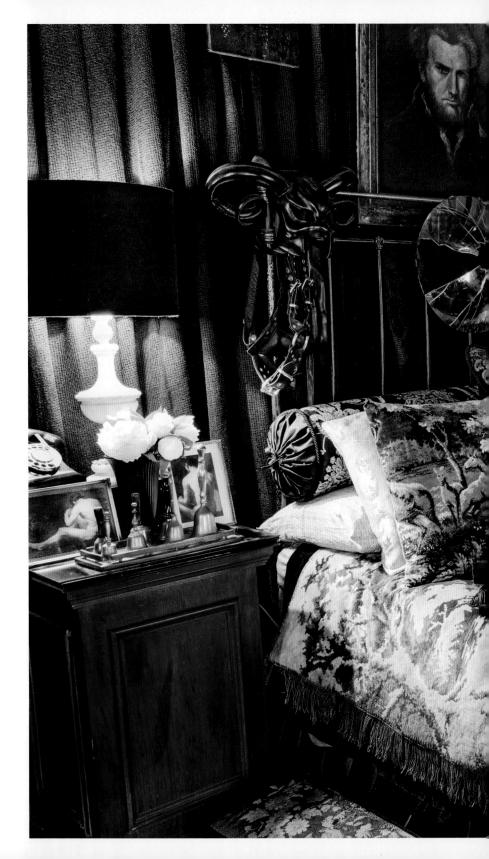

The bedroom sits at the far end of the once-industrial space that Andrew calls home. It is separated from the rest of the home by sheer black drapes, "which makes it intimate even though it is an open space. The bed was a gift on my twenty-first birthday. So, I've had it most of my adult life; although it's only a double, and I'm six-two. Throughout the room and the home, I've employed theatrical techniques in lighting and decor. All the artwork is mine, and I'll find old vintage and antique frames and paintings that sit within those comfortably."

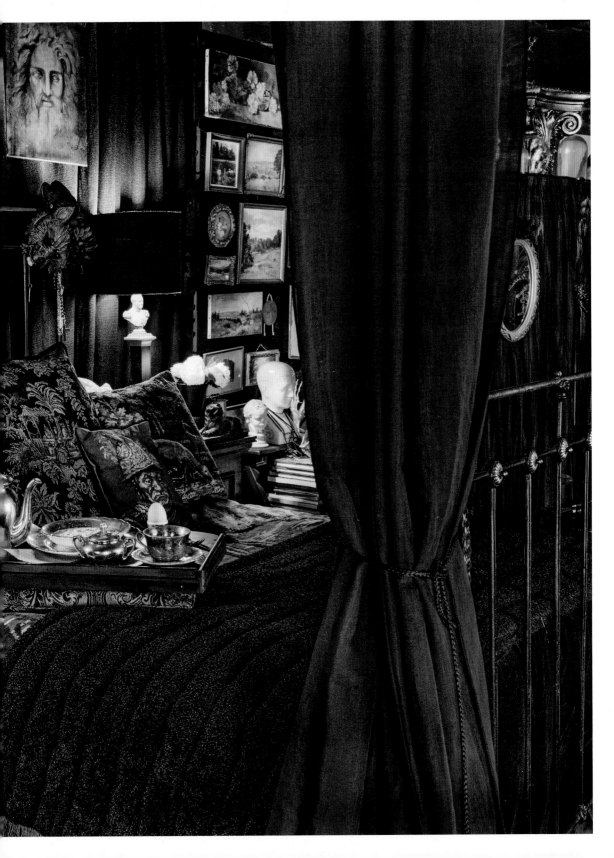

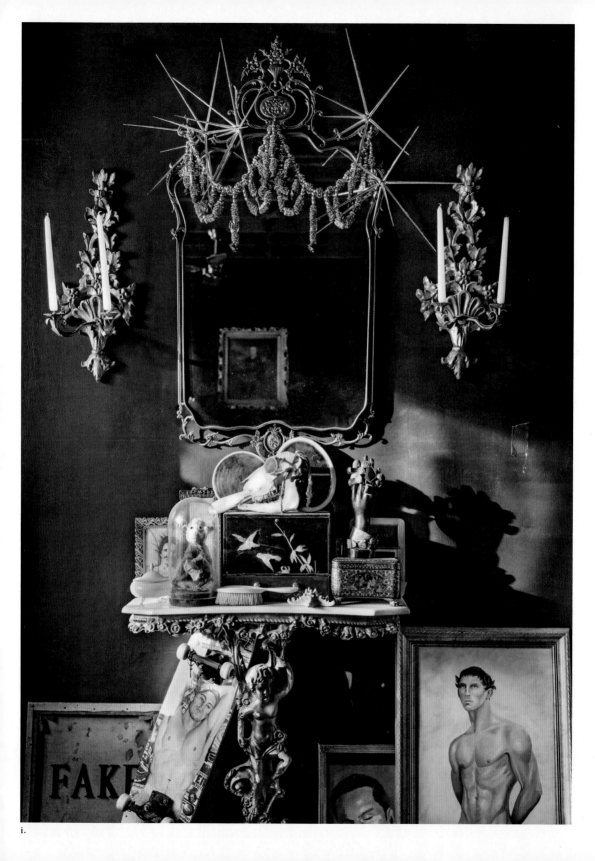

i.

i. An antique mirror hangs behind a tableau of an animal skull, vintage vanity mirrors, hairbrushes, a collection of rings, a pair of Chinese boxes, a lovely little hand puppet monkey under a Victorian dome, and a starfish. "This all sits upon a fabulously ugly, mid-century baroque table, which I find hilarious and wonderful. All the artwork there is mine; it sits to the right of the bed, making this the far-end wall, which I've only slapped one coat of black paint on. And that was as far as it went." ii. Andrew Delaney.

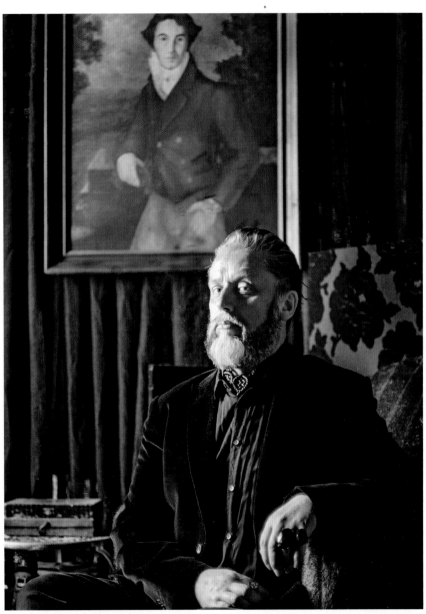

ii.

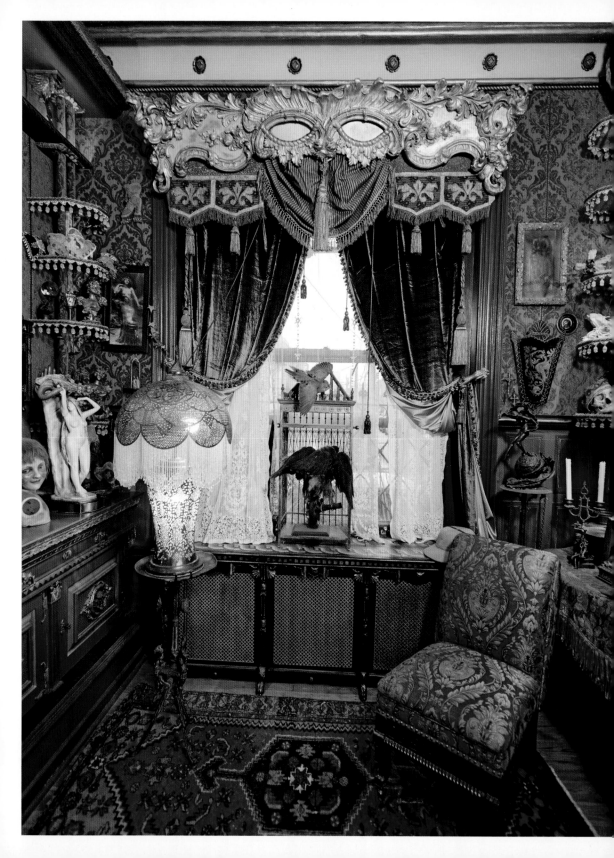

This restored Venetian valance has drapery that includes fragments from a Spanish tapestry circa 1750. One hand-tie back is Victorian metal; the other is a cast that Scott created.

✧

ANASTACIA + SCOTT FAHNESTOCK
Pennsylvania, USA

RECLAIMING THE PAST

Anastacia's first opportunity for home decorating came as a young girl when she was allowed to choose the wallpaper for her bedroom. "I opted for the dramatic. A rich, red flock number, but apparently the choice was overridden by my mother and instead got a pattern of little pink rosebuds. I could not wait to decorate my way! When I left, the first purchase for my apartment was Austrian drapes that I bought with S&H plaid stamps. When my mother

saw them, she said, 'It looks like a funeral parlor!' Success!"

When Scott and Anastacia discovered this house was for sale after years of abandonment, they jumped at the opportunity. Anastacia says, "I remember feeling as if I were in a spell. I gasped when we opened the door. I was blind to how much work the house would need; all I saw was its beauty."

Scott also saw the beauty but was well aware of the work the house would need. "Although it

Carved owls watch over from the antique Asian-themed French headboard while a funeral home casket lamp sits on the night table. Adorning the walls are just a few of the mourning hair wreaths found in the house.

was almost two hundred years old, it still had beautiful old bones, all intact but seriously in need of care. It had great woodwork, stained glass, sliding pocket doors, oak floors, and plaster moldings. It also had a unique feature for a city house like ours—a center stairway with a skylight. It had seen some very rough use, but we were surprised at how well the good parts had held up, and they came back strong with the proper attention."

When they first moved in, Anastacia stepped back and took it all in; she described the decor as "early crime scene." Her interpretation was not far from the truth. The son of one of the previous owners, "Big Red," killed himself in his bedroom, which is now the second-floor parlor. So, there was a stigma attached to the house after his death, and it sat vacant for a couple of years. "When we moved in, the walls were covered in layers of wallpaper, some with added sticky marble design contact paper. The various stages of decor

THE FAMOUS TENOR MARIO LANZA ONCE TOOK SINGING LESSONS IN OUR LIVING ROOM, AND I IMAGINE THE SOUNDS OF HIS MAGNIFICENT VOICE FILLING THE WALLS.

included beat-up Empire dressers and framed pictures of JFK, Philadelphia Police Commissioner Frank Rizzo, and the pope. There was also one of those old weight-reducing belt machines, and the curtains were nothing more than decaying plastic. We actually got a citation from the city for having an abandoned-looking property."

In addition to its infamous past, this home had some wonderful surprises, including that it was previously owned by Rodolfo Pili and his wife, soprano Gloria Marion. The Pilis were important to the Philadelphia opera community and founded the Apollo Grand Opera Company. "Rodolfo also taught the famous tenor Mario Lanza in

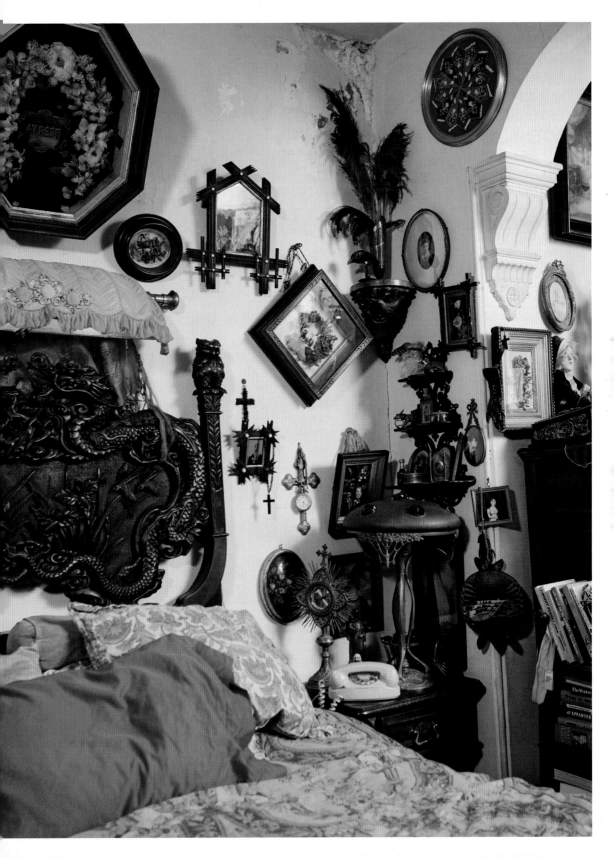

i.

ii.

iii.

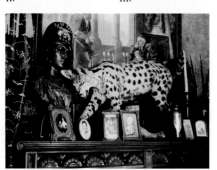

iv.

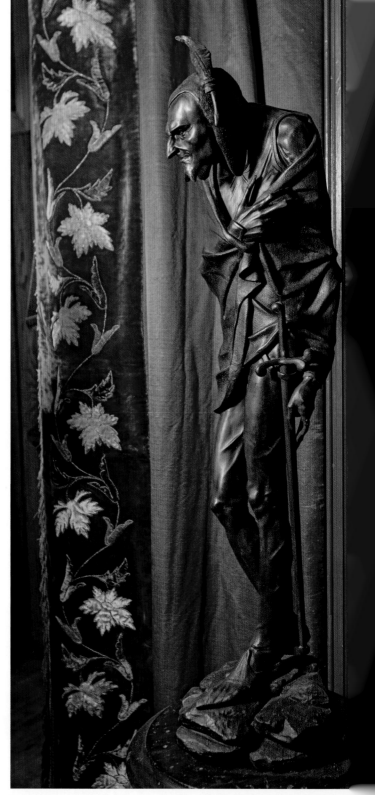

v.

❖

i. An antique French devil clock with red enamel numbers and snake hands; one of Anastacia's favorite pieces. The hands no longer move; they are set to the time their daughter was born. ii., iii. Antique wax store mannequin heads were draped in the latest fashion and now cast a ghoulish gaze upon you as you enter the room. iv. A taxidermy wildcat treads cautiously atop the bookcase. v. Richly embroidered velvet drapes and the original working pocket doors act as a backdrop for the magnificent spelter statue of Mephistopheles, circa 1900 by Jacques Louis Gautier. vi. Sanctuary or confessional? The Gothic powder room has silk walls, stained glass, and an oak confessional door. The commode is created from parts of an old pump organ. vii. "When our daughter Samantha lived at home, Scott built a sink and linen closet out of a Victorian armoire facade. This is a long view of the bathroom suite with the bath off to the right."

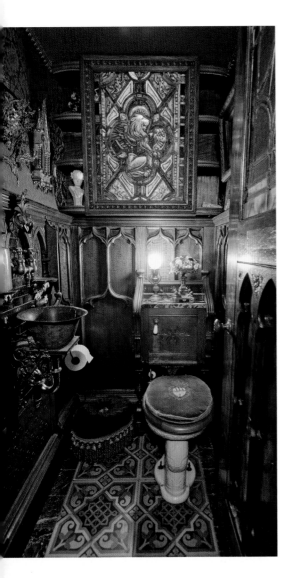
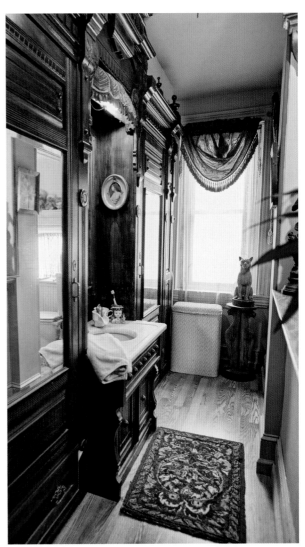

vii.

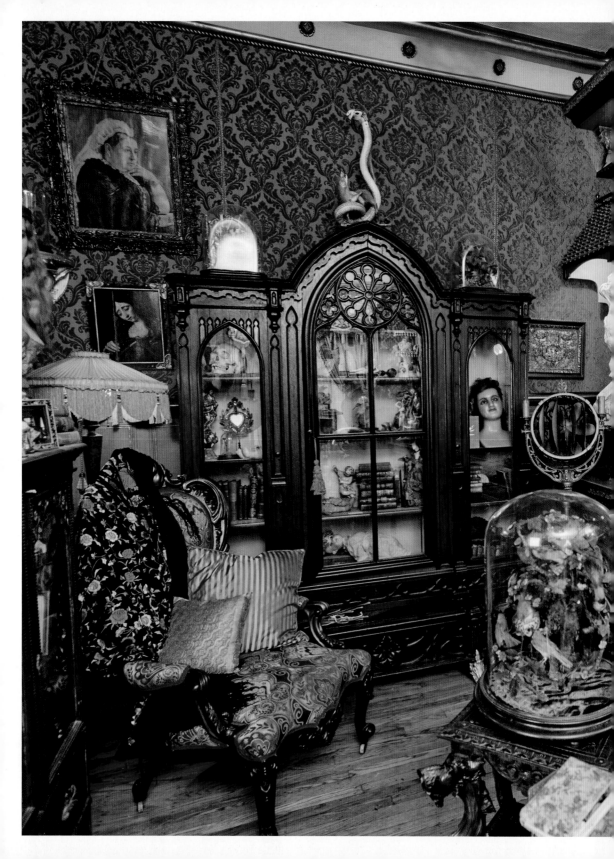

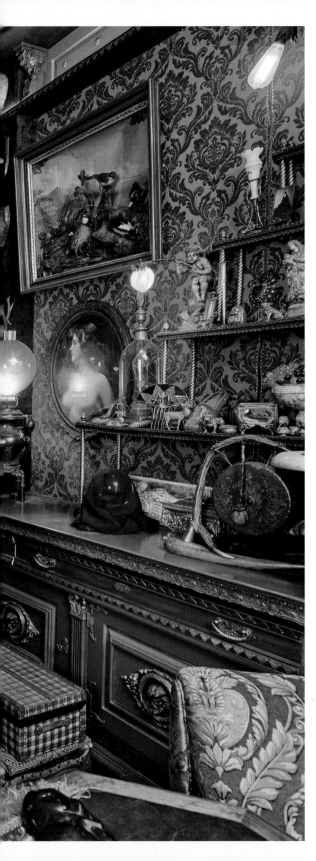

our living room, and I imagine the sounds of his magnificent voice filling the walls with his operatic practice."

In 1985, the pair bought their house and also started a business, Anastacia's Antiques. "We were suburbanites that had recently become interested in Philadelphia's stock of deteriorating old homes, and I was earning a living helping people restore them. My idea was to buy one, fix it up, and sell it. You know, just keep flipping houses. The idea for an antique store originated with Anastacia's mom. She collected, and although she never got into dealing, she passed down her dream to Anastacia. The two dreams merged when we bought this very rough fixer-upper.

"When renovating a house to sell, you think about what the new owners might like. That idea went out the window when we finally understood that we were going nowhere. This house is all for us. It is our sanctuary, and anything we do is structured around that idea.

5 3 .

✛

The Gypsy Room is designed in
a Moorish style and filled with
antique taxidermy. The fainting
couch begs someone to lie down
and nap. This large, imposing owl
was inherited by the couple years
ago and protects the room high
atop a carved room divider.

"Our social life revolves mainly
around the public space of the shop.
We do very little entertaining at
home. If we bring something in, it
is because we enjoy it, and it adds
to the peaceful, joyous feelings
the house provides us, not to try
to impress anyone else. For that
reason, we were initially skeptical
about the idea of publishing photos.
But getting the place ready to be
photographed, and seeing it through
another's eyes, has reenergized us
and put new vigor into our thirst for
the next project."

Anastacia and Scott are true arti-
sans; sometimes, projects can take
months and even years to complete.
Finding the proper amount of time
to devote specifically to crafting
the red parlor was one of those
projects. "My favorite room is the
red parlor. I am full of delight each
time I go in. It was always a vision
to have a red velvet room. Scott
encouraged me and devoted his
artistic energy. Together we cre-
ated my dream room. My advice?
Always decorate with your heart

and not with the thought of what
people may think. Find your inner
voice. It's in there."

While Anastacia basks in the
beauty of her red room, Scott has
a very intimate relationship with
the powder room. "It is the small-
est room in the house and the one
I put the most effort into. The idea
was to make a Gothic cathedral
jewel box. We had saved all sorts
of Gothic parts and finally decided
to put them to use in there. I had a
beautiful old ceramic Gothic-style
toilet bowl but needed a tank. I
dismantled an old oak parlor organ
and made one from it. When you
close the door, it is a tranquil and
peaceful place.

"It was slow going in the begin-
ning, with very little money, but
I was motivated by a deal struck
early on between us. Anastacia
said, 'If you build me a Victorian
house, I will do your laundry for-
ever.' She has kept her word, and I
will keep building."

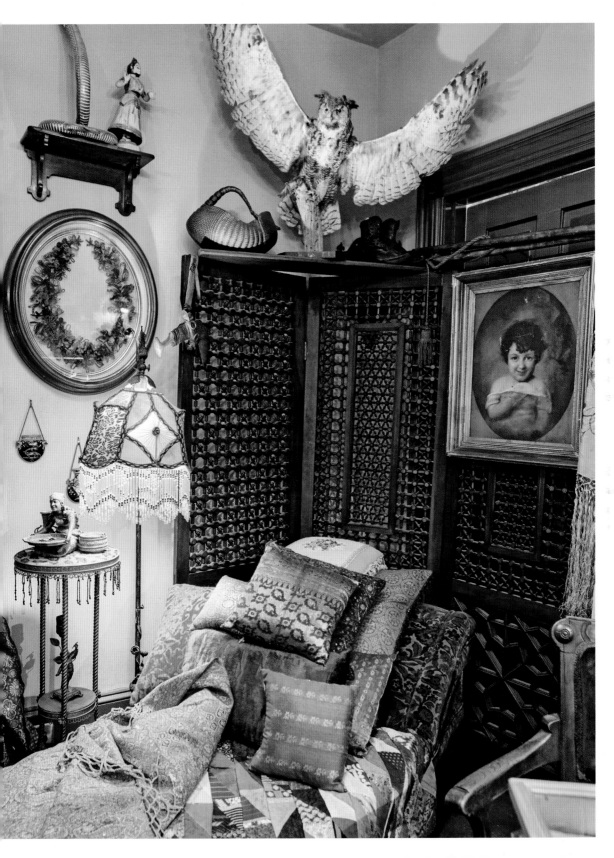

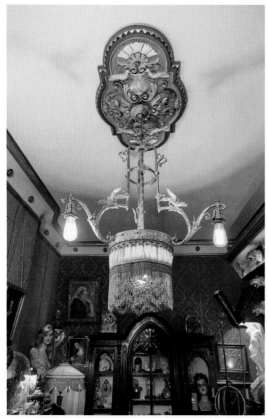

i.

ii.

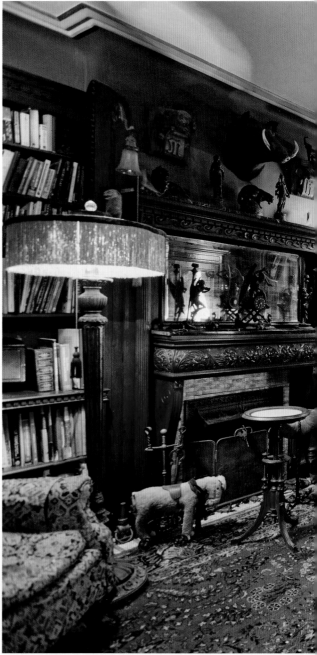

iii.

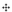

i. The ceiling medallion is original to the house; it was carefully stripped by Scott and painted by Anastacia. She also made the beaded shade using antique materials. ii. Anastacia and Scott Fahnestock. iii. From the 1920s through the 1950s, this house was occupied by the Pili family. Rodolfo Pili was a renowned impresario. He and his wife, soprano Gloria Marion, were stars in the opera community. He founded the Apollo Grand Opera Company and gave voice lessons in this room, where famed tenor Mario Lanza was one of his students. Anastacia and Scott tried to infuse the Opera Room with the drama that its history deserves, yet keep it cozy. This room is a place to settle and relax. Choose a book from the bookcase Scott built that flanks the working fireplace—warm and inviting with heavy velvet drapery to block the chill.

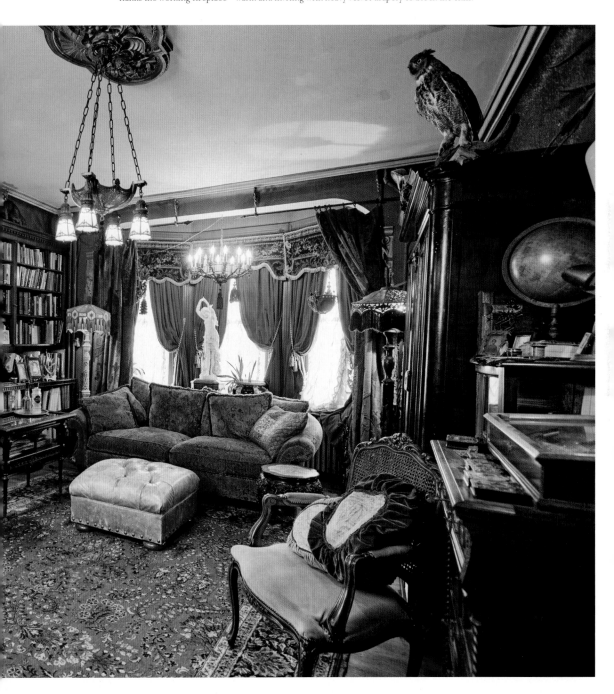

⁜

GIANO DEL BUFALO
Rome, Italy

THE COUNT OF MODERN GOTHIC

Giano casually describes how he grew up in a typical Italian country house—an open floor plan, lots of stone and terra cotta, exposed beams, and a large utilitarian kitchen. However, there were aspects that made this typical Italian country house not so typical. Giano's father was and still is a major player in the buying and selling of antiquities. "The interior decor of the house included many influences. My father collected ancient Roman antiques, marble and plaster columns, and beautifully sculptured busts, and these pieces would find themselves mixed in amongst my mother's choice of classic wooden countryside furniture. All in all, it was a very charming home."

All this talk of growing up in a quaint country home set against a bucolic backdrop appears relatively generic until you realize this conversation is happening while this young man sits on a priceless couch in the thousand-year-old castle he

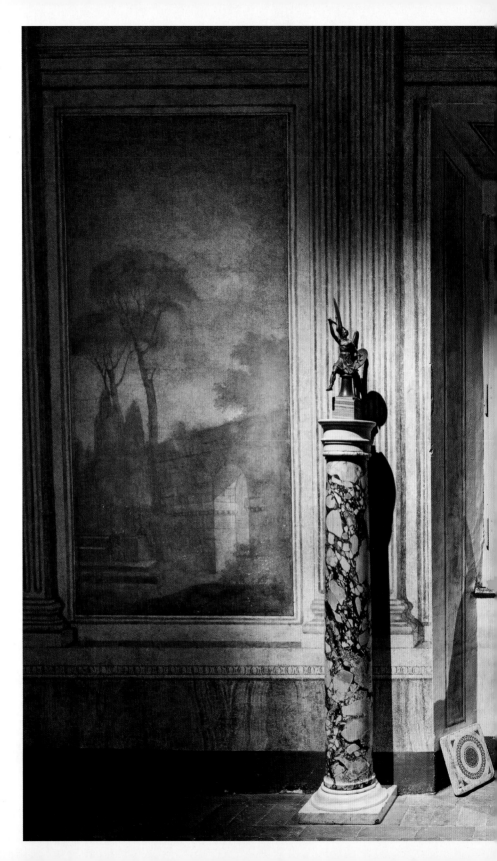

Two Roman columns flank an ancient sculpture of a Roman helmet and weapons. Atop the columns are statues of Hercules and Nike. At the right of the photo, you can see a hidden door that leads into one of the bedrooms.

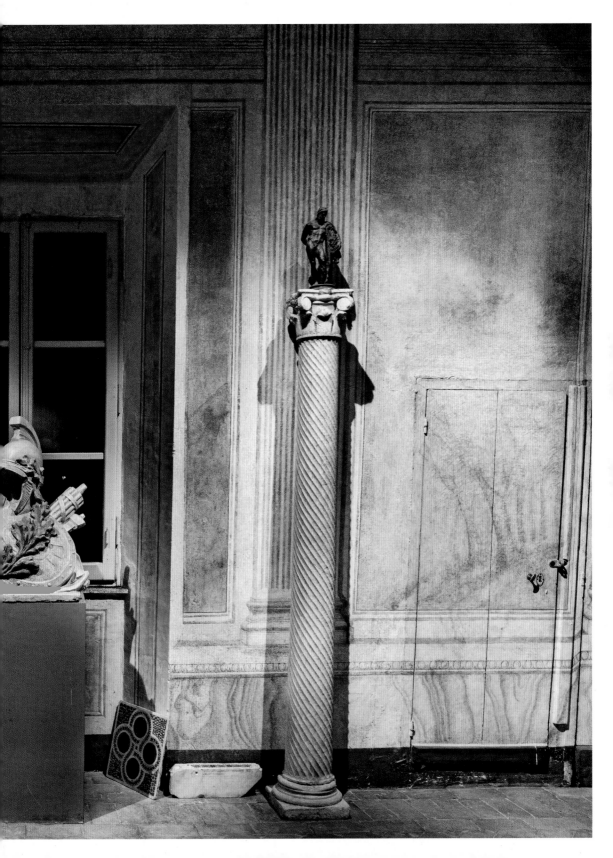

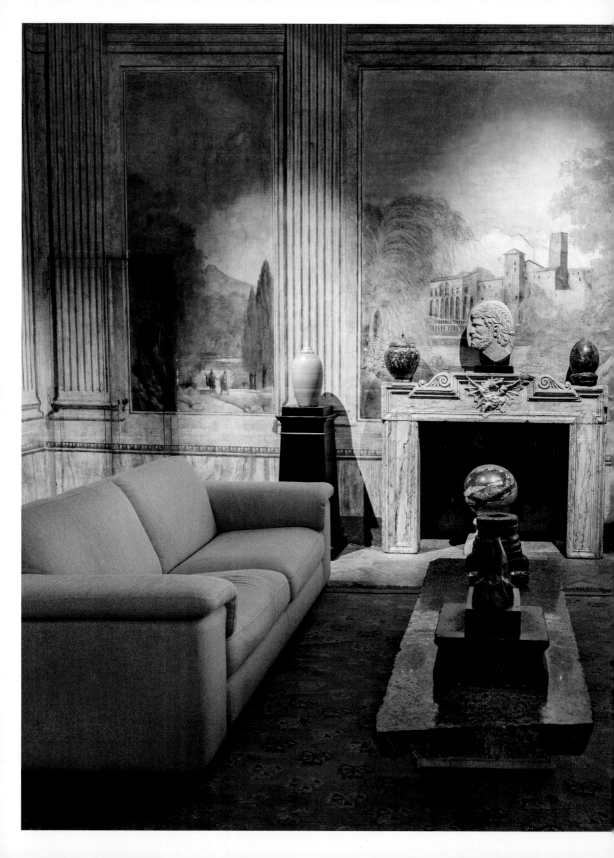

This formal living room serves as a space to display some of Giano's archeological collection. Some have been in the Del Bufalo family for years, and some are new acquisitions made by Giano. The castle's living room walls are one of the many gems of the castle, adorned with original seventeenth-century frescos depicting the construction of the castle. "When we took over the castle, these frescos were coated in layers of dust and dirt, and it took a lot of time and skill for the restorer to bring these walls back to 'life.'"

calls home. "Twelve years ago, my family and some friends had the opportunity to purchase a huge and very important property. After much debate and figuring out the finances and logistics, we decided to combine our assets and buy it. The logistics being, we divided up the interior to accommodate nine independent homes—one for each of us."

The castle that Giano shares with his family and friends is steeped in ancient history. It was the summer residence of two popes, Leone XII and Paolo V Borghese, who used this stone structure as a refuge to cool off during the hot Roman summer periods. Although the property is situated within the city limits, it was built in a "fresh air" valley, just far enough from the noise of the city.

"We kept as much of the interior and exterior as original as possible, including the original frescos

✥

i. An ancient statue of a scribe's head. ii. A trio of masks from Africa and Nepal sit on the table behind a Kota knife, sometimes referred to as the "bird head" knife, from Gabon, Africa. In the background is an oversized photo from the photographer Massimo Listri of a section of the Vatican museum. iii. A complete human skull. iv. A beautiful and rare piece of Gandhara art of a fasting Buddha carved out of schist stone. After reaching enlightenment at Bodh Gaya, Shakyamuni meditated and fasted for forty-nine days. As an emaciated renouncer, this symbolized his enlightenment and status as someone with ultimate control over his body. "I am very, very in love with this piece and would never sell it. A little-known fact is that the 'bun' on top of the Buddha's head is not hair, but rather an extension of his skull that houses the extra parts of his brain, since he possesses so much knowledge it cannot fit in a normal-size brain." v. An authentic Tsantsa ceremonial shield from a tribe in Papua New Guinea that is adorned with human hair.

i.

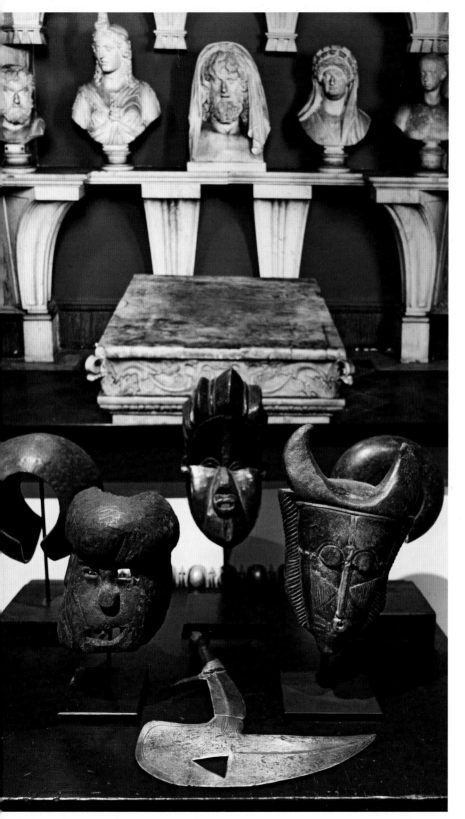

iii.

iv.

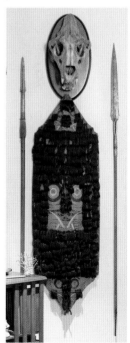

v.

A beautiful eighteenth-century life-size terra-cotta statue of a cardinal wearing a Cavalieri cloak. "The Cavaliers are a secret order dating back to medieval times; my father is a chevalier, and I may become one someday."

painted by Annibale Durante, all of the original flooring, and the many wall hangings and original Renaissance furniture that survived throughout the years. Unfortunately, we don't have paintings or drawings of the castle during the popes' stay.

"In addition to the fresco, the dragon adorning the chimneys is a highlight. It is a symbol of the aristocratic family who was here before us. Sometime in the past, it was removed from above the mantle, and after months of cleaning and exploring the gardens, we found it behind a shed."

Giano has lived in the castle for over a decade, but he is the first to admit there are still times he cannot believe his good fortune to live in such a unique home. "I could never imagine being able to live somewhere else. As an art historian, I dream continuously about the life experiences that went on here before us. The people this place called home. The parties that were hosted. The religious events

that transpired. The adventures that happened here. This house has over one thousand years of people coming into this world and leaving this world."

With a thousand years of history, the prospect of the residence being haunted is a reality for many. "The year we began restoring the home, many workers told us about odd noises coming from inside certain rooms and objects appearing and disappearing without explanation." Giano and his "neighbors" did not escape the potential supernatural occurrences experienced by the restorers. "Not long after we moved in, we had some strange unexplained events. We heard voices and had items moving around the house. We decided to call a well-known Roman priest who specialized in exorcisms to ask if he would come and assess the home. He came and blessed the entire property via a lengthy Catholic ritual. We are happy to report that since that home exorcism, things have been normal around here. Before

The castle's main rooms are situated on the second floor of the three-story building. The first floor holds the guest bedroom and the formal living room. The landing hosts a very large taxidermy Nile River crocodile and a beautiful seventeenth-century painting of the Romans among the ruins of the Forum in Rome, both suspended above an extraordinary floor constructed of ancient fragments.

A PRIEST CAME AND BLESSED THE ENTIRE PROPERTY VIA A LENGTHY CATHOLIC RITUAL. SINCE THAT HOME EXORCISM, THINGS HAVE BEEN NORMAL AROUND HERE.

that experience, I never believed in ghosts, but I will admit I felt 'something' was happening in this house."

Giano's professional life encompasses many aspects, and they all revolve around the buying, selling, and collecting of amazing artifacts. His specialty lies in tribal artifacts and natural history, and many pieces are on display in his gallery in the center of Rome. He also lends his talents to auction houses as a consultant and as a museum expert/buyer. The pairing of Giano's good looks and expert knowledge landed him hosting two top-rated television shows in Italy called *Cash or Trash* and *Il Codice Del Boss*.

With such a busy lifestyle, it's important that Giano has a quiet space where he can decompress. "My favorite room is my personal *Wunderkammer*, where I keep all my treasures—they fill the walls and the ceiling—it's a lifetime collection. I sit there at night with a glass of wine, contemplating the beautiful objects surrounding me. My favorite piece in the *Wunderkammer* is a mummy head from Fayyum, Egypt. That was the first piece I ever had in my collection, and it became the catalyst for a lifelong passion for art and history. I am chasing a fantastic, large, ancient outdoor drum from the Vanuatu archipelago, but the owner isn't sure about selling it now. Although, I am trying my best to persuade him because it would be great in my garden. Well, I do have one other crazy idea, but I wouldn't call it a home decor piece. I want the prow of an old ship in my garden!"

i.

ii.

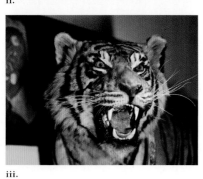

iii.

iv.

i. A peek through the doorway leading to the dining room. A huge, beautiful late-seventeenth-century oil painting and the gaze of a taxidermy lynx offer an invitation to dine. ii. Giano Del Bufalo. iii. A large vintage taxidermy of a beautiful Siberian tiger. "This is an example of how taxidermy was done fifty years ago. The skull of the tiger is still within this mount. Later in the twentieth century, the skulls of these animals were fetching very high prices, and taxidermists began stretching the fur over plastic head molds and selling the skulls as separate items. This tiger is completely intact." iv. The stairs leading to the second-floor living room, dining room, and master bedroom are lined with trophy taxidermy hunted by Giano's ancestors. Some of the pieces date back to the eighteenth century. v. A magnificent cabinet displaying a portfolio of photographs of Constantinople (Istanbul) from the late 1800s and early 1900s. These photographs were taken by a famous Turkish photographer who photographed royalty.

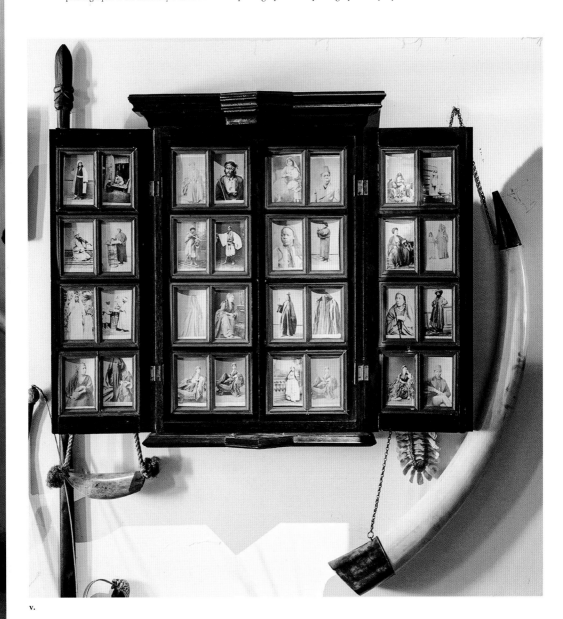

v.

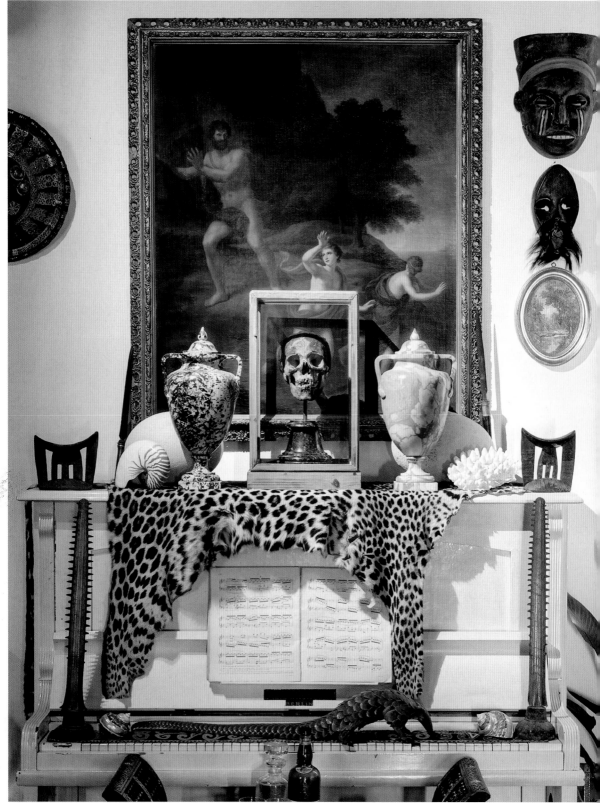

i.

i. Hanging above the piano is a painting of Polyphemus, the savage man-eating giant who first appeared in the ninth book of the Odyssey; it's one of Giano's earliest antique acquisitions. "I purchased this painting almost twenty-five years ago. I love the story behind Polyphemus, and I found this painting fascinating since you rarely see mythological creatures appearing in classical baroque paintings." ii. The decor of Del Bufalo's dining room has a focus on antiques and antiquities but also incorporates a bit of personal history. "We can see a couple of nice paintings, but the most important is the one above the mantel. The woman in that painting is my aunt, Faustino Del Bufalo, from the sixteenth century." That's an aunt with thirteen "greats" in front of it. "The painting was done by her cousin Julia Del Bufalo."

The Freeman and Fugate
family. The future
looks bright.

✣

JAMES FREEMAN + KATE FUGATE
Southern Georgia, USA

DOMESTIC MYSTICISM

Although James and Kate grew up only minutes from one another, their childhood homes were remarkably different. As described by James, "I grew up very poor in a mobile home park, and it was typical of any Southern family living in poverty. Elvis and Jesus reigned." While Kate described her situation like this: "I grew up about ten minutes from James in a typical, suburban home in a cul-de-sac. I would describe the style as a '90s home movie. All it was

missing was Bob Saget holding the camcorder."

Kate and James now live in a quaint lakeside town that "has a real Twin Peaks vibe to it." The area was initially developed in the 1930s to serve as a vacation town for the Atlanta elite, with the sale of 20-foot-by-100-foot lots for $69.95. Over time, and like many towns built pre–World War II, this town eventually fell on hard times. "Now it is a bit more ramshackle and full of artists and musicians."

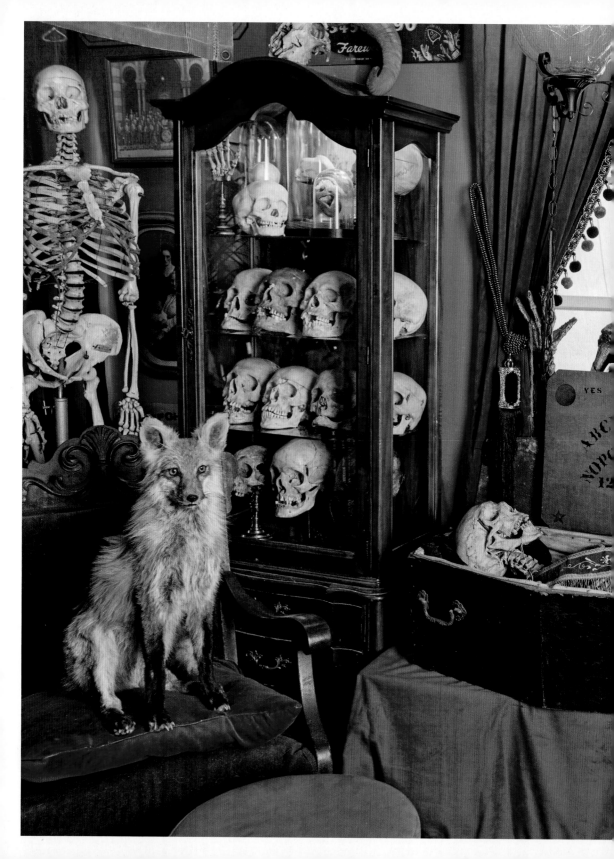

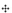

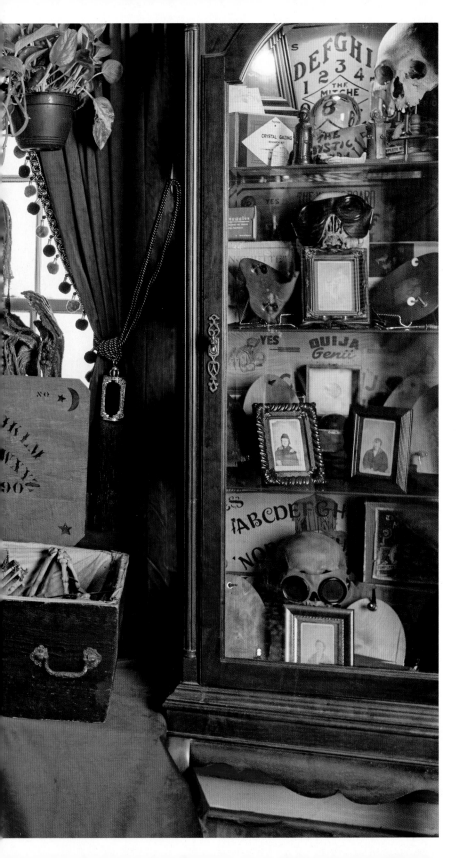

A Victorian-era taxidermy fox stands guard before a cabinet displaying human skulls. This is an Odd Fellows skeleton from the nineteenth century that James and Kate's daughter named Tom. It was found in a VFW hall in Georgia. The lodge caught fire, and a box in the basement was opened by a firefighter, revealing a skeleton in a ceremonial casket. That VFW hall had originally been an Odd Fellows lodge. The skeleton's jaw is wired so you can pull on it, and it would "speak" during ceremonies. The skeleton behind the casket is a prop from the now-defunct Dante's Inferno Dark Ride in Coney Island.

An incredibly oversized two-headed baby sideshow banner by Fred Johnson that was formerly on the World of Wonders tour covers the entire ceiling of the living room. Scores of taxidermy share the wall space with original early 1900s magician posters, and four of the six skeletons that reside in the house can be found in the "living" room.

"When we moved into this house in 2015, it was full of surprises: some original to a house built in the 1930s and some from the renovations done by the eccentrics who owned the house before us. For instance, with the house's structure, the main room has a beautiful vaulted ceiling with two triangular windows up top that look like eyes at night. On the other hand, the previous homeowner had made many DIY 'improvements' to the home, like a foot massaging bathroom floor. We've been slowly changing things like that to fit our particular style."

The James Freeman and Kate Fugate style may not be your typical Gothic representation; however, they chose to focus on their inherent interest, which happens to be many of the interests of the original Gothic era—mysticism, magic, and the unusual.

"Finding the museum pieces currently in our home was the most difficult part. We wanted to focus on one-of-a-kind pieces with historical relevance. Unfortunately, there aren't many stores where you can walk in and buy signed pictures of Harry Houdini, automatic writing planchettes, nineteenth-century Mumler spirit photographs, or rare Ouija boards.

"The latest acquisition was a Fred Johnson two-headed baby sideshow banner formerly on the World of Wonders tour. The banner was used for a conjoined twin wet specimen exhibit. Unfortunately, someone took offense at the display of the babies, and the exhibitors were arrested and forced to give the specimen a 'Christian' burial. They replaced the remains with a 'bouncer' [fake rubber baby], and the text at the bottom of the banner that formerly read 'real' and 'why' were painted over to read 'replica' and 'facsimile.' The banner is twelve feet tall and is on our living room ceiling, and dominates the room.

"The dining room, where I spend most of my workday for our family

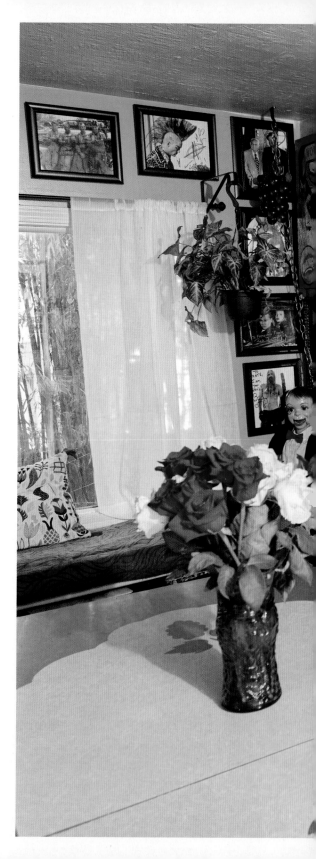

The kitchen is referred to as the Freakatorium. A 1950s kitchen set is surrounded by walls lined with an original poster of the famous Siamese twins, an Edna Price Sword Swallower poster, a Girl in a Fish Bowl Illusion banner, and a Robert Ripley CROCO poster.

business, Freeman and Fugate Oddities, has a Jack Sigler mermaid act sideshow banner that covers a wall."

James's favorite room is the Séance Room. It's filled with talking boards, spirit trumpets, taxidermy, and signed pieces and posters from Houdini, not to mention a working 1880 pump organ discarded from a Victorian mansion in Atlanta that fell under the ownership of someone with more money than taste when they were modernizing the home.

Kate also has a favorite room. "The bedroom! It's my perfect sanctuary. And I do have a couple of favorite pieces. One was a handmade wedding gift from a friend who makes model trains. It's a little model of a graveyard plot, and when you flip it over, it has a viewing glass to show our side-by-side graves. The second is a piece of folk art I have never seen before or since: several painted tin plates tell the story of a woman who accidentally catches the sleeve of her dress

✥

On the table of the Séance Room sits an original spirit trumpet from the *Progressive Thinker*, a nineteenth-century spiritualist newsletter that sold planchettes, trumpets, and other medium items, including an original nineteenth-century automatic writing planchette. The one-of-a-kind board is from the 1890s and is the only one known to exist, making it very rare.

on fire on the iron stovetop. The final plate is an image of her cats crying over her ashes. It is wonderful, and I wish I knew more about its origins."

The Freeman and Fugate house will always be in a state of continued decorating; as pieces present themselves, they will be incorporated into the home decor. Regarding significant renovations, they plan to paint the exterior to reflect a Victorian home with lots of dark purple and black.

Is their house haunted? James quickly responds, "I'm an atheist that doesn't believe in any afterlife. I don't believe in ghosts, which is odd considering I primarily collect items devoted to contacting ghosts!" Kate patiently waits and then calmly says, "James and I have BOTH experienced creepy phenomena, so why he is still so staunchly a nonbeliever is beyond me. That said, our home is usually freshly saged and spirit-free." However, they both agree that if the house were haunted,

i. The original lithograph on the wall of the controversial magician Torrini hangs above a 1930s talking skull, which sits among a shelf of William Mumler's original spirit photos. ii. Personally owned artifacts from Harry Houdini, including Houdini's copy of the 1917 edition of *M-U-M* magazine. In the corner is written: "Please Return This. It's the only copy I have. H H." In front is a booklet by Houdini exposing the medium Marjorie as a fraud. Houdini's crusade to expose fraudulent mediums began in 1922 after a vacation with Sir Arthur Conan Doyle and his wife, Lady Doyle. Lady Doyle, a self-proclaimed medium, offered to contact Houdini's departed mother. While "speaking" to Houdini's mother, she drew a cross and ten pages of communication in English. However, Houdini's mother barely spoke English and was Jewish. This event ended the friendship between the Doyles and Houdini. iii. A vintage Ouija board, an early 1900s geriatric skull, and the articulated bones of a right hand. iv. Jars containing a cycloptic pig, conjoined pigs, and a pig born with hydrocephalus. In the lock-top jar is a plastinated heart of a girl who died from an enlarged aorta. It was prepared by Gunther von Hagens, who invented the plastination process. The human skull is that of a five-year-old child. v. The hallway features portraits of Freeman and Fugate's families. "My wife said, 'It's cool that the house is all Gothic, but we are a family, and we're going to have family pictures in the hallway.' The carpet is of the same pattern as the carpet from the Overlook in *The Shining*."

neither would leave. As James says, "Absolutely not. Despite being a skeptic, I love ghost stories, and I'd gladly accept being proven wrong about their existence with definitive proof! I've had many experiences that many would call paranormal, but I believe they all have a rational scientific explanation." To that, Kate joyfully exclaims, "No! I would love to have a cozy little ghost to share our home with."

With James being the proprietor of Freeman and Fugate Oddities, a company buying and selling morbid antiques, specializing in Victorian spiritualism, Ouija, occult books, mourning pieces, sideshow banners, and obscure medical items, his business and home life are very closely related. "We also sell a ton of nineteenth-century photography, mainly spirit photos, circus sideshows, cadaver labs, and post mortem. I'm also the proud father

WHILE KATE SAYS THE HOME IS USUALLY FRESHLY SAGED AND SPIRIT-FREE, SHE WOULD LOVE TO HAVE A COZY LITTLE GHOST TO SHARE THEIR HOME WITH.

of an amazing kid, and I skateboard every day at forty-two years old. Now, Kate is the glue that holds our little family together."

She adds, "I'm a full-time restaurant manager, and I've been in the industry for years and enjoy what I do. I can also provide health insurance for the family with my job, which is something that a small two-person business generally cannot offer. I'm also a proud mother to Evelynn. And I make sure James doesn't spend our entire life savings on Houdini memorabilia or skulls."

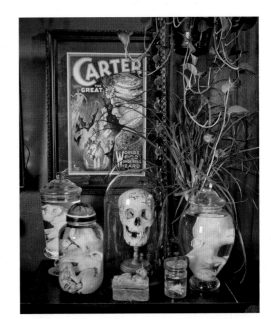

iv.

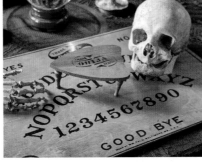

iii.

v.

⬩⯊⬩

i. James explains that the organ is circa the 1880s. "It came from a beautiful black Victorian mansion in Atlanta, whose new owners decided to throw it out when modernizing the interior. It still works, and I play it occasionally. Among the four skulls sitting on the organ, one has a large trepanning hole in its frontal lobe. The Ouija board on the organ is a 1902 William Fuld. That board appeared in the movie *My Best Friend's Exorcism*. The planchette was given to me as a gift from the production company." ii. Before gaining entrance to the kitchen area and the bedrooms, you have to brave it out past a human skeleton, whose original owner was stricken with scoliosis, and taxidermy looming above.

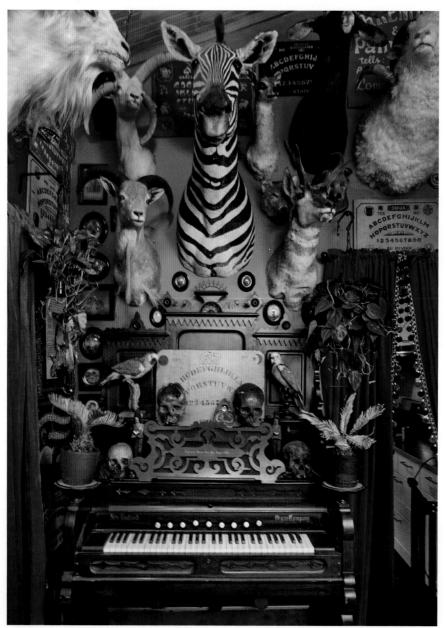

i.

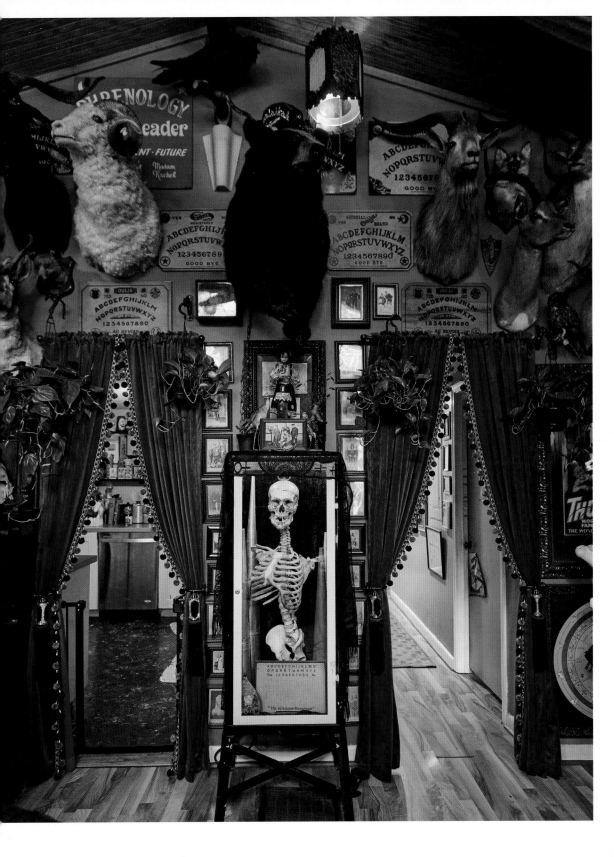

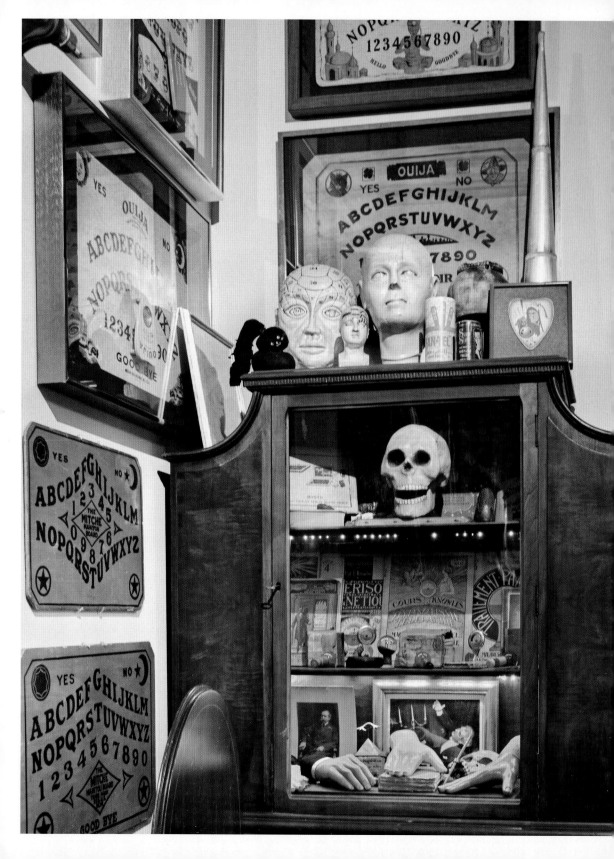

A nook in Brandon's home gives you a peek into the future and the past via rare and antique items used by spiritualists.

✣

BRANDON HODGE

Texas, USA

THE GOTHIC "SPIRIT"

Brandon's description of his childhood home rings somewhere between a Hallmark card and a Hitchcock movie's opening scene. "It was a brick house on a large farm among the swamps of the Texas Gulf Coast, right on the border of Louisiana. It was a long, A-frame style home with two wings, a tiny central loft, and a steep cedar plank roof, set far off the road down a long driveway and nestled among towering Southeast Texas pines.

"My parents finished building it just two weeks before I was born in the mid-1970s. It had features common to the era, including not only the typical avocado-green appliances and mustard-yellow shag carpet but also dark wood paneling, built-in display cabinets, and tall, overstuffed bookcases. That style of decor continues to influence me to this day, and started my fascination with dark, richly stained wood and weird hidden recesses put to good use. I have the

Brandon's home is centered around a bright and open kitchen, which features displays of hypnotism, mesmerism, and palmistry; fezzes from various fraternal societies; and artifacts and framed illustrations depicting the spiritualist practice of table tipping. The kitchen's central island is a repurposed Max Wocher & Son oral surgery cabinet from the 1940s, featuring cauterization terminals, controls for internal ether pumps and dental vacuum suction apparatus, and an array of drawers that now hold kitchen utensils. The cabinet's top lifts to reveal a hidden liquor cabinet.

fondest memories of my childhood in that home."

Fast-forward to 2008, and Brandon purchased the home he and his children live in now. Brandon says that although the house doesn't host many stunning architectural features, it is solidly built and still has the lovely original wooden floors, which are beautifully preserved and perfectly offset the dark wood pieces he favors when furnishing the home.

For almost nine years, Brandon's extensive collection of antique and rare spiritualism pieces was primarily confined to what was then the guest bedroom and a converted room adjacent to the garage that he had rebuilt into a Victorian-style parlor, both of which were decorated in the maximalist style.

However, in 2017 that all changed. "I installed bead board ceilings and wide, flat moldings that

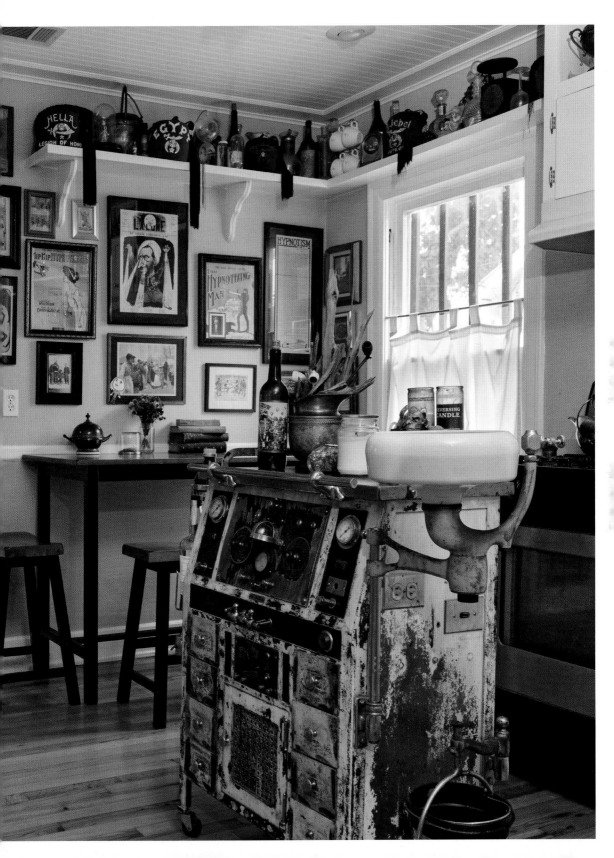

i.

ii.

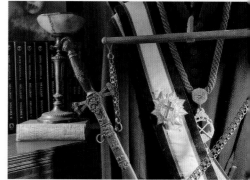

iii.

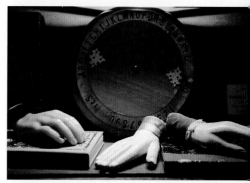

iv.

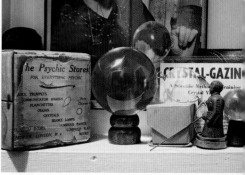

v.

i. The kitchen wall adjacent to the back parlor's entryway features a Voodoo Tipping Table produced by American Manufacturing Concern in the 1930s. It's surrounded by related illustrations depicting the spiritualist practice of table tipping, a mode of spirit communication first developed in the early 1850s that utilized the mysterious movements of tables under séance sitters' hands to speak with the dead through a series of taps. ii. An antique display case houses a rare 1905 Hamley Brothers Vishnu fortune-telling game. This is the sole known surviving Vishnu set. iii. Items from the Knights Templar secret society, including the iconic crested ceremonial sword and various medals and trappings of the member who once wore it. iv. This shelf contains a set of rapping hands—magic props used by stage magicians that purportedly allow communication with the spirits by mysteriously tapping out responses to questions, such as once for *yes* or twice for *no*. They are displayed atop rare books on magicians' public exposés of spiritualist practices—a typical side career for many stage magicians in earlier eras. v. The hallway from the master bedroom features an array of crystallomancy-themed artifacts, including crystal balls, talking boards, and other fortune-telling apparatus.

THE COLLECTION IS TRULY LIKE ANOTHER FAMILY MEMBER THAT COHABITS WITH US, OR US WITH IT!

extend about six inches over the ceiling perimeter rather than down the wall like typical crown molding. Together, the two elements—the room-length narrow grooves of the bead board and the deep perimeter trim—create the illusion of a higher ceiling by creating more depth."

This architectural renovation was prompted by an earlier decision to move the collection from the detached collection room into the entire home. "It was a major adjustment in the house's interior appearance and our lifestyle. The collection, and the art of collecting itself, is no longer this detached activity. You realize everything you do will have some consequence on your daily life, including how you navigate your home and how others perceive it. My maximalist design style would probably be far better suited for a home of an earlier vintage with higher ceilings, and if I could make one change, it would be to add some interior height. However, the collection is truly like another family member that cohabits with us, or us with it!"

Display is a foremost consideration when Brandon is envisioning a room's decor. "My various quests for new decor are always closely tied to the pieces I feel need to be appropriately displayed, and while I am always on the lookout for great antique cabinets and display cases, limited remaining space dictates that new acquisitions have to trump older ones in a significant way to make all the trouble worthwhile. And I've found that some ideas don't pan out, in reality, the way they do in your mind. I had fallen

in love with a fantastic pair of Civil War–era pharmacy cases, but once I stood near them, I realized they would totally dominate the room. I abandoned the plan to acquire them, even after driving two hours in a U-Haul to pick them up!

"However, for years, amid artifact collecting and acquisition of larger display pieces, I found I was continuously drawn to ornate Victorian frames, and I found that as previous generations continued to discard that aesthetic, I could pick them up cheaply—often for only $2 to $3 a piece—at yard sales and flea markets. I stockpiled them for years, and one of my great surprises was the amazing assortment of those frames I had at my disposal and how elegantly and effortlessly they matched up with key artifacts, prints, illustrations, paintings, and photographs I wanted to display framed."

Brandon's relationship with his daughters is paramount, which meant balancing the decor of what would best be described as the living room or family room in an oddities style consistent with the rest of the house, while still being kid-friendly. The result was a room that Brandon says is special. "Given that the kids and I spend most of our time in the front den, I think it is probably our favorite room. While I feel the entire home was meticulously curated when redecorating, the front room I spent the most time creating new versions of until I settled on a space that was just right for us. I love its combination of vintage couches, the different types of antique display cases, and the dense arrangements of framed art and artifacts. The imposing desk—a converted Empire-style square piano—and the fireplace and stacked barrister cases create nice centerpieces that help ground the seemingly chaotic array of frames, shelves, and artifacts on display from floor to ceiling on the surrounding walls. I also feel this room best exemplifies the 'asymmetrical symmetry' aesthetic that I believe defines my

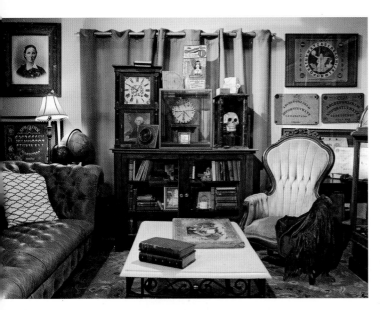

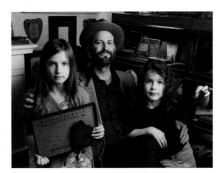

ii.

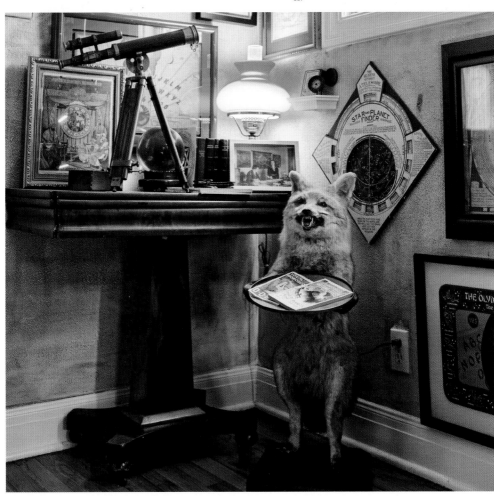

iii.

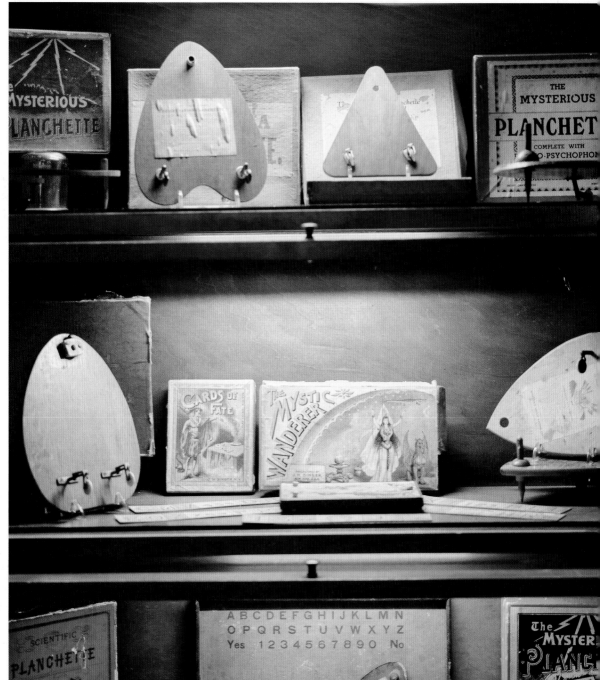

A set of antique barrister cases displays an assortment of rare spirit communication apparatus, many of which debuted decades before the advent of the Ouija board in the 1890s. The case features several key automatic writing planchettes from Brandon's collection. Also displayed is an extraordinarily rare J.H. Singer "Mystic Wanderer" from 1892: an early competitor to the Ouija that featured a fancifully illustrated box depicting a mystic oracle.

particular approach to maximalism, particularly the way seemingly disparate elements mirror one another spatially from opposite sides of certain centerpieces. For example, a wall-mounted planchette on one side of the fireplace might be mirrored by an oval frame on the other side. It brings some order to the chaos when you have so many disparate artifacts you want to display correctly.

"Although my favorite room is the front den, my favorite piece of furniture resides in the main room. It's the stacked barrister cases arranged in the main room and how they display what's in, on, and above them. These cabinets exhibit some of my rarest and most precious artifacts, from the plate glass Kirby & Co. planchette to the bright and colorful J. H. Singer Mystic Wanderer from the 1890s. Its top serves as an excellent bookshelf for some of the world's rarest occult volumes. Above it is framed some of my favorite historical depictions of spirit communication devices in

action. They are centered around an extraordinarily rare copy of the 1896 *Calendrier Magique*—a highly illustrated French occult calendar. The cases, frames, and artifacts combine to make a perfect centerpiece that draws the eye and perfectly encapsulates the home's entire aesthetic."

Multi-fascination appears to be a common personality trait among the Modern Gothic. Brandon owns and operates two popular retail shops in Austin's historic South Congress shopping district: the circus-and-sideshow-themed Big Top Candy Shop, a confectionary with an old-fashioned soda fountain, and a kitschy toy shop a few doors down called Monkey See, Monkey Do! So during the day, he is literally surrounded by gum drops and lollipops, but after a long day behind the candy counter, Brandon returns home to the "dark side."

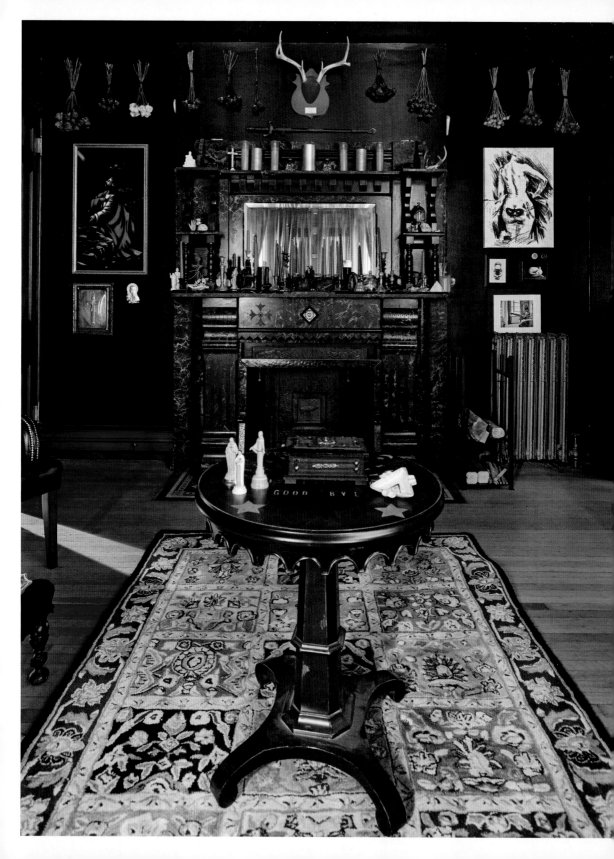

The Black Room hands out no apologies. "We wanted it to be the most ludicrously Goth room in the house, so we gathered all our religious items and put them in this room," D'arcy explains.

✤

D'ARCY + LEIF HOLMBERG
Pennsylvania, USA

ASMODEUM HALL

Many prosperous cities across America of the late 1800s and early 1900s fell upon hard times in the 1960s and have struggled to recover, leaving beautiful inner-city Victorian brownstones to fall into disrepair. A small city such as this offered D'arcy and Leif an opportunity to land their dream home and become part of a group of people hell-bent on restoring the beauty of these landmark structures.

Leif was born in 1985 and summed up his childhood home

decor with a bit of a lament. "I feel the home's decor was just stuff left over from the 1960s and 1970s. Yellow painted walls. Brown furniture. Shag carpet. Single bathroom. My room didn't have a door, but like swinging saloon doors. Maybe my parents were prepping me to be the king of bar fights when I got older."

D'arcy's reflection of home life is a bit different. "My home was a green and white storybook cottage-style home built in the mid-1920s. It was the first home my

99.

i.

ii.

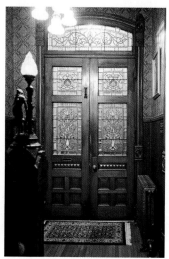

iii.

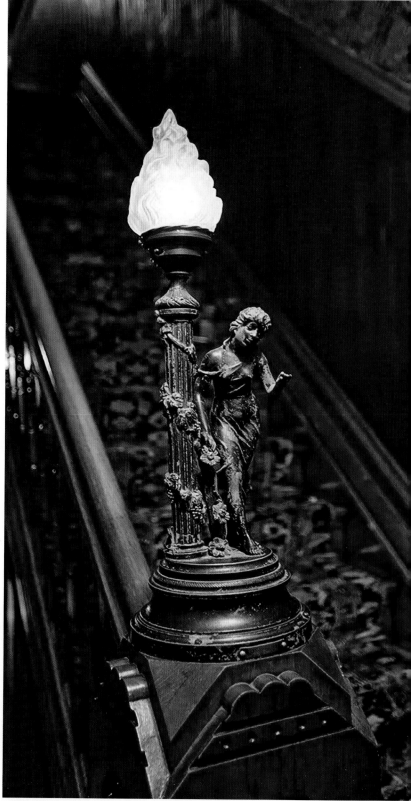

iv.

✥

i. Tucked under the stairs leading up to the second floor is a small nook where a lovely Victorian-era sink sits, waiting for guests to arrive and wash their hands before entering the formal parlor. When this house was built, it was rare to allow guests into your upstairs bathrooms, so this sink served as a way for guests to clean up. ii. One of the many original ceiling light fixtures found throughout the home. iii., iv., v. After opening the relatively unassuming front door to Asmodeum Hall, you enter a vestibule with a second set of magnificent, handmade doors with stained glass. It is here where you get the first inkling of how grand the rest of the house is going to be. There is stained glass throughout the house; Reading was once the stained-glass capital of Pennsylvania. vi. All the radiators are original, resemble works of art, and, equally important, work with no leaks. D'arcy adds, "The top piece above the radiator is by the artist Félicien Rops. The three at the bottom are two photographs of me and a piece of artwork based on a photograph of me."

The uneven waviness of the
120-year-old leaded glass windows
create an eerie effect as D'arcy
pours herself an early evening
cocktail.

parents ever owned. [They were] eccentrics and collectors, and I grew up surrounded by antiques, vintage clothing, thousands of records, art, and theatrical costumes . . . all in a home that looked like a witch's house from a Betty Boop cartoon. Unfortunately, the house itself only exists in our memories. It was torn down in 2016 to make room for a soulless gray and glass apartment building that no one lives in. However, a friend who lived nearby was willing to go on a secret mission the night before demolition and secured all the original faceted glass doorknobs from the interior for me. Eventually, I will install a few throughout the house in loving memory."

The couple purchased Asmodeum Hall in September 2020, spent a year on repairs and renovations, and began living there full-time in late August 2021. "The home only had three previous owners before we took possession. Thankfully, none of them removed any of the original details with significant

I GREW UP SURROUNDED BY ANTIQUES, VINTAGE CLOTHING, THOUSANDS OF RECORDS, ART, AND THEATRICAL COSTUMES . . . ALL IN A HOME THAT LOOKED LIKE A WITCH'S HOUSE FROM A BETTY BOOP CARTOON.

renovations. However, when there are screw holes left by an entertainment center awkwardly placed in a wall at the far end of a formal Victorian living room, one can assume the people who placed it there weren't exactly marveling at the original beauty of the space.

Mainly due to the nature of D'arcy's work as a vintage clothes and antiques dealer and her general passion for beautiful old things, the couple has been able to furnish and decorate their place in record time. "Our apartment was filled with beautiful furniture and art, but it was a one-bedroom apartment

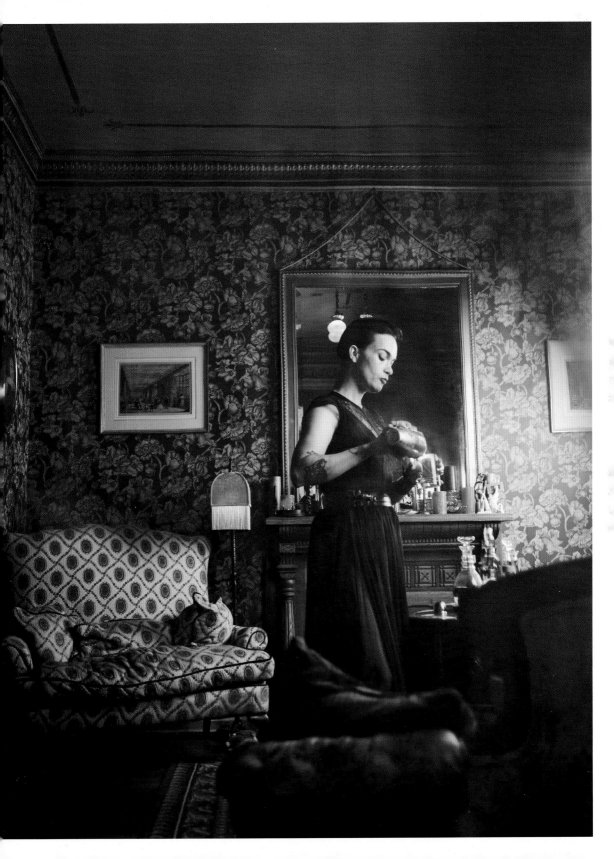

i.

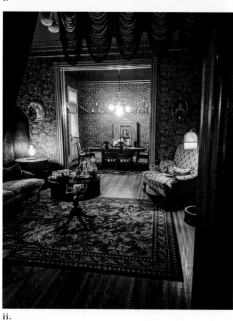

ii.

iii.

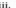

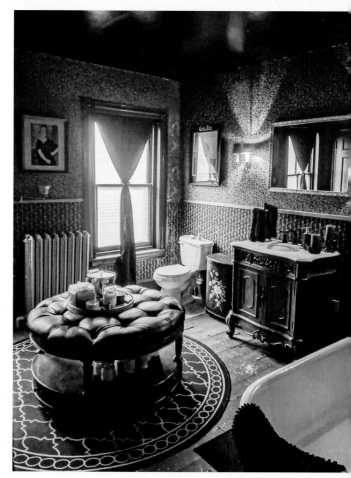

iv.

i. "The big thing about older houses is that many materials are discontinued," D'arcy laments, sighing. "We searched for a matching floor tile, but it was nowhere to be found. We came close, but you can see it doesn't match . . . which I now kind of love. I'm very good at putting up patterned wallpaper, but I was losing my mind when putting this up. I spent hours and couldn't make the pattern match up between rolls. We decided to look up that wallpaper batch number online and discovered they had messed up the repeat, so you can't match it up! We had twelve rolls of it, so we were like, let's just make it crazy." ii. A view from the downstairs parlor looking into the dining room. iii. When guests sit down to dine, the center light is extinguished and the room is illuminated by the flickering of the countless candles. iv. The owners have dubbed the only bathroom not assigned to a bedroom as "the soaking room." "The bathtub is an oversized, claw-footed piece with a completely flat base. So, it makes it perfect for soaking, watching a movie on your laptop, or having a bath with someone else," explains Leif.

with a small living room and not even enough to furnish a single floor of Asmodeum Hall. I was tearing through local thrift stores and flea markets daily while Leif scoured Craigslist and the Facebook Marketplace. We rented a U-Haul almost weekly for these epic evening trips to pick up furniture and art. We hauled everything ourselves, including a solid cherrywood hutch so heavy that I wept from exertion carrying it up our three front steps. If we hadn't been willing to devote so much time and thought to what we needed and make sure we found the specific pieces that best fit our style, we would have either gone broke buying from high-end antique furniture galleries or been left with an IKEA- and West Elm–laden space that would have always left us feeling disappointed.

"We furnished almost every other room before we finished our bedroom. We slept on an air mattress on the floor for months because we wouldn't compromise. And then

we found the bed of our dreams five miles away for less than $100. Absolutely worth the wait."

Regarding a favorite room, D'arcy and Leif have the same one in mind, albeit for slightly different reasons. D'arcy explains, "If I must choose, while predictable, I have to say our master bedroom is my favorite. I cried when we finally found a beautiful iron bed, set up all the furniture, and placed the canopies, sconces, and art on the walls. I've spent much of my life existing within a mentality of scarcity. I grew up poor, moved to New York alone, and started and ran a business alone. Building my life involved a lot of time spent in spaces that felt 'in between' and 'almost.' It hit me at that moment that I was standing in the house of my dreams, with the partner of my dreams, in a bedroom that was directly out of my childhood fantasies. There was nothing that room was lacking at that moment. Nothing I wanted to change. I'm not sure I'd ever felt that before, and I

✤

i. The master bedroom has a massive built-in that includes a vanity and closets. D'arcy and Leif slept on an air mattress for five months as they patiently waited for the perfect bed, which came in the form of an iron four-poster at the outrageously low price of $100. This room had incredible original border wallpaper, and the Holmbergs were able to match the paint to the original green. The light fixture that hangs directly above the bed is classic and original. ii. A gloomy light pours in through the oversized, triple lead glass windows as D'arcy stands in front of a huge Victorian-era full-length mirror. iii. This angle of the room shows the massive built-in wardrobe and vanity that is original to the house and Baxter, one of two tabbies that rule over the home.

still get hints of that same joy every time I fall asleep and wake up in that room."

Leif's reflections on the room are like this: "I sleep like a corpse in that bedroom. The lighting is dim and calming. Our cats always sleep with us, and I feel that animals are a good judge of a quiet room. I love the artwork on the walls, and there is plenty of seating in the event we have company. The color schemes are excellent, and the ceiling wallpaper is one-of-a-kind (maybe). It feels like my first adult bedroom."

There's no denying that an element of "spookiness" is inherent in a home built in this style, but do the owners believe the house may be haunted, and if so, would they move out? "Not in the least. I don't believe in God or ghosts, and I've slept soundly every night since my first spent here. My beliefs aside, even our more spiritually inclined friends have stated that they feel nothing but warm and welcoming energy when visiting the house. All phenomena that at first appear

I SLEEP LIKE A CORPSE IN THAT BEDROOM. THE LIGHTING IS DIM AND CALMING. OUR CATS ALWAYS SLEEP WITH US, AND I FEEL THAT ANIMALS ARE A GOOD JUDGE OF A QUIET ROOM.

unexplained are most often later attributed to the cats.

"Regarding moving out? Absolutely not! If every ghost story has taught me anything, it's this: ghosts are all talk. How many 'real' hauntings involve anyone being physically harmed by a spirit? They're annoying roommates at worst. Even if I believed in such things and the house was haunted, an occasional scare wouldn't be enough to drive me out. With their track record, I can't imagine I will be the first person in history to be killed by a ghost. Rattle your chains if it makes you feel better, Jacob Marley, but I'm here to stay. I will love this house . . . forever."

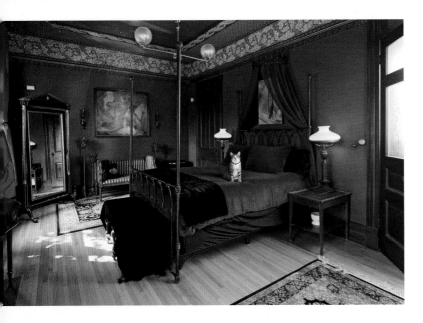

ii.

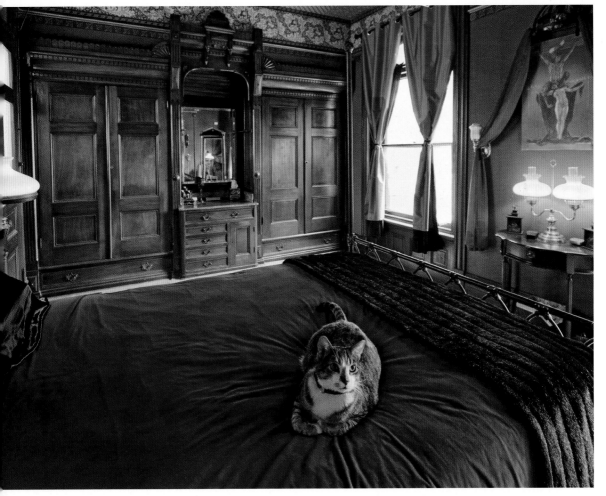

A salvaged gargoyle stands guard in
front of the Enchanted Church.

✣

BRIDGETT JOHNSON + DAVE MOSCATO
Western Ohio, USA

THE ENCHANTED CHURCH

Bridgett believes there are no
coincidences in life and is a firm
believer in the expression "every-
thing happens for a reason."
Many times, those reasons may
come from a "supernatural" origin.
"Believe it or not, this is not the
first church we tried buying. We
were in the mix to purchase a
church in Pennsylvania but were
eventually outbid. However, my
pendulum told me we were get-
ting a church; although soon after,
a series of unfortunate events

unfolded, ultimately with my father
becoming ill, and I was completely
distracted. However, it wasn't
but two days after his death that
Dave and I bought the Mount Zion
Church in western Ohio . . . sight
unseen. I believe we were able to
get this church with intervention
from my newly deceased father."

Bridgett grew up in a very
un-Gothic area of sunny Scottsdale,
Arizona, and her husband, Dave,
is from the East Coast. The two
ultimately fell in love in Las Vegas.

i.

ii.

iii.

i. Bridgett and Dave, owners of the Enchanted Church. ii. The Enchanted Church sits in its pastoral setting. iii. The doors open up to a cemetery directly across the road. Here, Bridgett takes her dogs for long walks and long conversations with the dead.

There, in Sin City, they became local celebrities—although, as you can imagine, not your typical Wayne Newton/Carrot Top celebs, but well-known more for their underground lifestyle and unique home, dubbed the Snow White House. "It was called the Snow White House because, amongst all the urban blight of the Las Vegas neighborhood we lived in, the cutest cottage stood up on a small hill, and that was our home."

Bridgett is a professional picker, scouring conventional and some-times unconventional sources for unique antique oddities, and with this special sensitivity to the spirits of the deceased, she feels many of her antique finds come via offerings. "I can't tell you how many people have come to me with, most notably, antique portraits of long-dead rela-tives. They say, 'I don't have a place for Great Uncle John or my spinster Aunt Grace, but I know you'll hang them on your wall,' and I do."

Other than a spiritual organiza-tion, who owns a church? Bridgett and Dave are not the first owners of the Enchanted Church (previously known as the Mt. Zion Brotherhood Union Church). They bought the building from a professional juggler, who did some renovations but only lived there briefly before selling it to "Jack." Jack was an elderly gentleman, who, rumor has it, was not the most pleasant of fellows. Eleven years later, Jack died in the Mt. Zion Brotherhood Union Church. When Bridgett first crossed the threshold of this 1880s house of worship, she got the strong impression that the person who lived in the church before them did not want her to live there. However, in her heart, she felt "there was a reason God put me here."

With Dave's encouragement, Bridgett ignored the spiritual ill will and decided she belonged there. Especially since she gets to take her dogs for long walks in the church cemetery across the road. "I communicate to the people buried there. If they are restless and feel like talking, they'll answer back;

When asked how many photos reside on the Memorial Wall, Bridgett responds with, "Oh geez! I don't know, but what I do know is that there is a lot more to go up. Presently, we can't get any higher with a conventional ladder. We have a friend with a hydraulic who will get us to the next level." One woman, who spoke to Bridgett while she was unpacking the boxes, has two portraits. She is the only person up there twice. There is one living person up on the wall: Stevie Nicks. She appears on the wall "because I love her, and we got her from Stevie's personal photographer, Neil Preston. There is also a photo of three nuns that came to the wall via a truckload of antique furniture that we intercepted before it was donated to Goodwill." Looking out from the loft/guest room gives a bird's-eye view of a mid-century modern couch and chairs sitting conspicuously among the Gothic interior. Dave said he is only willing to go so far with their Gothic home decor; he drew the line on couches because "Gothic couches are uncomfortable."

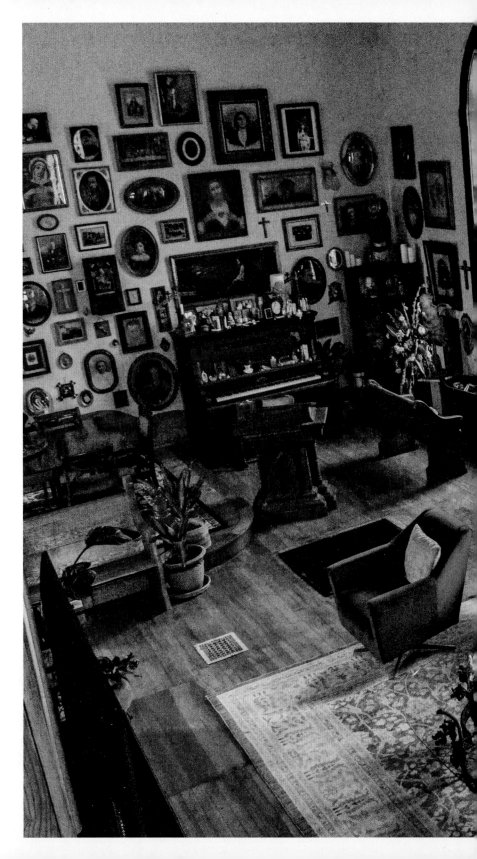

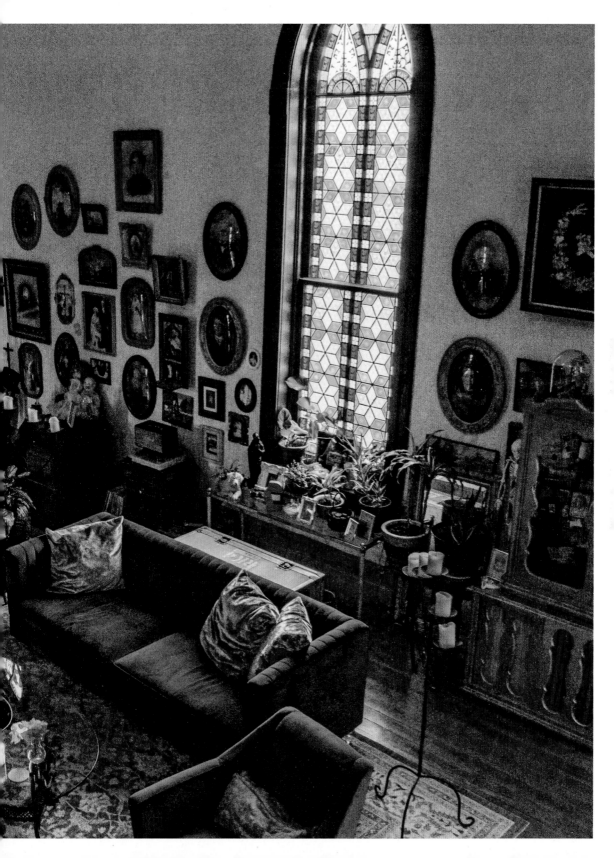

✥

While filming the TV show *Portals to Hell*, this chandelier was captured on video swaying on its own.

if not, it is still a relaxing way to connect with the whole church experience."

Even before their move to the church, Bridgett collected antique portraits, whether picked from an antique shop or given to her by someone who wanted her to care for it. "The unboxing of the portraits was one of the first things I did after settling in. Immediately I felt the portraits 'speaking' to me. One particular woman asked me to put her on the wall, and she appears on the wall twice. In fact, they all wanted to be hung up on the great wall. This wall is now a place of remembrance and a memorial. I know people who have somehow found their way into my home and others of long-dead family members whose relatives asked me to hang them on my church wall.

"The community has been very supportive of me taking care of the church. Sporadically I host a 'congregation' of about a dozen octogenarian women who meet in my living room to just, well, revisit

I COMMUNICATE TO THE PEOPLE BURIED IN THE CEMETERY. IF THEY ARE RESTLESS AND FEEL LIKE TALKING, THEY'LL ANSWER BACK.

the church of their youth. We also own a haunted bed and breakfast named the Odd Inn, and an antique store called Deceased Vintage here in town."

Bridgett is no stranger to supernatural experiences. Throughout her life, she has had visions and "visits," and moving to the church has not ended those encounters. "The only items original to the home, besides the structure itself, are the walls and the stained-glass windows, which have their share of cracks that make for chilly nights during the winter, and the piano. Oh yeah, and some burned crosses we found in the yard. Heating a home with such high ceilings does make for economic issues, and when we first moved in, the boiler was run by oil; this proved very

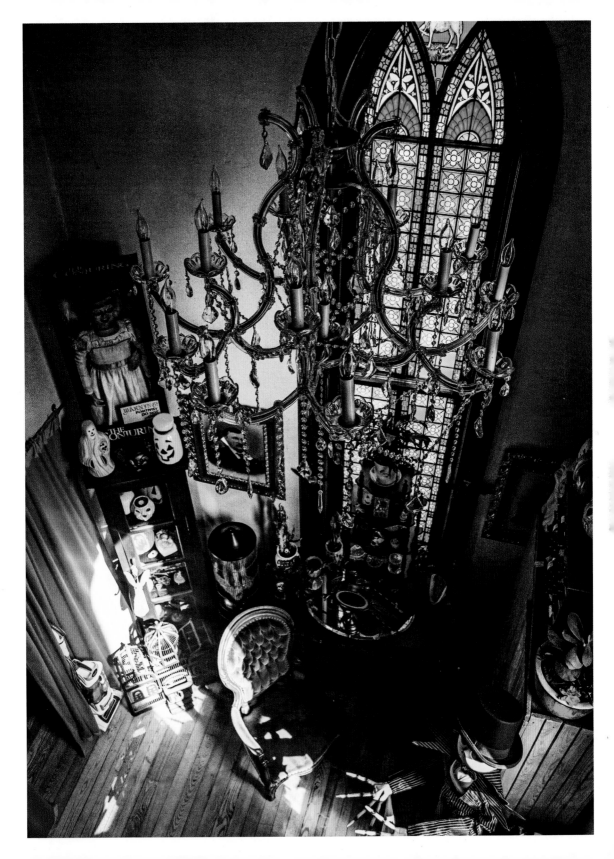

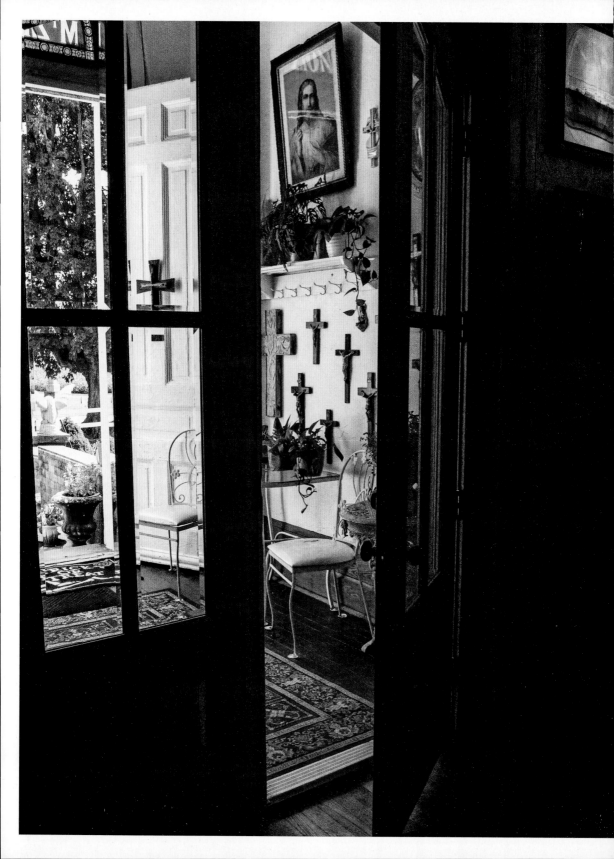

⁘

A look into the narthex (vestibule). One of the many areas of the home adorned with crucifixes.

SPORADICALLY I HOST A "CONGREGATION" OF ABOUT A DOZEN OCTOGENARIAN WOMEN WHO MEET IN MY LIVING ROOM TO REVISIT THE CHURCH OF THEIR YOUTH.

expensive, and when it ultimately died, we were quick to replace it with a natural gas boiler."

It wasn't long before that piano became the centerpiece for one of Bridgett's encounters. "We were only living here a few weeks when we were fortunate enough to purchase a complete human female skeleton we named Rosie. And after dropping her off, we had to leave on a previously planned trip back out west. We were gone for about two weeks, and Dave was dealing with our luggage in the car. I walked in ahead of him only to find the piano playing by itself. I bolted from the home, and it took me hours to muster up the courage to walk back into the house."

Although Bridgett refrains as much as possible from referring to items as haunted, she believes things possess energy, and that is what you are experiencing. However, not all the energy is happy or positive. "I did have a puppet that creeped me and everyone else out. I'm a clean freak, so after it sat up on a shelf for a few weeks and a giant cockroach came out of a crack in its head, that got to me. But I didn't sell it or stow it away. I believe it chose me to live with, so here it lives.

Because of Dave's career as the stage manager for Ozzy Osbourne, Bridgett and Dave have distinctive friends who stop by the church to visit and hang out. Some of these friends are also Bridgett's customers, who come to her when they need that particular Gothic piece for their home.

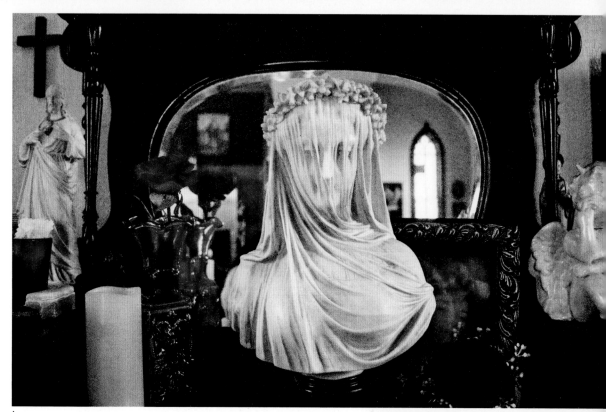

i.

ii.

iii.

✥

i. A veiled mourner watches over the home. ii. Hundreds of crucifixes spanning hundreds of years find a home within this house. And yes, the camera captured something some would call paranormal. iii. A somber water bearer cast in cement perpetually stands frozen in time. Although over eight decades old, she has held up well against the effects of bitter Ohio winters and blistering summers. iv. This piece comes from Ozzy Osbourne's twenty-seven-million-dollar Los Angeles home. Ozzy asked Bridgett and Dave to "hold onto it unless someone is interested in buying it." v. No Gothic home is complete without a Victorian-era taxidermy red fox. Especially one that stands guard for two Victorian mourning hair pieces, hanging on the wall behind. vi. Bridgett's makeup room is aglow from the sun striking the red stained glass. When the Mount Zion United Brotherhood Church was constructed, one of the elements used to make red stained glass was gold. The abundance of red stained glass that appears throughout the windows in this home is a confirmation that despite its relatively isolated location, it was founded by a wealthy congregation.

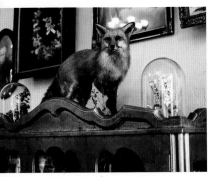

vi.

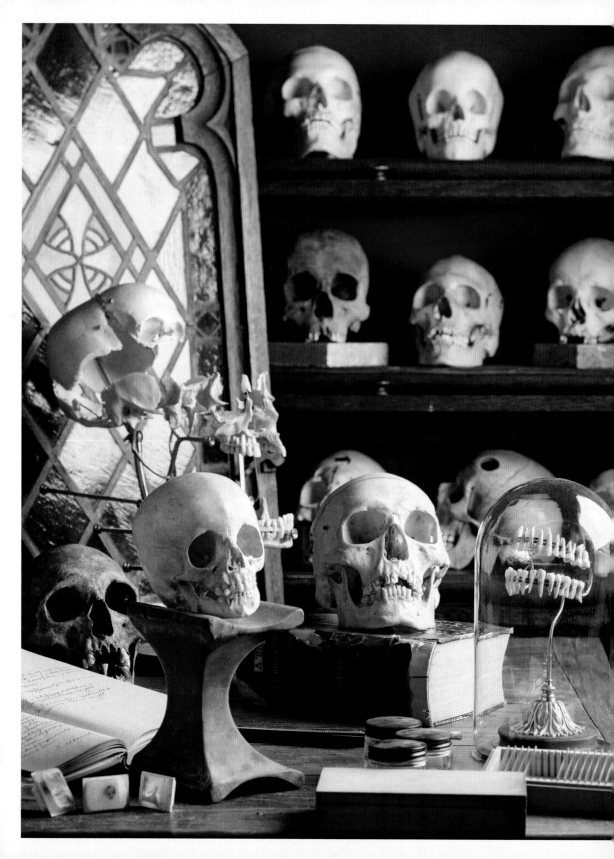

An impressive display of human
skulls, from children to geriatrics.
On the left is a beautifully executed
Beauchene skull (exploded
skull). On the back shelf is a
trepanned skull.

✥

RICHARD MARINI
Rockland County, New York, USA

A CALMING ENERGY

Richard says he was pleasantly surprised when he moved into this small apartment, which is an extension of a much larger house, to discover it was a blank canvas: an opportunity to design space from scratch, just the way he wanted it to be. "I grew up in a 'typical suburban home' with a mother, father, and a sister. Absolutely nothing out of the ordinary." But all typicalness regarding home decor was about to change once Richard stepped across that threshold in 2015.

For many, moving into a new home has at least a few surprises in store, but not for Richard. "The main house was built in the 1970s. My living space used to be a garage and a woodworking shop for a local artist. The area was then converted into an apartment where my girlfriend and I lived. We broke up, and I eventually moved back here in 2015. So, there are absolutely no surprises for me here. In fact, I helped build this apartment, so I am intimately familiar with the space."

❖

i. A variety of antique medical oddities, including vintage photos of medical students with their dissection cadavers. ii. Archibald and six human skulls. iii. Wet specimens on the kitchen counter, including a head, "which I obtained through another collector who had come into possession of a retired doctor's extensive collection. This is my favorite wet specimen. The fetus cat that is dissected to show organs and the cat head that is also dissected rank up there as well."

Although Richard had a hand in the design and construction of the apartment, he had no input on the amount of square footage allocated to the structure. "The most difficult part of living here would be the amount of display room. Due to limited space, I've had to be very picky with what I keep or add to the collection. I have definitely had to take the maximalist approach to get the most out of my micro space."

The theme of the house is anchored by Richard's human skull–filled barrister bookshelf flanked by pristine adult male and female human skeletons. "That barrister holds one of my favorite pieces, the skull of a five-year-old child with exposed dentition revealing the adult teeth that have yet to erupt. I am looking for a complete child's skeleton. They are definitely very difficult to come by, definitely a white whale.

"On a bit more conventional side, I am also looking to add more birds. Especially some Victorian bird taxidermy. I need more birds."

THE THEME OF THE HOUSE IS ANCHORED BY RICHARD'S HUMAN SKULL–FILLED BARRISTER BOOKSHELF FLANKED BY PRISTINE ADULT MALE AND FEMALE HUMAN SKELETONS.

Since this is a rental, Richard is hesitant to take on any major renovations. "I guess the next major renovations will likely be to find a larger place. One day I would love to buy an original Victorian home to renovate. I would convert the lower half into a museum where people could come to admire the pieces I have collected over the years. Everything could have detailed labeling with facts and background history.

"People always asked if I have ever purchased an item that 'creeped me out' or if I believe my house is haunted, and I always say 'Never, not once have I come into possession of an item that I felt was 'too creepy.'

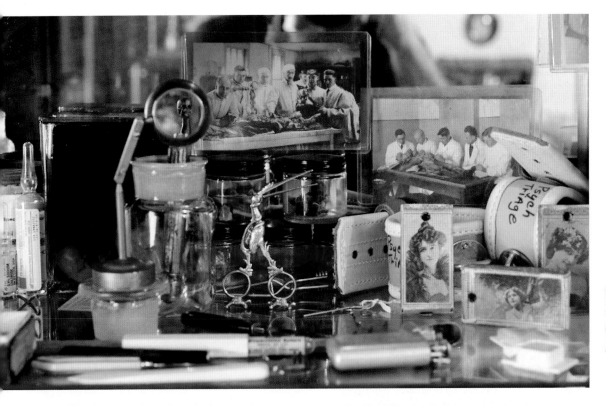

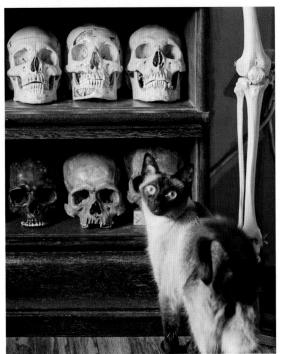

ii.

iii.

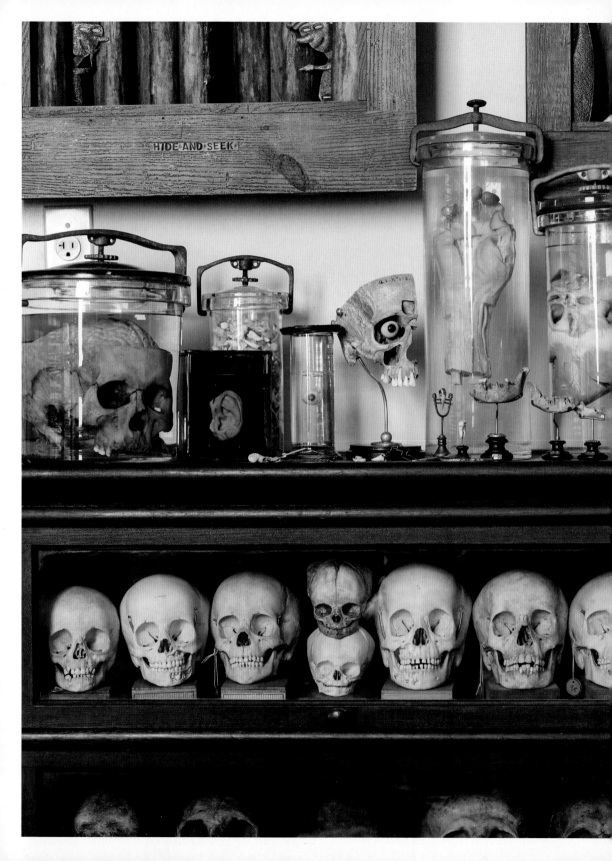

❖

A barrister bookcase that is
full of twenty-five skulls, on
top of which are various wet
specimens: a brain with full
spinal cord in a Tatum specimen
jar; an ear; a jar of teeth; an
eyeball; a forearm that has
been dissected to show various
nerves, muscles, veins, and even
bone; and a human heart. All
were acquired from a fellow
collector who obtained them
from a retired doctor. A full
medical skeleton stands guard.

"I've actually been told that my
home carries a very calming energy.
I believe it is watched over by the
man who worked in the wood shop
here that has passed on. He was a
gentle giant of a man, and I often
feel his presence in a positive way.
If my home was haunted, I probably
wouldn't leave as long as it was a
kind spirit. It's those evil ones you
have to look out for."

When Richard isn't scouring
the internet and flea markets for
oddities, he finds himself behind a
desk as a purchasing manager for
a local heating and air condition-
ing company. "They find my hobby
quite interesting. Whenever there
is a box on my desk, it's not uncom-
mon for one of my fellow employees
to comment, 'Hey, is there a skull
in there?'"

i.

ii.

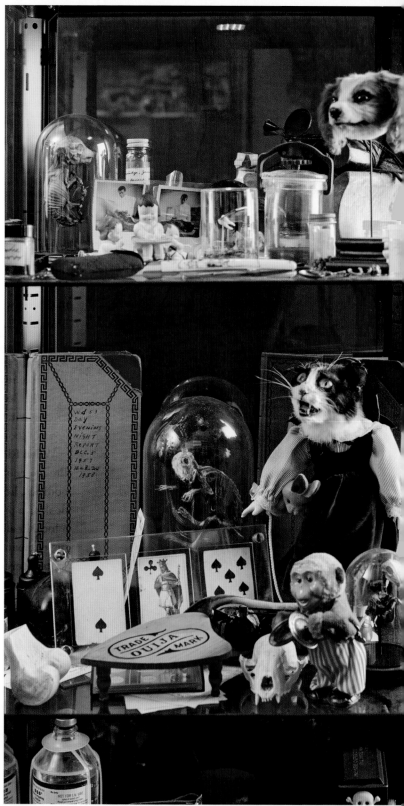

iii.

i. Richard Marini. ii. A modern Beauchene preparation done by Kris Swain. "I have always loved Beauchenes and would even go as far to say that they are the reason I got into collecting skulls in the first place." iii. These shelves are a potpourri of the macabre, including a mummified cat on a doll's body, a mummified pig, goat fetal specimens circa the early 1900s, a Ouija planchette, brothel playing cards with hidden naughty images that appear once a light is shined through them, and psych ward logbooks. iv. This lobotomy half-skull prep, done by Ryan Matthew Cohn, is featured in the book *Skulls: Portraits of the Dead and the Stories They Tell*. The skull on the right is circa the early 1900s and shows trepanation. There are two trepanning tools in the case, as well as various medicine bottles and a mandible. The brown bottle on the left is particularly interesting; it is from a local psych hospital pharmacy and reads SODIUM CHLORIDE AND DEXTROSE (which is salt and sugar, making these pills just placebos). The fetal skeleton is carved out of wood; it was originally made from one piece, but suffered much damage in transit and needed to be restored.

Created in 1559, this was originally
the front door but was moved to
the hallway two hundred years ago.
"I wonder how many have clicked
on the latch in the last five hundred
years," Alison reflects.

⁜

ALISON + DAVID MCKINLEY
Somerset, England

THE BOURNE HOUSE,
CIRCA 1559

Unlike some of the homeowners
in this book, Alison and David
McKinley never had to worry about
bringing character to a blank slate
of a living space. They both live in
a Tudor manor house dated 1559,
built for the Bishop of Bath and
Wells, who unfortunately never
got the opportunity to live there.
He was imprisoned in the Tower
of London by Elizabeth I when she
became queen, and the English reli-
gious order changed. And although
he was later released, he spent the
rest of his life under house arrest in
a nearby home.

"The interior was initially 'mod-
ernized' in the early 1800s into
smaller rooms as opposed to the
original large open halls, but luck-
ily many of the original features
remain. The structure is constructed
of three-foot-thick sandstone walls
with oak and metal-studded doors,
exposed ceiling beams, an inglenook
fireplace, and rare oak plank and
muntin screens. None of the walls
are straight, and it has unusually

i.

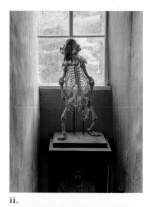

ii.

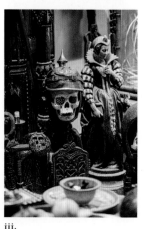

iii.

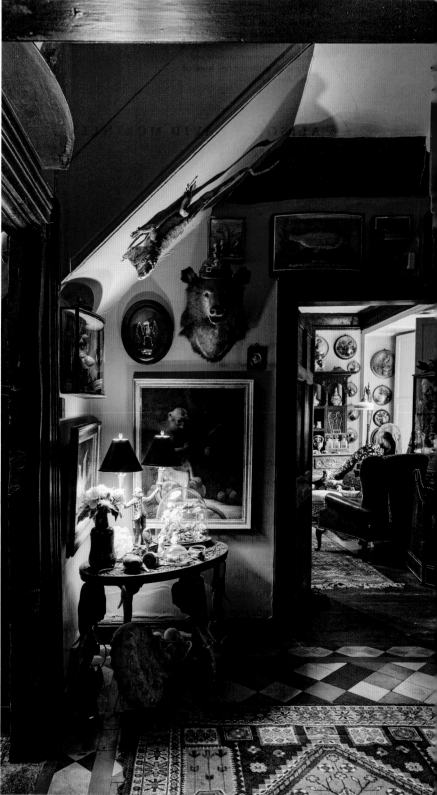

iv.

i. A rare kowar skull of the indigenous people of Northwest New Guinea. This figure would contain the soul of a deceased family member so that it could be consulted by the members of the family concerning major decisions. ii. An antique honey bear skeleton stands in the stairwell atop a glass case display of Victorian-era wax aboriginal tribesman. iii. A Dayak trophy monkey skull from Borneo. The Dayak tribes are notorious for their head-hunting practices. iv. The inner hallway leading to the main sitting room. With no windows, it's the womb-like heart of the house. Its walls are home to several cased fish by Cooper and Homer, plus a bear and a lizard. v. The view down the rear hallway. The fox, badger, and otter heads are all by Peter Spicer of Leamington Spa, considered one of the best taxidermists of his era. The puppets are mostly from the Tiller-Clowes troupe of marionettes, famous in the late 1800s and the last to perform as a traveling troupe in the UK. These are rare one-offs; similar examples are on exhibit in the Victoria and Albert Museum collection. The great horned owls at the end are by Victorian taxidermist J. B. Waters, circa 1870. vi. A vintage (non-tourist) wooden ritual mask from Sri Lanka. vii. Vintage animal and human skulls peer out from an antique cabinet.

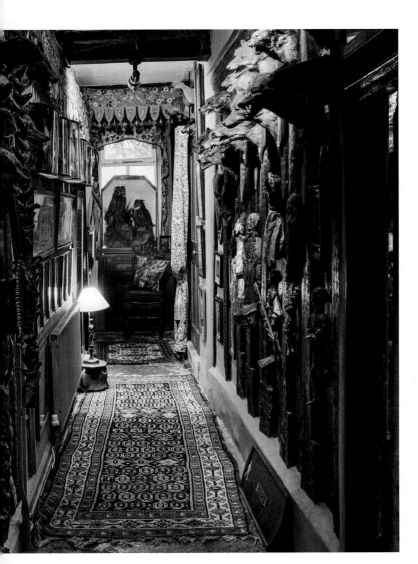

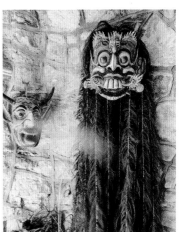

vi.

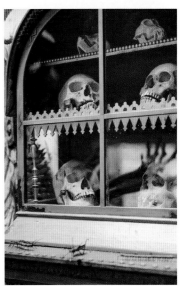

vii.

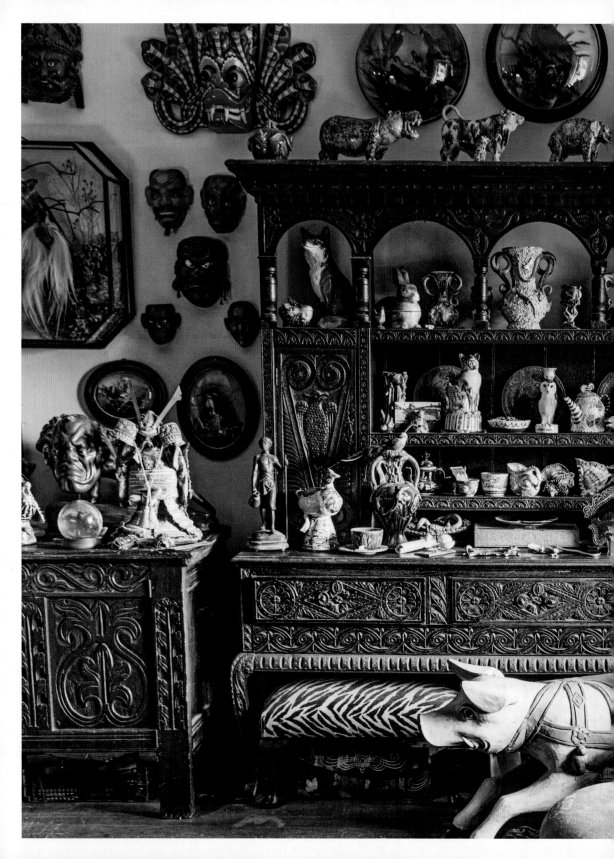

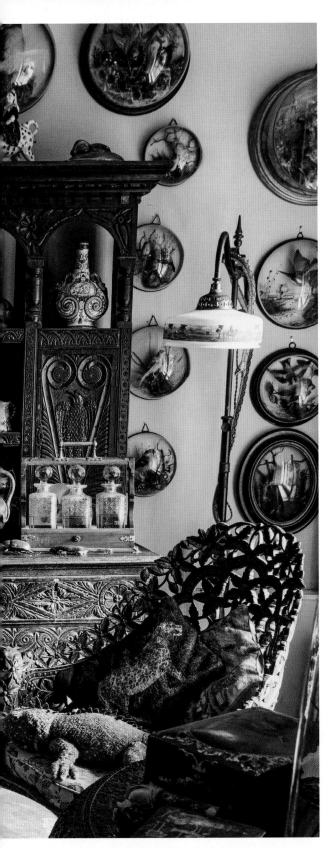

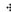

high ceilings for the period, but low doorways as people were so much shorter then.

"When we took possession of the property, it was decorated in a 1960s style that was run down and certainly worse for wear. For years it was being used as a small private school, and though the teacher-owners continued to live here after it closed, many rooms remained little more than bare classrooms.

"We definitely underestimated how much work it needed. It was in serious disrepair, with chimneys falling and holes in the roof. We had buckets catching the rain, and the one-acre garden was waist high with grass and brambles. However, it was cheap, and apparently we were the only ones mad enough to take it on. We didn't have much income, and it was a struggle with a young family, but we did most of the work ourselves whenever possible. Admittedly there are still leaks, and bits fall off even now, but we have tried to keep its character rather

133.

These are part of a growing collection of wax moulage heads, circa 1900. They were previously on display in now-closed medical museums across Europe, which featured various diseases and abnormalities.

than overmodernize. Fortunately, or unfortunately, the house is Grade II listed. This means it is of historical architectural interest and bound by UK laws regarding any significant renovation work."

Alison and David discovered a few surprises, which is unsurprising given the amount of history in their house. Those have included an original Elizabethan fireplace intact behind a "modern" mantel, and an old muntin-framed window. In the Victorian era, the technology needed to manufacture large sheets of glass had not yet been developed. Large windows had to be constructed with small, individual panes of glass held together with vertical pieces of wood separating the panes—muntins. This window was found in situ but hidden behind a cupboard. "We also uncovered oak screens plastered over . . . they were only discovered because a small bit was showing through the plaster. It was revealed through holes that pupils had poked at while waiting to go into class. So, I

ADMITTEDLY THERE ARE STILL LEAKS, AND BITS FALL OFF EVEN NOW, BUT WE HAVE TRIED TO KEEP ITS CHARACTER RATHER THAN OVERMODERNIZE.

removed the plaster to expose the wood along with several hundred years of dust."

Alison and David met as young teenagers, after both leaving school at fifteen; come 2023, they will have been married for fifty years. The two held a variety of jobs before discovering taxidermy. This turned into a career for David, who has been dealing primarily in antique taxidermy and natural history items for the past forty years, including buying and selling complete collections and renting out specimens for films and the theater. The number of taxidermy pieces gradually grew into a huge inventory, while they set aside select pieces that would form their private collection.

THE ART OF GOTHIC LIVING

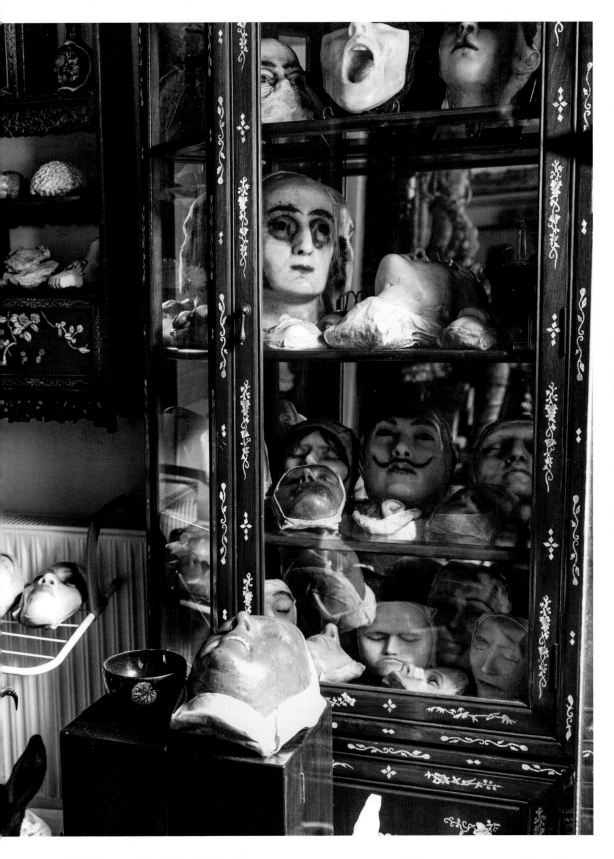

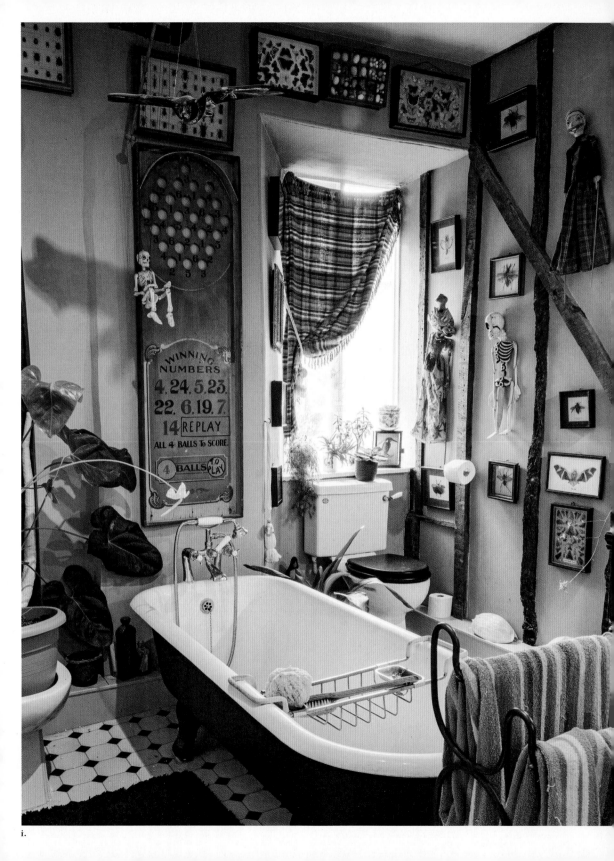

i.

i. A wonderful place to lie back and relax in the bath while enjoying all the collections—vintage Balinese puppets, insects, and medical antiques. ii. "The antique anatomical dissected frog was a Valentine's Day gift from David to me. I treasure it!"

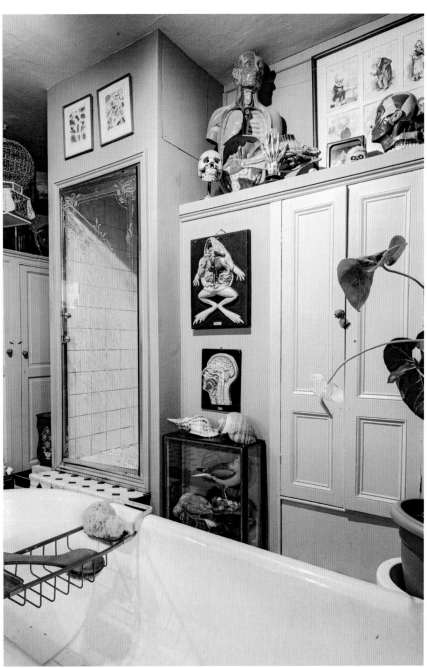

ii.

The carved fireplace is from
the later Victorian era; it was
a lucky find at a local auction
when Alison and David first
moved in and were renovating
the house. It fits perfectly in
both size and style. The pair
of lions, although purchased
separately, are both the work
of Rowland Ward, who was a
famous British taxidermist
in the mid to late 1800s.
His company specialized in
taxidermy work on exotic birds
and big-game trophies. The
large tiger head, circa 1920, is
by Van Ingen of Mysore. Van
Ingen is considered the best
taxidermist for Indian wildlife
and usually mounted his heads
on oversized shields. The
lioness is by Rowland Ward,
circa 1880, and rarer than the
male. The McKinleys found
her in a pub over thirty years
ago and rescued her before the
owner took her out of the case
to hang on the wall.

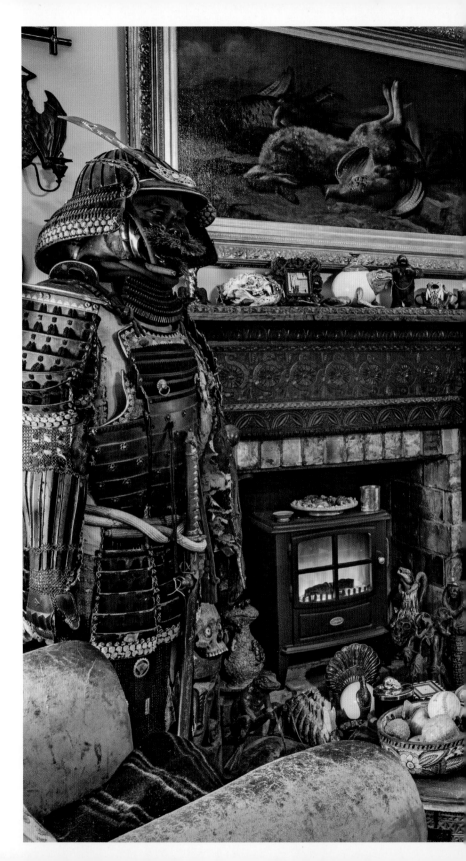

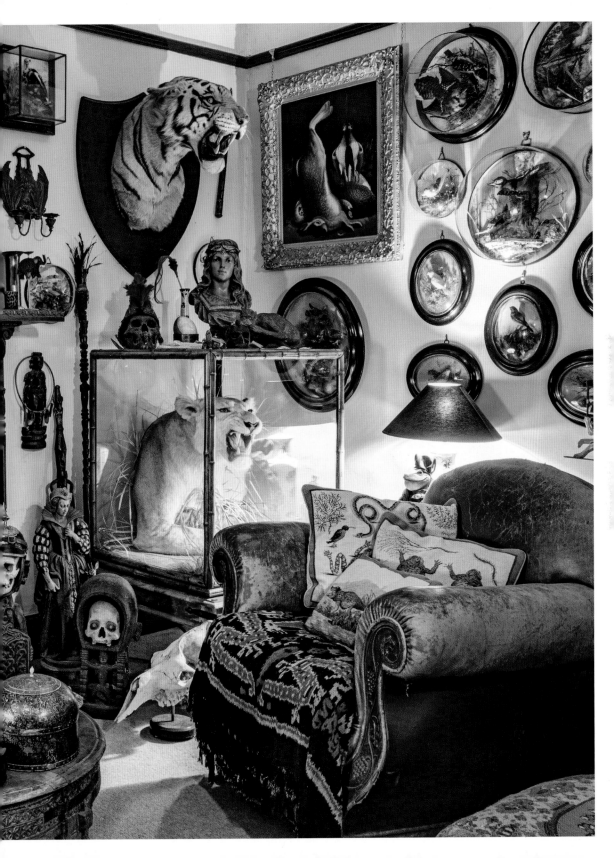

i. Sloth bear by Rowland Ward, circa 1925, is standing on a circular cross-section of tree trunk. It was bought in the 1980s along with original photos of the hunt and the bear being carried back over the river on a raft to the camp. Several of these taxidermies were turned into lamps, although few survive in this good condition. ii. "A modern case of boxing hares by Tony Armitstead. Another gift to me from David. He knows I love hares." iii. This taxidermy badger stick stand, circa the 1920s, rests in the front hall. iv. Edwardian-era taxidermy poodle dog. v. Displayed in its original bamboo-framed case, circa 1880, is the front half of a male lion by Rowland Ward, with the remaining lion skin draped behind it. This piece was purchased over forty years ago when the McKinleys were living in a much smaller house—only to discover it wouldn't go through the front door. "So, he lived in the back of our van for a long while until we moved into a larger house," explains Alison. "There are a handful of these around, but ones in this good shape are rare to come by." vi. This king colobus monkey, circa 1890, was created by an unknown taxidermist and was superbly mounted. Alison says this is one of their favorite pieces: "It's housed in a stunning case with vibrant colors. It's one of the items that we never want to be parted from. Very rare; I have never seen another from the same period outside of a museum."

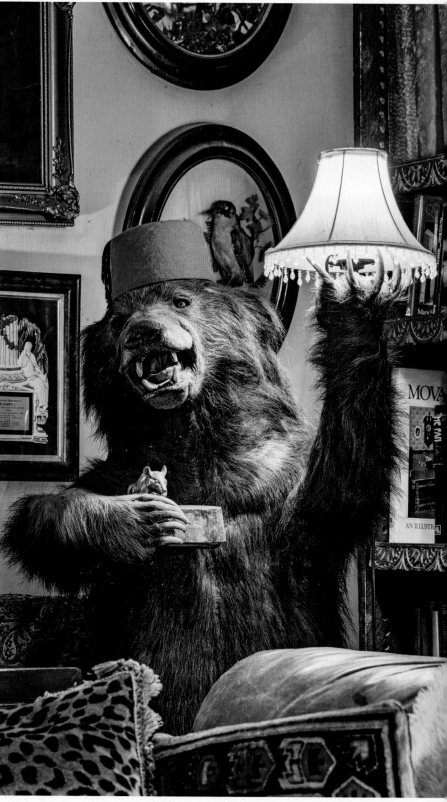

i.

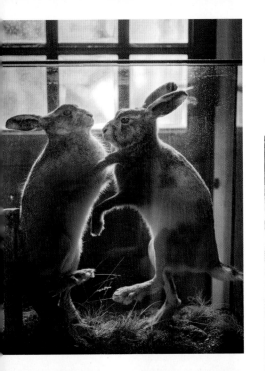

iv.

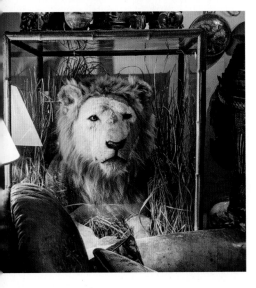

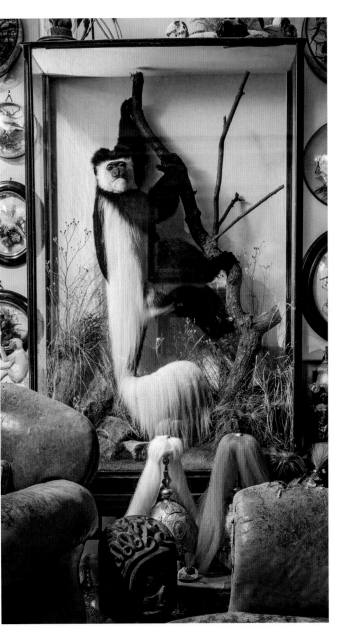

vi.

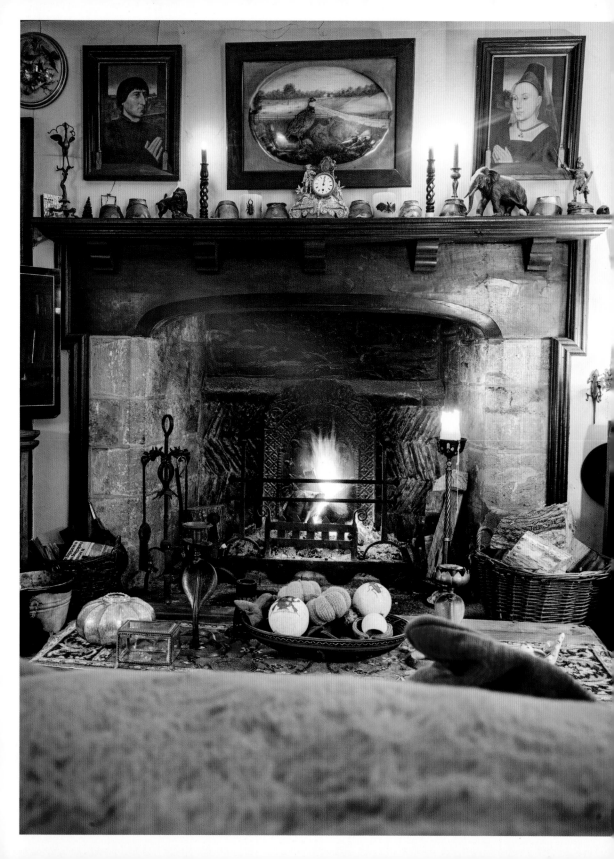

The original 1559 Tudor fireplace was discovered hidden behind a modern frontage, and is still in perfect working order. The row of military horse hooves on the mantel are by Ward and Spicer. Some are inscribed with the horse's name and date of death. The paintings are nineteenth-century copies of medieval works by Hans Memling, and the group of taxidermy bobwhites in the bubble-glass is from the US but was bought in a UK auction forty years ago.

"It was a joint venture at first. I was already dealing in general antiques, so I also started taking taxidermy to sell at antique fairs. We opened a taxidermy/antique shop when we first moved to Somerset in 1983. David spent hours traveling up and down the UK, buying and selling, while I looked after the shop and family back home. We moved to this house a few miles away where David trades as Heads and Tails Taxidermy. I had the opportunity to open a shop in our small town, and rather than have all our eggs in one basket, started to sell new quirky gifts and interior items and continue there to this day, although trying hard to retire."

Despite being in the business that they are in, it took years for the McKinley home to be filled with such an eclectic assortment of odd treasures. "We found so many pieces pre-internet, you know, when it was possible to buy entire collections and when these things were considered much less cool. Plus, there were those lucky moments when no one else turned up at auction on the day of. We bought an entire waxwork museum like that. It was closing and [we] ended up with most of it, keeping the best pieces and selling the rest."

Alison and David are kindred spirits who spent their childhoods often being taken around the amazing ethnographical collections in the Pitt Rivers Museum in Oxford, which instilled a mutual love of the macabre, extraordinary, and unusual. "However, I never imagined that years later, having started from nothing, we would live in such a house full of wonderful things. More importantly, it has been a welcoming home for our children and their families to visit and enjoy."

i.

ii.

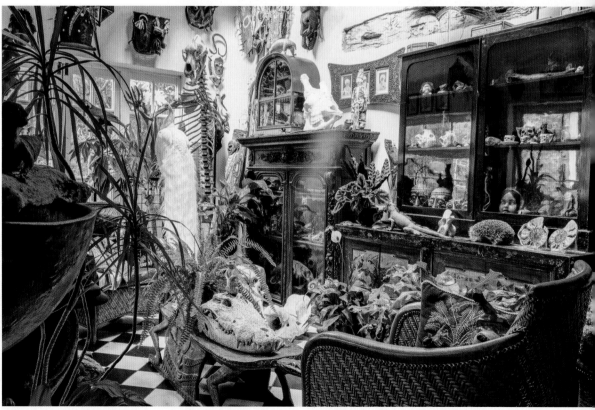

iii.

⟊

i. An old hippo skull from a museum, circa 1900, was purchased many years ago and now doubles as a vase for peacock feathers. ii. Tibetan human and monkey kapala skulls used in rituals. The monks in Tibetan monasteries would use a kapala as a vessel to symbolically hold blood (wine) and flesh (dough) as offerings to wrathful deities, such as Dharmapala ("defender of the faith"). iii. Looking into the Museum Room, the only brightly lit room in the house. It was converted from an old outbuilding about twenty years ago and is home to many skulls, fossils, and pieces largely unaffected by sunlight. iv. A hybrid skeleton made from old spare parts the McKinleys had lying around—horse, human, and lion. In the chair is a large vintage marionette bought in an outdoor market while traveling through China. v. A friendly mouse sits atop a crocodile skull. vi. A Victorian dome is home to zebra finches by James Gardner. vii. Alison and David McKinley sit beneath an alligator-shaped canoe purchased from an auction from a missionary who spent time in Papua New Guinea.

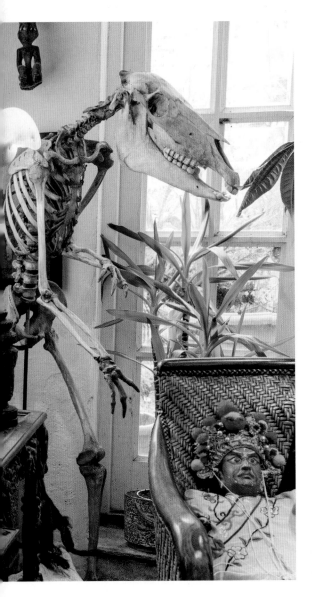

v.

vi.

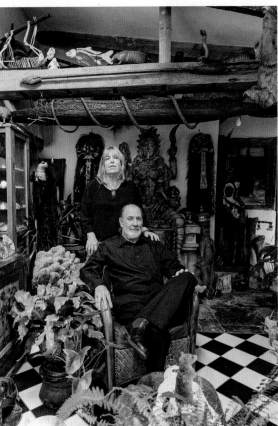

vii.

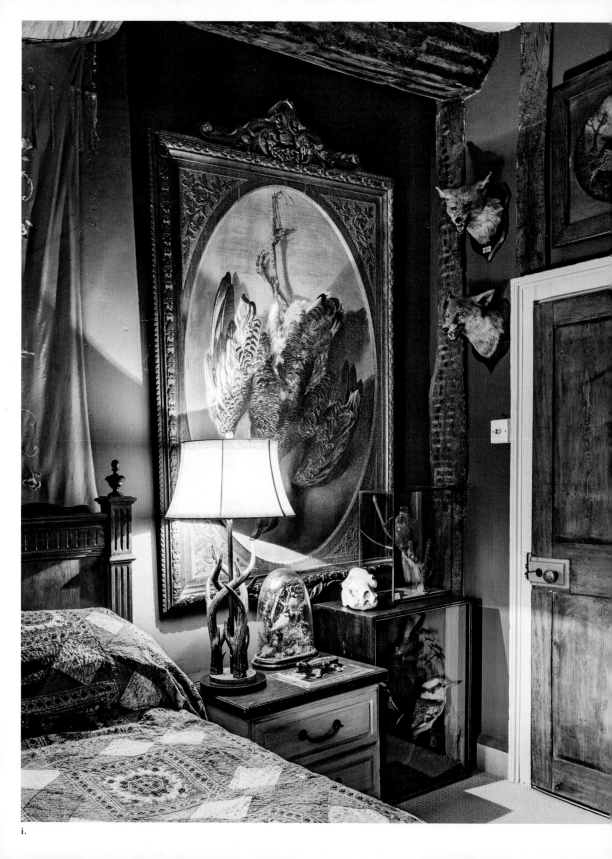

i.

i. This corner of the bedroom holds a life-size oil painting of a great bustard in a carved oak frame, circa 1890, by Peter Spicer. Spicer was one of the best UK taxidermists of his period; his work is much sought-after, and he was also an accomplished artist. Only a few of his paintings are known to still exist, therefore making them very rare. ii. "The guest bedroom contains vintage prints and taxidermy; hopefully any guests manage to sleep well here," Alison says. "Although, I do have to remove the baboon head when my granddaughters are staying in there!"

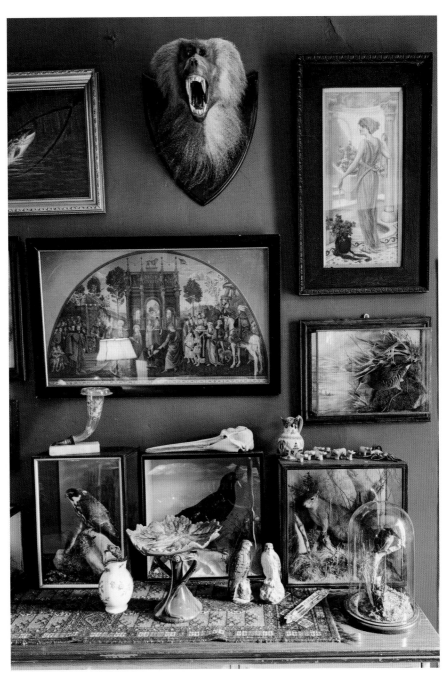

ii.

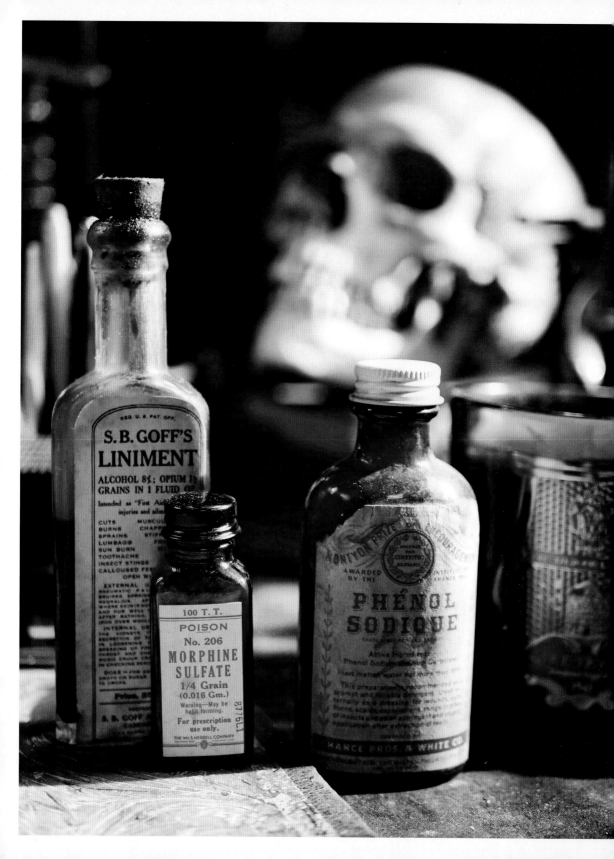

A small example of Evan's antique medicine and prescription bottles, including a frightening poison bottle that at one time contained morphine.

❖

EVAN MICHELSON + JOHN GOULD
Eastern New Jersey, USA

THE HOME OF OBSCURA

Evan Michelson has been in "the game" for a long time, and some may remember her as a co-star on the popular reality series *Oddities*. The show revolved around the shop she co-owned with Mike Zohn, known as Obscura, that was on New York City's lower east side, in two different locations, for more than twenty years.

Evan and her partner, Johnny, moved into this home in the early 2000s. The house had been neglected for decades and had not been renovated since the 1980s. "This house is all quirks! It is an 1880s Second Empire 'cottage,' which means that it is relatively small (by Victorian standards) and has only two floors. However, we do have a servants' quarters and a narrow, steep servants' staircase in a small single-family home! The layout is eccentric, with weird angles, curving walls, and small rooms tucked away under the eaves. Since we have a mansard roof, many of the upstairs walls slope inward,

149.

✥

i. This staircase is off the kitchen and leads up to the "servants' quarters." Although a small house, it is quintessentially Victorian—formal, proper, and vaguely ridiculous. "Servants' stairs are traditionally treacherous, and these are no exception: the treads are narrow, uneven, and steep," Evan comments. "Hanging on the walls is a collection of postmortem photographs—which seems fitting. This is the only part of the house where I've ever felt someone or something might be watching us." ii. This is a nineteenth-century anatomized preservation of a full-term baby that originally belonged to a professor of anatomy. Like many fetal anatomical specimens, this one is preserved using only the connective tissues. Until the late nineteenth century, infant mortality rates were shockingly high, so sadly, these were not difficult to obtain. iii. An antique taxidermy raven keeps warm basking in the afternoon sun. iv. Evan standing at the base of the servants' stairs. v. The home exterior's muted two-tone colors create a serene setting that matches the calming atmosphere of the interior.

i.

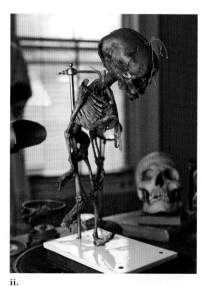

ii.

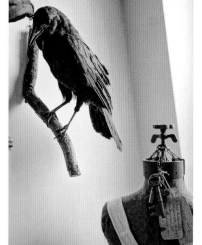

iii.

iv.

v.

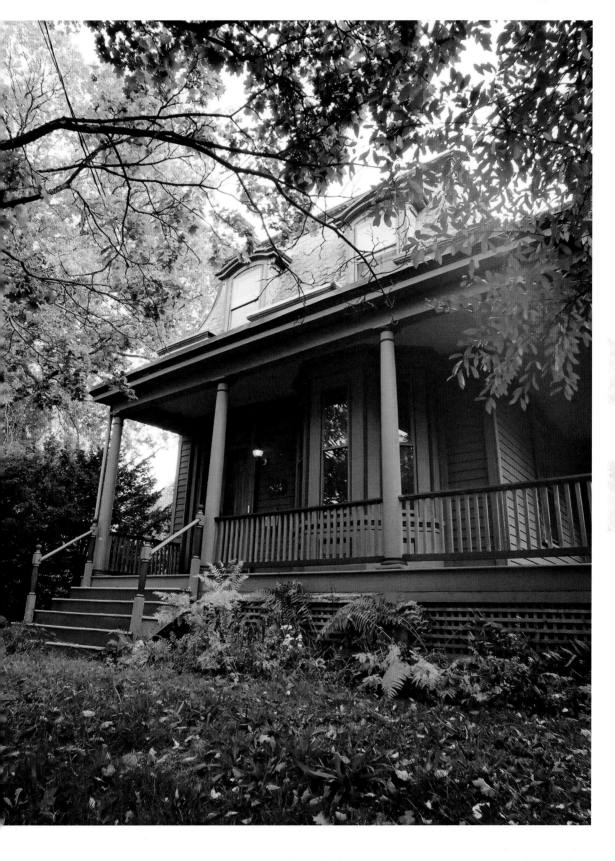

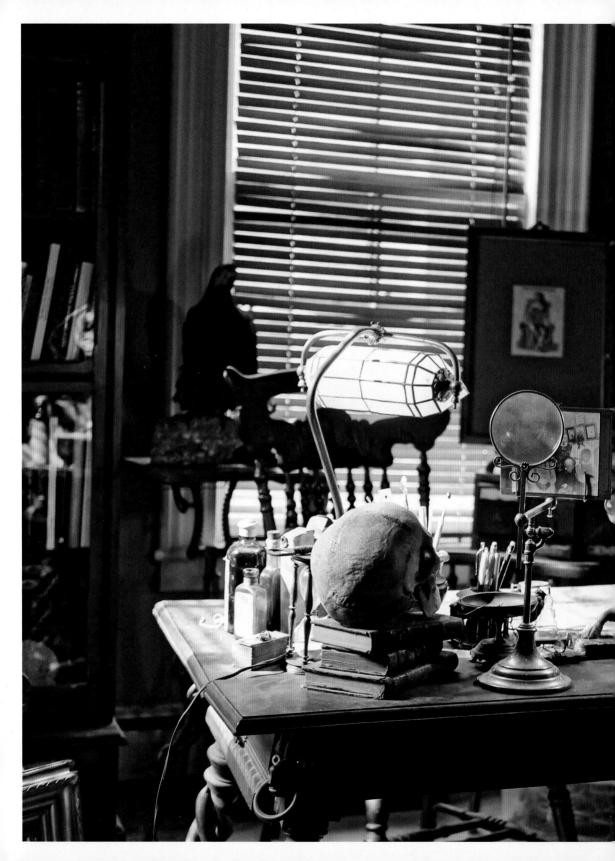

❖

Evan says this is her favorite room in the house. "I always wanted my private library—a *sanctum sanctorum*. This is that room. The 'bones' of the room were perfect, and since I'm a bibliophile, I had many of the books ready to go. I've found antique bookcases as needs arose, including the magnificent mid-nineteenth-century American Gothic cabinet. This room houses several of my cabinets of curiosity. I used it as a study until I outgrew my small restoration studio on the second floor; the library has now become my workroom. Since I do all my restoration and repair work here, there's a constant parade of unique objects passing through—everything from religious santos to skeletal preparations to antique insect specimens."

making hanging anything large or heavy virtually impossible. The windows are deeply set, and they all have a lovely nineteenth-century arch built into the woodwork with the original wavy glass window-panes still in place. There are tiny stairs leading from the main bed-room into the servants' wing, which is two small rooms.

"The moldings are thick, the doors are heavy, and the ceilings are high. There is what looks like an original lean-to kitchen in the back-yard, with an old brick fireplace. Friends call it 'The Doll's House' because it's a grand Victorian style on a relatively small scale."

The home may be relatively small, but it still has its share of Victorian architecture and Gothic influences, like a set of servants'

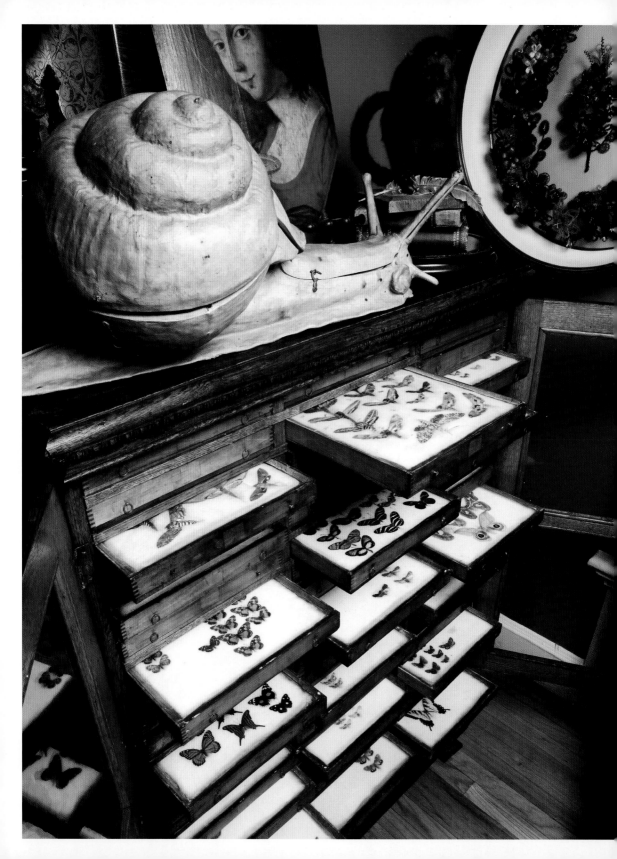

A mid-nineteenth-century enlarged model of a snail, produced in the workshop of the great Dr. Louis Auzoux, a French anatomist who specialized in paper-mâché anatomical models. It is unpainted, and it came directly from his workshop in France. "It is the only unpainted Auzoux I've ever seen or heard of; you can see the materials and the elaborate construction," Evan proudly expounds. "It's breathtakingly fabulous and probably one of a kind." The snail sits atop a large oak specimen cabinet that dates to 1910 and contains sixty-six drawers of moths. Finding complete antique cabinets has become increasingly difficult. Evan was lucky enough to find this display many years ago at the Brimfield flea market: the sellers had picked it up at a barn sale. Luckily, it was untouched. "I never get tired of it, and I often open the drawers to contemplate the contents. My love of science and the display, preservation, and study of objects from the natural world balances my love of the Gothic. I find it irresistible."

stairs, lead glass windows, and odd shaped rooms, including Evan's favorite room. "The library is my favorite room, no question. It's one of the great loves of my life. I've always been a bibliophile, and all I ever wanted was a library of my very own. When we first got the house, and the room was empty, I could see that the proportions were already perfect. The room not only contains all my books on death culture, anatomy, art, photography, architecture, and decorative arts, but it contains two cabinets of curiosities, including my Gothic dream cabinet. The windows are large, the ceiling is high, and the moldings are impressive; yet it's a small, intimate space.

"These days the library doubles as my workshop, where I spend hours cleaning, repairing, and restoring antiques. Every moment spent here is a happy one."

It is wonderful for Evan as an antiques dealer to have a home where she can keep some of the beautiful pieces she comes by in her endless picking and antique shopping. "I hunt for rare, beautiful, and remarkable objects for a living, and I've found so many wonderful things for this house! One of my favorite objects of furniture is the antique collector's cabinet, containing sixty-six drawers filled with moth specimens. Another would be the gigantic antique 'two-story' brass bed with swiveling curtained 'wings.' It's nineteenth-century excess at its finest. The absolutely gigantic nineteenth-century oval mirror over the parlor fireplace was such a lucky find (on Halloween weekend, no less). It is so massive it took four people to lift it! But my favorite piece is the mid-nineteenth-century Gothic cabinet in the library—that's something I've always wanted, and I just adore it.

"Those would be my favorite pieces of furniture; however, I have two favorite pieces in my 'collection.' One is a rare, unpainted, fully anatomized nineteenth-century papier-mâché snail model from the

i., iii., iv., v., vi., vii. These are life-size antique wax mannequin busts, circa 1910 and 1925, from America and France. These heads were usually set on a jointed mannequin body and were primarily display pieces for shop windows. Each hair was individually implanted with a hot needle, and there were female artisans whose only job was to fix the head's gaze. "I've never seen two identical heads, but you do come to recognize the makers, and they do have something of a 'family resemblance.'" says Evan. "I've been an antiques dealer for many years, and I'm pretty proud that I've sold the vast majority of the remarkable objects that have come my way. However, I have a particular weakness for these wax ladies; they've been excellent company." ii. A collection of ghoulish mid-nineteenth-century marionettes.

Parisian workshop of Dr. Auzoux. It has tiny brass hook-and-eye closures, and the materials and artistry are so beautiful. It's a perfect object.

"My other favorite is a very large hairwork shadowbox. Nineteenth-century hairwork is my favorite thing, and this wreath is not only beautiful work, but it has photos of every member of the family who donated their hair set into the frame. You can actually look into their faces, and it's a massive, marvelous object."

Although there are no plans for significant renovations, because "Architecturally speaking, she is perfect just the way she is—well, she could have been a bit larger. And location-wise, I'd love to live somewhere quiet and green that's not in a busy, noisy, crowded city.

"I don't really believe in ghosts per se, but this house has an interesting 'haunting' story. In the months when the house was empty before we moved in, we had people come in to do some basic

THESE GUYS FROM STATEN ISLAND CAME IN TO SAND THE FLOORS FIRST. WHEN THEY LEFT, THEY TOLD ME THEY FELT A FEMALE PRESENCE IN THE HOUSE, THAT SHE WAS HAPPY, AND THAT SHE "SPARKLED."

maintenance and repairs. These guys from Staten Island came in to sand the floors first. When they left, they told me they felt a female presence in the house, that she was happy, and that she "sparkled." I thought that was somewhat unusual. A bit later, a local painter came in to do the walls. When she left, she told me the same thing: that there was a female presence in the house, that she was warm and positive, and that she 'sparkled.' So there you have it. This home does have a warm, positive vibe to it, and folks do feel it.

"It appears our home is at least occupied by some kind of energy, and I get along with it rather well."

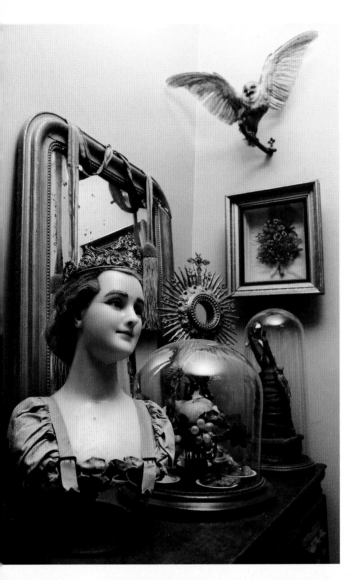

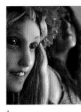

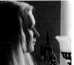

iii.

iv.

v.

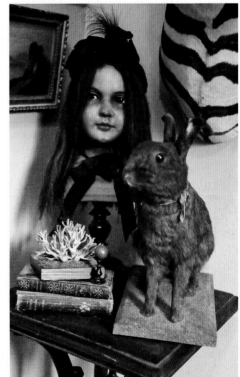

vi.

vii.

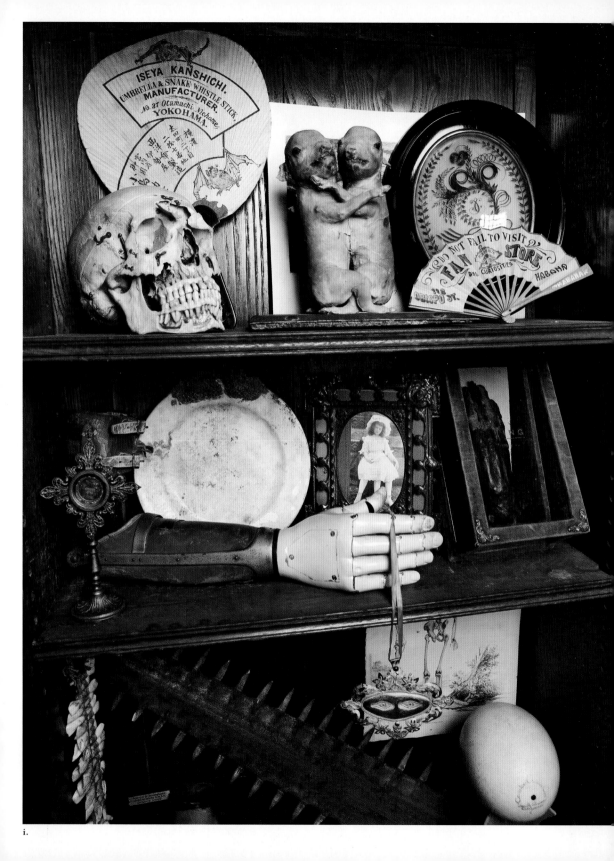

i.

i. A shelf of curiosities, including a vintage skull with exposed dentition, a vintage prosthetic arm, and a vintage largetooth sawfish bill. ii. Evan Michelson stands in front of her living room mantel and a massive Victorian mirror.

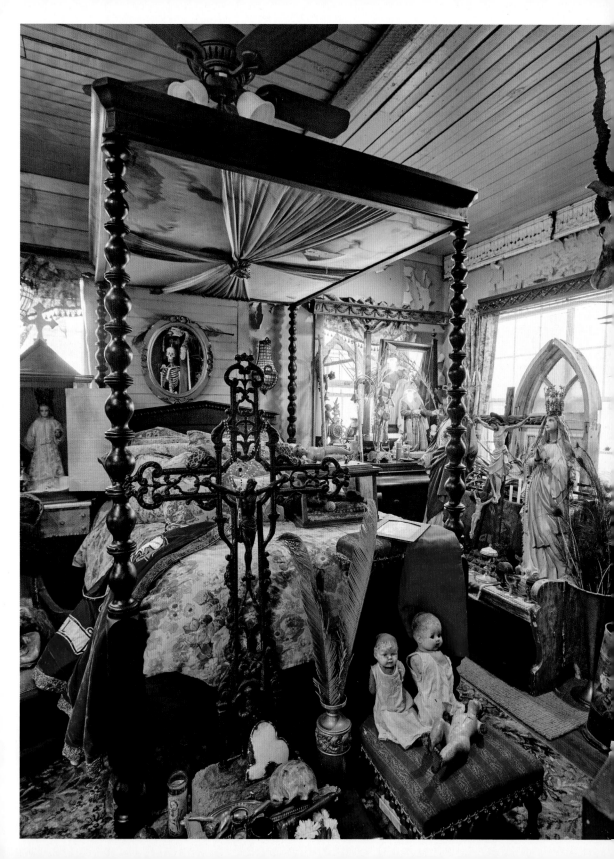

An overall view of the bedroom.
A variety of decorative elements
were incorporated into the design,
including an antique chandelier
from the estate of world-renowned
author Anne Rice.

⁜

RICK MORGAN
Southern Alabama, USA

A HOME FOR THE HAUNTED

With its mysterious and eerie atmosphere, it's easy to see why New Orleans, Louisiana, has been the setting for countless spine-tingling tales of Gothic horror. "I was born and raised in a home located in New Orleans, Louisiana. Here there's no shortage of music, restaurants, seafood, jazz celebrations, voodoo, aboveground cemeteries, vampires, hauntings, the macabre, and ghosts. These are all part of the city's history. I lived between two mansions owned by Anne Rice."

Architecturally there are a variety of home styles on any given New Orleans street. Many of the houses combine elements of Greek Revival and French Colonial architecture. This includes a mixture of large columns, dormer windows, and large front and back porches adorned with detailed wooden corbels and tall wooden shutters. It's a design blend of French, Spanish, and Caribbean architecture.

"For most of my life, I stayed in the Garden District on a street

i.

ii.

iii.

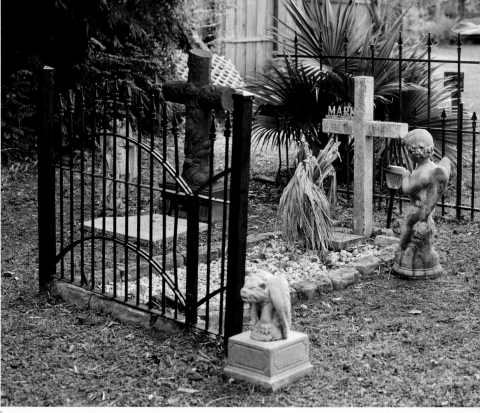

iv.

i., ii., iii., iv. The backyard cemetery
with grave markers and statues.
Rick believes the opportunity to
have a backyard cemetery should be
available to everyone.

THE CONCEPT OF MINIMALISM
DOES NOT APPEAL TO ME IN
ANY WAY. I BUY, AND I BUY,
AND WHEN THE PIECE COMES
INTO MY HOME, I REARRANGE
IT TO WORK WITHIN THE SPACE
ACCORDINGLY.

lined with oak trees and only a
short walk to St. Charles Avenue
with its mansions and street cars. It
was also close to Magazine Street,
peppered with scores of antique
stores, many of which I frequented
very often.

"It was from that house in the
Garden District that I moved into
the one I live in now. Built in 1918,
it is located in a small town near
the Gulf of Mexico. Being over a
hundred years old, with relatively
minimal upkeep, the building was in
a state of disrepair, although struc-
turally very sound. However, for
the home to comply with current
building codes, some updates had

to be made. I had work done on the
electrical and plumbing systems,
painted the house, and work done
on the roof. Throughout the reno-
vation, I was mindful of retaining as
much of the home's original details
and woodwork as possible."

Rick did have a considerable
amount of work to get the house
up to code, but the Gumbo House
was a diamond in the rough with
brick fireplaces, large windows, a
century-old claw-foot bathtub, and
original hardwood floors through-
out. There are also twelve-foot
beadboard ceilings, which easily
accommodated his Tester and Half-
Tester antique beds and furnish-
ings, a structural feature he is sure
would have been hard to come by in
contemporary construction.

"As a curator, I constantly seek
new pieces to add to the Gumbo
Home and its collection. It is chal-
lenging to furnish a period home
while maintaining its authenticity
and incorporating antique accents,
such as Persian rugs and artwork.
The concept of minimalism does

✣

i. An antique wooden Belgian church tabernacle sits alongside a taxidermy alligator with a large snakeskin and a human skull. An antique hand-carved polychromatic religious santo stands among the sacred statues. ii. A vintage taxidermy antelope shoulder mount and a life-size statue of St. Rita. An embroidered hooded religious cape adorns the wall. iii. This is the first antique life-size religious statue that Rick acquired; an elaborate Mardi Gras cape made of rhinestones and ostrich feathers is draped behind her. iv. The salvaged Virgin Mary. "An antiques dealer contacted me after Hurricane Katrina and asked if I was interested in purchasing the statue. During the hurricane, the figure was completely submerged under water and lost its brilliant colors. The store owner revealed that her home was being renovated; however, the workers had halted the renovation due to alleged paranormal activity associated with the statue. The workers stated that the glass eyes of the statue blinked while they were working. The workers would only return to the home once the statue was removed." In the background is an antique French Morbier tall case clock, various artworks, altar lights from a French church, and hand-stitched pillows from a Catholic cardinal's home.

ii.

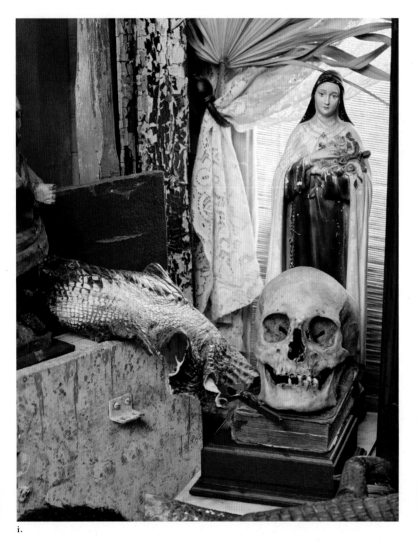

i.

iii.

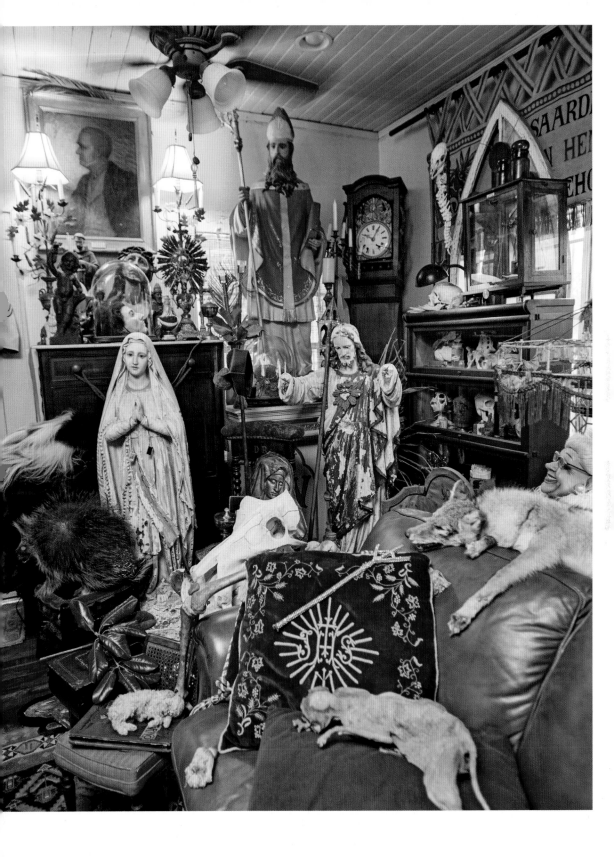

A vintage taxidermy blue marlin
and various turtle shells, including
one with a shark bite. Over the
toilet is a painting by an artist from
New Orleans.

not appeal to me in any way. I
buy and I buy, and when the piece
comes into my home, I rearrange
it to work within the space accord-
ingly. Although you will never
find motivational slogan signs
around my house: no 'Live, Laugh,
and Love.'

"My experience has been that you
need patience, and when you find
a piece that fits, it is a gratifying
moment. For instance, I've been
looking for a love seat with specific
measurements. Then this weath-
ered and well-worn Chesterfield
love seat I recently found met both
my size requirements and my aes-
thetic goals. That was a good day."

I came in contact with Rick
because of his vast and fabulous
collection of the macabre. That fan-
tastic and ever-growing collection
is most prominently displayed in
the room he has deemed his favor-
ite: the library.

"It's the floor-to-ceiling book-
shelves that I love most. It's on
those shelves that I display my
oddities, macabre items, and

haunted objects. You can find full
human skeletons, medical mod-
els, religious iconography and
artifacts, taxidermy, and haunted
items throughout the room. I have a
special antique curio cabinet for my
skulls. And a taxidermy alligator
hangs from the ceiling. That alliga-
tor is so large that it had to be cut in
half when shipping. The only 'living
things' in that room can be found
in an aquarium filled with African
cichlids. It is here where I can read
and admire the collection in peace."

The question of whether Rick
possesses a haunted item, or if he
feels that his home is haunted, is
certainly not an obligatory one.
As he says, "Over the past several
years, I have endeavored to acquire
items that I believe to be authenti-
cally haunted pieces. And in doing, I
presently have close to one hundred
paranormally researched haunted
objects, with accompanying docu-
mentation, in my collection.

"Having witnessed paranor-
mal investigations and conducted
investigations on people, I have

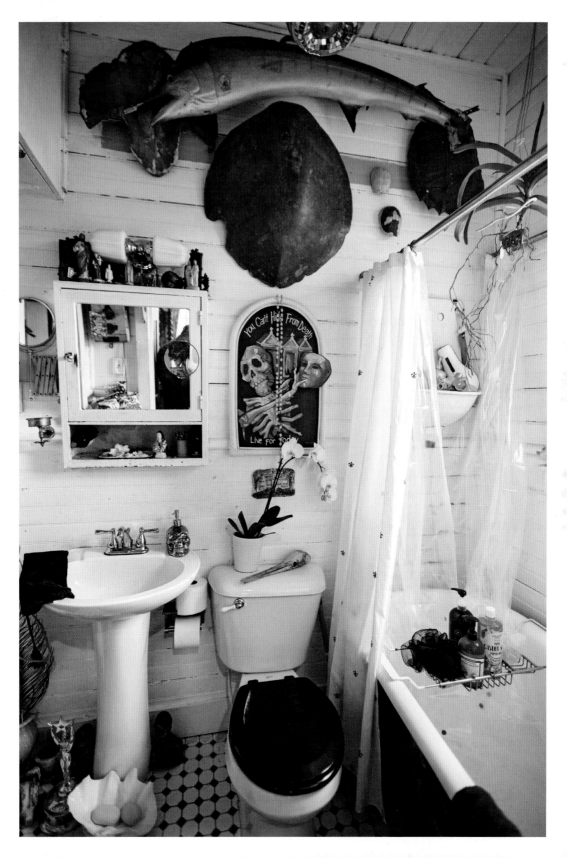

i.

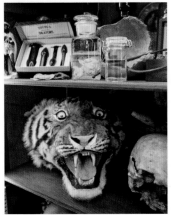

ii.

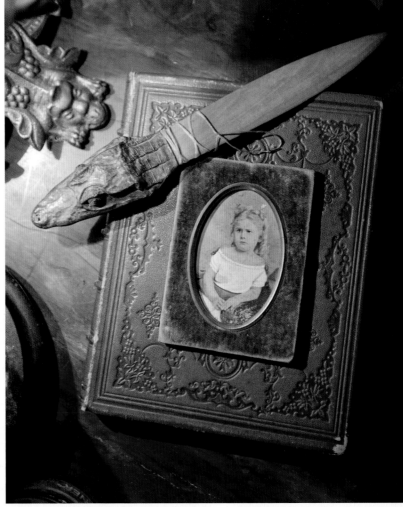

iii.

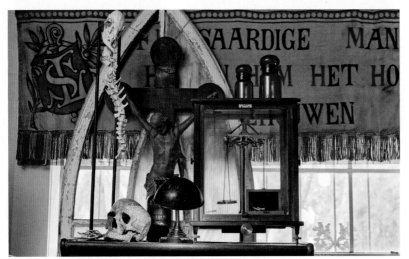

iv.

v.

✢

i. A wax head and face in the likeness of oddities collector Ryan Matthew Cohn, created by artist Sigrid Sarta. On one side of the skull are the skeletal features; on the opposite, a realistic rendition with real hair and teeth. ii. Various antiques associated with medical studies and an antique taxidermy tiger head warn everyone to beware. iii. A haunted sentiment book, circa 1859. This book is possessed by the ghost of Lydia. Her classmates wrote the prose in her book. Literary sentimentalism is a genre of literature from the eighteenth century that focuses on the expression of emotion. In both poetry and prose, sentimentalism was in vogue. In addition to being a timid ghost, Lydia is susceptible to being intimidated by her surroundings. The process of gaining her confidence takes some time. iv. A shelf of oddities, including a vintage medical skull, circa 1918; a fetal skull under a dome; a coffin crucifix; and a ceremonial carved skull cap. v. An antique Eskimo fish hook, passed down from generation to generation. An emu and an ostrich egg stand alongside a taxidermy bear head. There is also a selection of laboratory and apothecary vases on display.

I BELIEVE THAT THIS HOME IS HEAVILY HAUNTED, AND THAT IS GOOD. THE HAUNTED ITEMS GIVE ME A SENSE OF CALM AND NEVER DO I FEEL ALONE.

surrounded myself with the most qualified sellers in this field. However, before purchasing, I obtain as much information as possible, ask questions, conduct my research, view images of the item, and follow my instincts.

"My goal is to have peace about every item that enters my home and avoid purchases that are likely to leave me with an unsettling or negative feeling. I have heard of cases where purchased items have caused disturbances in their homes. The buyer beware. So far, all my haunted items appear to share their haunted spaces well.

"I believe that this home is heavily haunted, and that is good.

The haunted items give me a sense of calm and never do I feel alone. They must be well cared for to ensure their history and stories are told and heard. The exchange is positive. Most haunted items have experienced sudden, unexpected, and traumatizing events in the past. If they choose to interact with me, I hope to provide them with a safe environment in which to do so. They also have the opportunity to communicate with other spirits. If they choose to communicate with me, I have spirit boxes, EMF meters, ghost balls, and any other means available to them. I want us all to live in a harmonious environment."

A HOME FOR THE HAUNTED

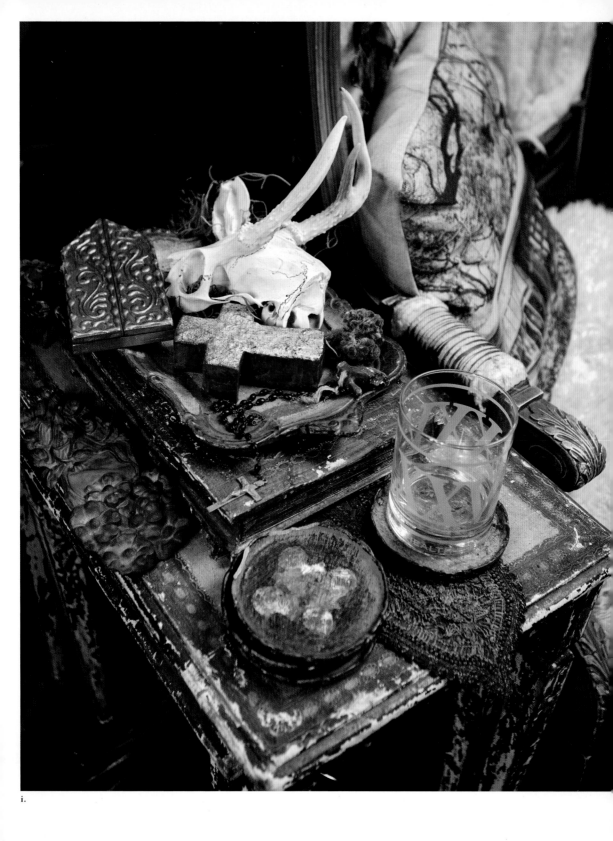

i.

✣

i. An antique set of Florentine nesting tables and coasters with deer skulls. The etched crystal glass is the work of New Orleans artist Mignon Faget. ii. The subject of the large tin type in the center is a woman named Mavis. She is said to haunt the image, which is still in its original glass frame. A glass eye is attached to a cotton piece behind her picture. It is believed that this glass eye is from a doll dating back to the 1800s. The purpose of its placement was to protect the spirits that were attached to it. One of Mavis's family members found the tin type in the attic but did not want to keep it. Mavis is a comforting spirit.
iii. Rick Morgan. iv. Three medical human skulls for study. The corpse's skull in the center is on a vintage cadaver stand. A pair of antique scissors originally owned by a Victorian prostitute is located beneath the cadaver skull.

iii.

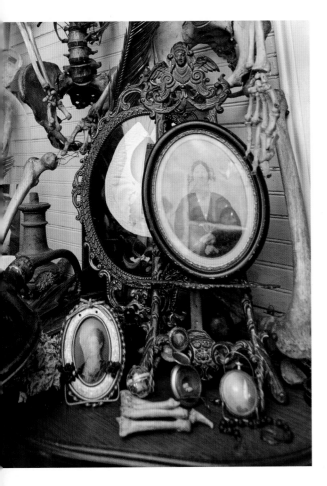

iv.

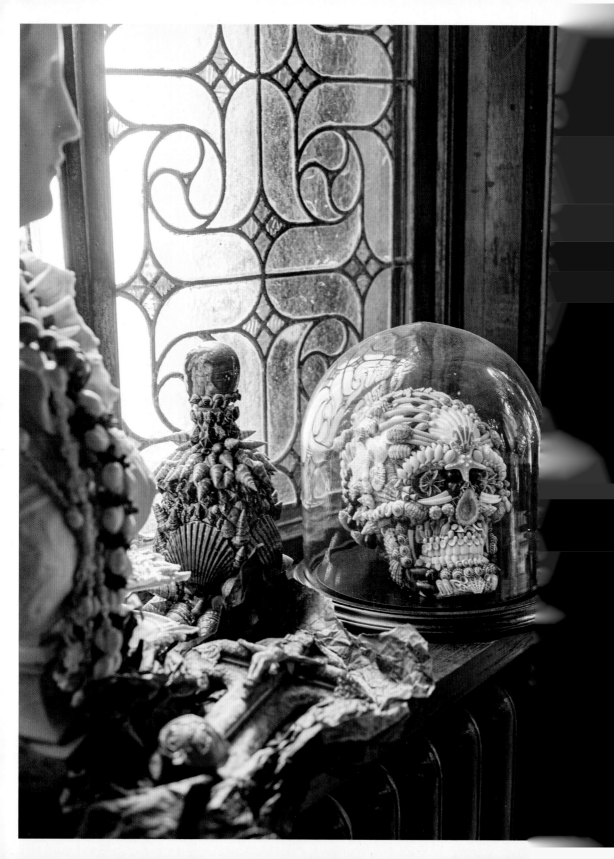

The stained-glass windows were purchased at an antique store. "They fit perfectly against the existing windows. I'm going to have them cleaned and properly framed." Beneath the dome sits a seashell skull created by Susan Lloyd.

⁜

ADAM WALACAVAGE

Pennsylvania, USA

A GOTHIC GALLEON

Adam grew up in the suburbs of Delaware County, Pennsylvania, in a home surrounded by five acres of woods with a stream running through the property and various skateboard ramps he built as a teenager. However, it wasn't this pastoral setting that he felt was most influential regarding his current approach to style and home decor.

"My biggest influences come from my childhood summers in Wildwood Crest, New Jersey. I loved the boardwalk, the haunted houses like Castle Dracula, and all the weird '50s and '60s boardwalk rides. Plus, there were all these fantastic themed hotels. They were incredible. The Tahitian was one of my favorites, and it looked like an authentic Tahitian building. It had this big fake palm tree out front, but it was realistic. There was the Hawaii Kai, the Pan-American, and the Satellite. And all these hotels had amazing neon incorporated into their design.

✣

i., ii. When reclining on the Victorian velvet couch nestled in the corner of the Jules Verne Room, one feels as if they are in a mythical underwater parlor around the turn of the twentieth century. The color scheme and unique painting technique, combined with the overwhelming Victorian-style nautical decor of this room, certainly help that feeling. The four smaller chandeliers are the first ones Adam created, circa 2001; he also cast the ceiling medallions they are centered on. The large chandelier was created for an art show in 2013; it is incredibly heavy and made from cast plaster and epoxy clay. The hammerhead skull was found in a shop called Romance Hollywood, and the sailfish head comes from the famous (now closed) antique shop Obscura in New York City. Real lobsters this large are hard to come by, but Adam found this one on Craigslist.

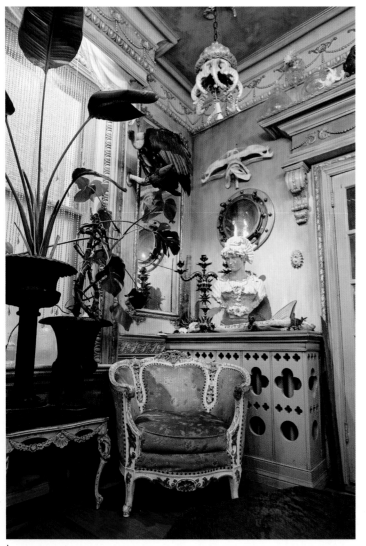

i.

ii.

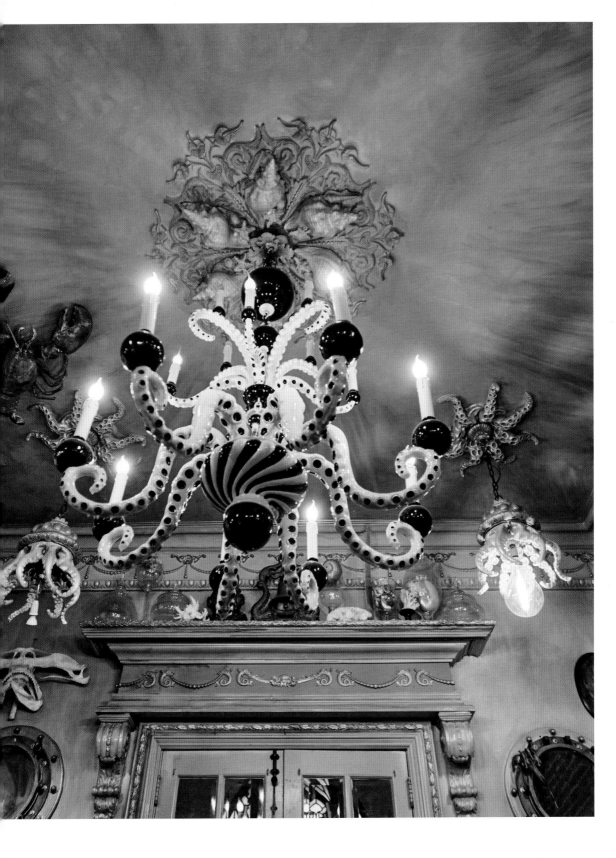

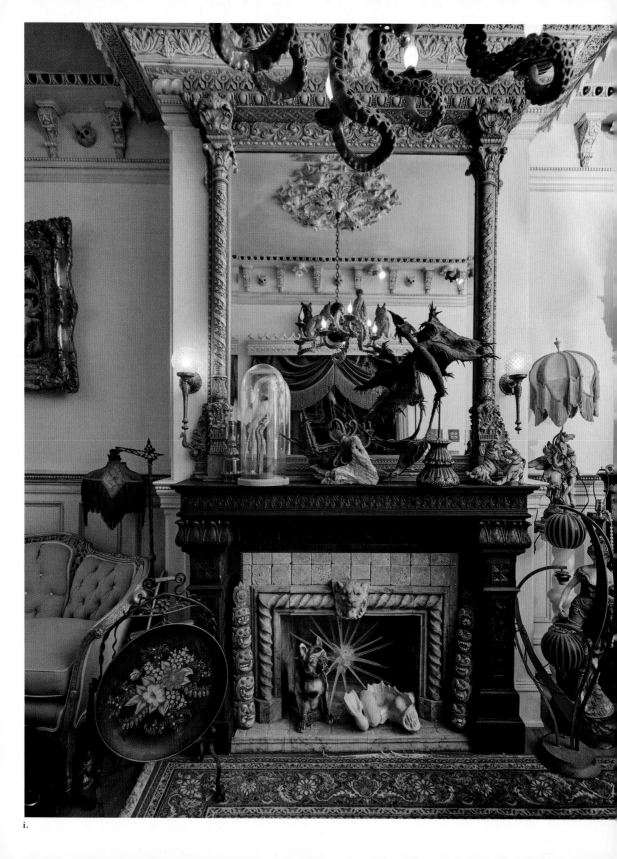

i.

⟡

i. When Adam moved into the house, this mantel was *dismantled*, with the legs and shelf in the basement and the mirror on the second floor. Like all the rooms in this house, Adam cast the molding, cornices, plaster framing, and flourishes by hand. "For the top section, I had to cast over sixty pieces of plaster and then piece them all together. For the bottom section, I employed the help of Kathy Vissar in Philadelphia. She has a company called Wells Vissar that specializes in scagliola, a technique of making plaster and other architectural elements appear like marble inlays." ii. The ceiling medallion that accents the parlor chandelier comprises thirteen different sections. "I got the parts for that medallion from a couple of pieces I found in Brighton, England; I packed them in my suitcase and made molds when I returned to the States."

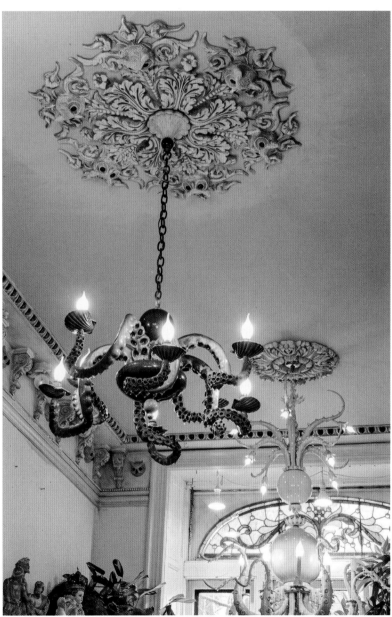

ii.

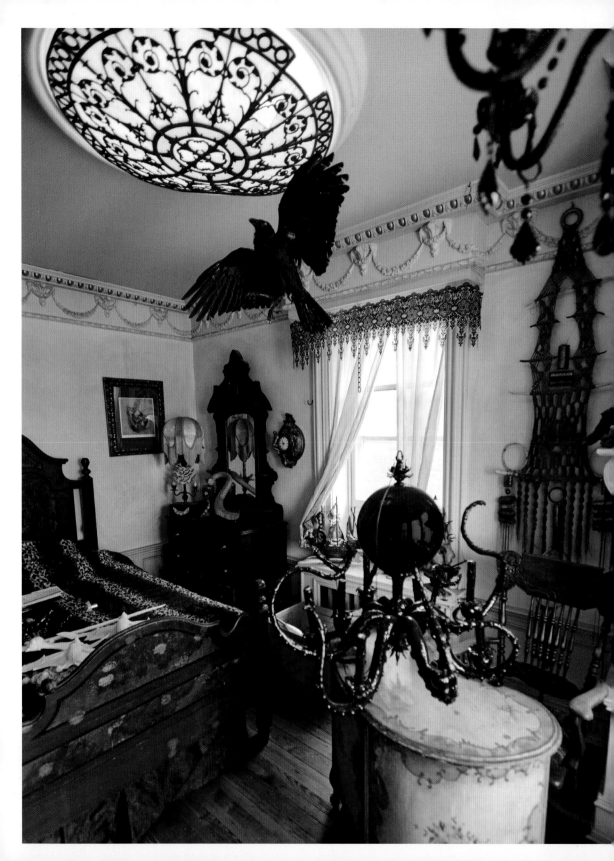

The guest bedroom is dominated by a large taxidermy raven created by the Australian taxidermist Julia deVille. Getting pieces from deVille can take years because she will only work on animals that have died naturally. This piece has paperwork and a microchip to prove its legality in the United States. The giant globe ceiling light comes from the famous Chelsea flea market in New York City. Adam cast the base it fits in and all the crown moldings in the room. A few guests have claimed this room is haunted.

A POP CULTURE/MID-CENTURY MODERN/KITSCHY/CONEY ISLAND/JULES VERNE QUALITY RUNS THROUGH ADAM'S HOME.

"On the other side of the inlet from Wildwood Crest is Cape May. And here are a bunch of historic houses; it has some of the country's largest collections of Victorian architecture. Now all the homes have been restored, but back then, many were run down, and although they were gorgeous, they looked more like haunted houses. So, I had this influence of beautiful, gingerbread Victorians and then the boardwalk and these garish mid-century modern hotels all mixed."

Adam's unique take on Gothic decor also has many classic influences in addition to Victorian interior and exterior architecture. A pop culture/mid-century modern/kitschy/Coney Island/Jules Verne quality runs through Adam's home.

A life-size Creature from the Black Lagoon leers out from behind a coffee table. At the same time, one of more than twenty-five octopus-style chandeliers (made by Adam) illuminates an oversized dining room graced with wood-paneled walls salvaged from a soon-to-be-demolished Victorian mansion and a cabinet of curiosities reminiscent of early 1800s Europe, except this cabinet includes 1950s pinups in addition to the more traditional taxidermy sea urchins.

When Adam's older brother returned from studying abroad with items and images of amazing eighteenth- and nineteenth-century churches, Adam began traveling to cities throughout America and Europe, documenting Catholic churches that were slated for demolition.

"It was heart-wrenching to see these beautiful buildings rotting away and being demolished and knowing I couldn't do anything to save them. So, when I bought my house, I started using the casting

Various ocean shells, a shark jaw, a
skull fashioned out of sea life, and a
wood carving of a humpback whale
make up the other half of Adam's
"element" shelves.

skills I learned in school to outfit
the home. I would find parts of
molding or a ceiling medallion, then
make latex molds and cast that with
plaster. I thought, well, I can't save
the entire buildings, but at least
I can save this stuff that's being
broken and tossed away. I believe
there's a wisdom in these designs."

In 2000, Adam was looking to
buy a house with the prerequisite
that it had high ceilings and stained
glass. He drove by his present
home, which had been vacant for
almost seven years, and called the
realtor. "The realtor said, 'It has
a classical interior, high ceilings,
some stained glass. Oh yeah, and
a basement that looks like a ship.'
Needless to say, that ship comment
was the clincher, and I didn't even
look at another house."

The house had three previous
owners before Adam purchased the
property. "I bought the house from
the last owner, who purchased it
around 1941. And that was the last
time it was modernized. Some of
the house was used as a doctor's

SOME OF THE HOUSE WAS USED AS
A DOCTOR'S OFFICE AND A MUSIC
SCHOOL. THE PARLOR WAS THE
DOCTOR'S WAITING ROOM, AND
WHAT IS NOW THE KITCHEN USED
TO BE THE EXAMINATION ROOM.

office and a music school. The par-
lor was the doctor's waiting room,
and what is now the kitchen used to
be the examination room.

"There was an organ on the
second floor and a baby grand piano
in the basement. I assume lessons
took place in the basement and per-
formances on the second floor.

"I will admit the place was a bit
creepy, and on some early nights
when I slept here, I had nightmares,
including sleep paralysis. That was
the last time I slept in that room.
However, I had to stop imagining
things, and I believe I was uninten-
tionally conjuring. So, I told myself
there's nothing here, or if there is,
it's good energy."

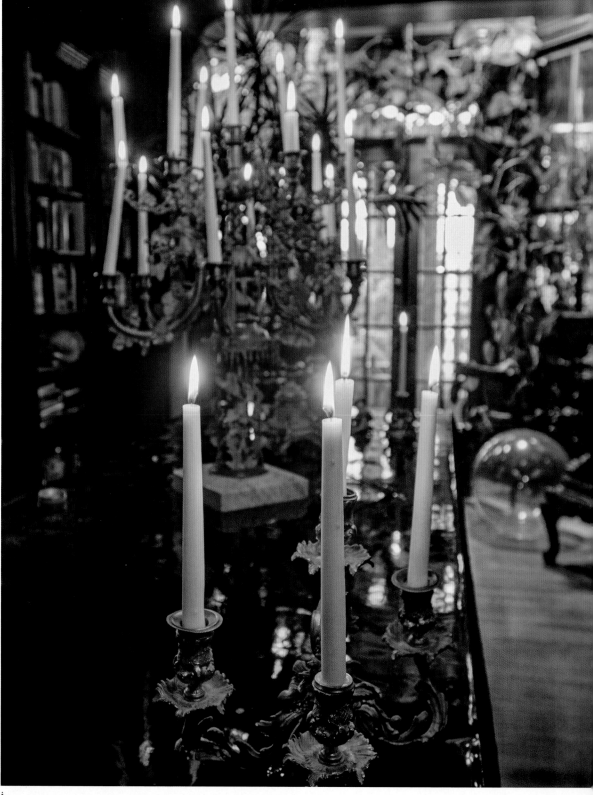

i.

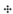

i. The great wall of Trumbauer wood and mirrors is truly impressive. The wood panels came in countless pieces and had to be reassembled at the house. Additionally, the panels were twelve feet tall and had to be cut to fit the ten-foot ceiling in Adam's home. The mirrors are not original; Adam recreated the molding framing around them. ii. Although this table is used to cast plaster on, it is adorned with a huge antique candelabra and multiple candles in vintage candlestick holders. In addition to being a workroom, this room is one of the largest in the house, and plays host to parties, where scores of candles become the primary light source. iii. An ornately carved antique Japanese love seat in the Trumbauer Room.

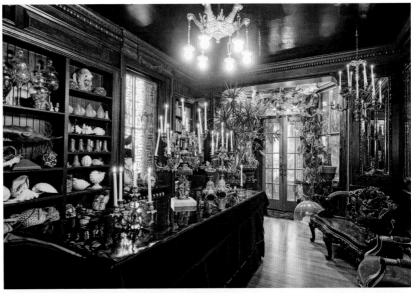

ii.

iii.

i., ii. The entrance to Adam's Victorian townhouse. The cement seahorse and antique novelty doorbell are clues to what lies inside. iii. A cozy corner in the greenhouse to lounge on a pink Victorian love seat. iv. The open-top octagonal standing fish tank was obtained from a friend who displayed it in his restaurant. The previous owners went on to purchase the New York City landmark restaurant Tavern on the Green. Presently, the tank is home to black angelfish; a pond fogger keeps the plants moist and the room spooky. "I cherish this piece. I think it's the coolest fish tank in the world. One of my Holy Grails."

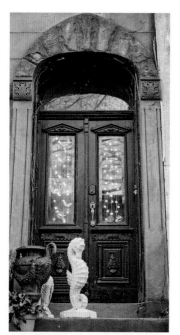

i.

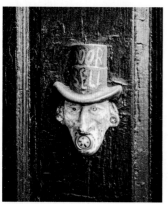

ii.

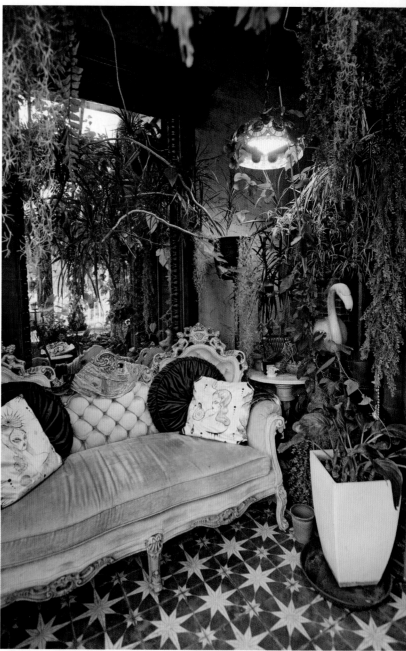

iii.

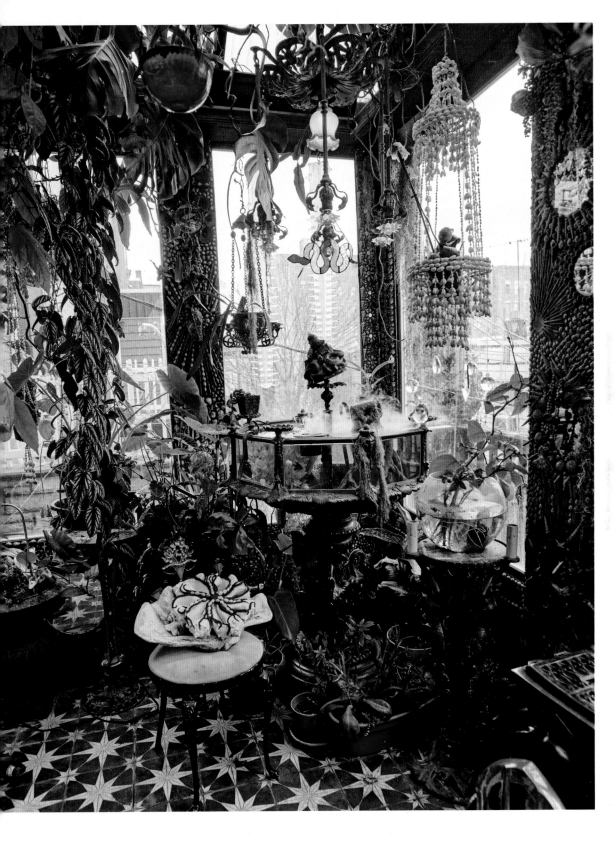

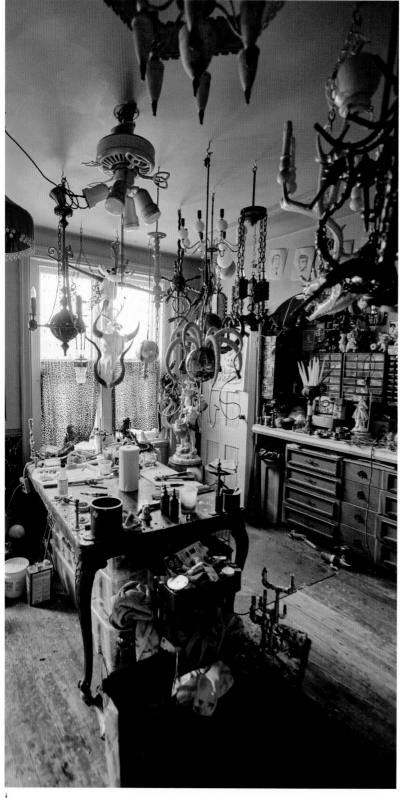

i.

ii.

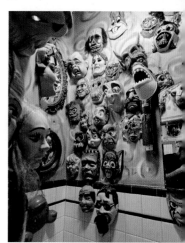

iii.

iv.

i. The workshop where all the "magic" happens. ii. Adam Walacavage. iii. Vintage Halloween masks decorate the walls of the first-floor half bath. iv. The bathroom adjoining the master bedroom maintains much of its original tile and is accented by a vintage chandelier.

IN THE 1930S, THE COUPLE WHO OWNED THIS HOUSE SOLD DISTRAUGHT WIVES "LOVE POTIONS"—CONTAINING ARSENIC OR ANTIMONY—AND LIFE INSURANCE.

Although Adam has come to realize his home is, in fact, not haunted, it does have a bit of a fascinatingly dark past. In the 1930s, the couple who owned this house was mixed up in a gang that preyed on newly arrived immigrants. They owned a tailor shop and also ran a sketchy insurance business. And when they heard of a marriage on the rocks, they offered the distraught wife a "love potion." These "love potions" usually contained arsenic or antimony. The husband would take out an insurance policy on the unsuspecting recipient of the "love potion," with him as the beneficiary. The gang was eventually arrested and became known as the Philadelphia Poison Ring.

In the past two decades, Adam has transformed the house, with a vast majority of the work being done by himself, including all the plaster castings. A highlight of the home is the Trumbauer Room, where Adam, with the help of a friend in the salvage business, was able to rescue the carved wood walls from a Villanova mansion designed by Horace Trumbauer and install them in one of the larger second-floor rooms.

"When I started building the greenhouse, I got busted for not having a permit. That forced me to eventually get an architect and do it the 'right way.' But if I had started the project the right way, I probably would never have done any of it. I didn't know how to do many things, and I learned different techniques through friends, especially the plaster techniques. Then I started making the chandeliers, and by 2008, I quit my work as a photographer and have been making chandeliers full time ever since."

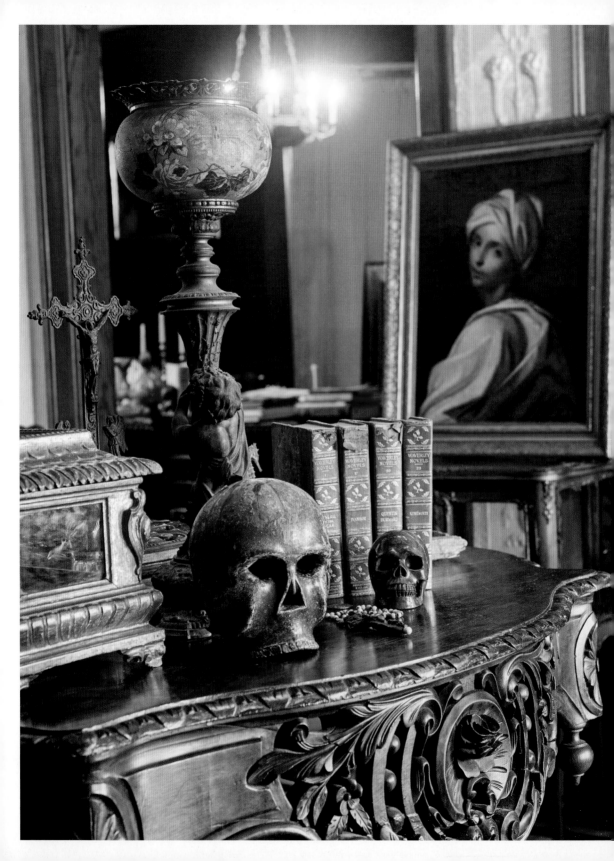

The séance table displays
reliquaries, a baroque book lectern,
an antique monastic rosary, and
a sixteenth-century hand-carved
wooden memento mori.

❖

VASILIOS
Somewhere in the US Midwest

MIDWEST
AMERICAN GOTHIC

Vasilios is a collector and keeper of *supernaturalis.* "My travels brought me to the medieval town of Sighișoara in the heart of Transylvania (Romania). Upon arrival, I immediately felt connected with the history, and this would catalyze my collecting and an insatiable curiosity for historical pieces of this vein."

Vasilios's collection comprises medieval artifacts, art, antiquarian books, and religious relics. Growing up in Athens, Greece, a place rich with antiquities, history, and mythology, and now predominantly residing in the United States would be enough to ensure an archive of anecdotes to keep a listener mesmerized. Vasilios has what a gambler may call "an ace in the hole."

"As a child, I remember the intricate architectural elements, the antique cast-iron radiator covers, and the ornate wall sconces that were all a part of the home I grew up in. However, what I recall most was that the home was haunted."

The front parlor is adorned with paintings of Beatrice Cenci and a sixteenth-century painting of Salome with the head of St. John the Baptist, done in the style of the Italianate school of Guido Reni.

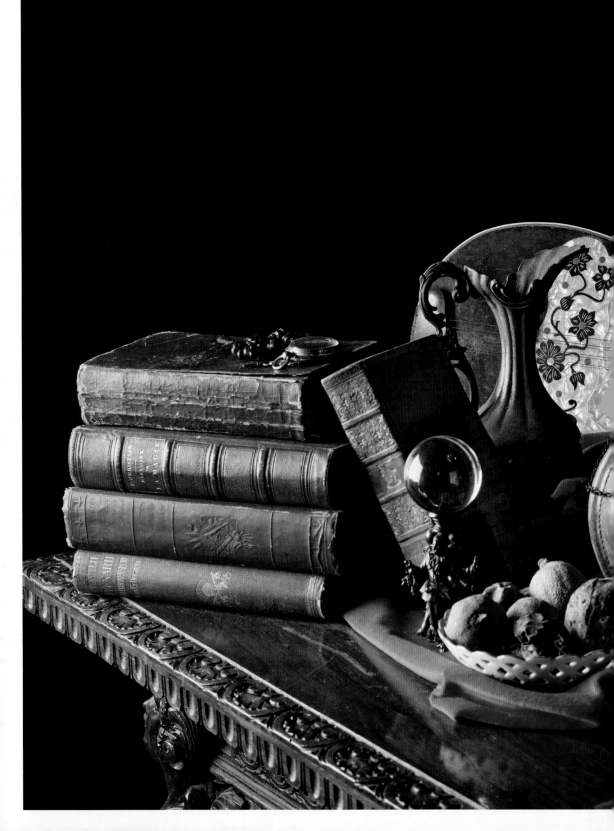

However, we didn't discover this until years after purchasing the house. The house was verified to be the scene of multiple suicides." Oddly enough, a realtor is not obligated to reveal if a house is believed to be haunted or was the site of a horrific event.

Although Vasilios has only lived in this home for a little under a decade, it has completely taken on the Vasilios mystique. "The house was built in the early 1900s, and I'm only the third owner. Luckily, the person before me had the sensitivity to only do minimal updates and have the home retain its original architectural beauty.

"Some of the unique features to this home are the original spiderweb window; the ornate fireplace; the traditional staircase constructed out of Douglas fir; the original Lincrusta, which is a thick, specially treated wallpaper that allows for elaborate embossing and relief patterns; the relief sculptures of cherubs; the many original light fixtures; the original

i.

ii.

iv.

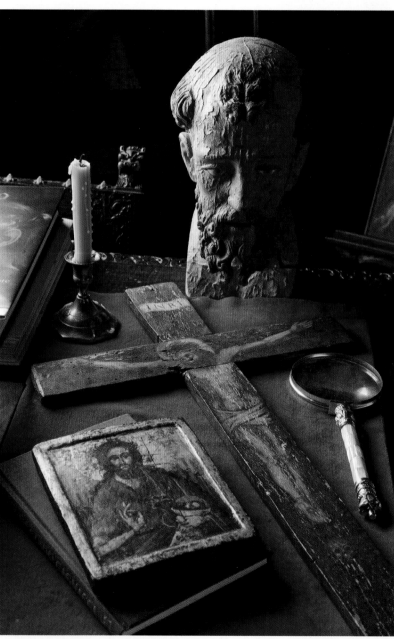

iii.

v.

i. A Spanish collar, a relic of the Inquisition. ii. Monastic flagellation devices from the collection of an Italian monk known for performing exorcisms. These were brutal instruments of self-punishment and penance. iii. Elements of suffering, martyrdom, and crucifixion are often found throughout Vasilios's collection. This theme is evident in these religious relics: a nineteenth-century Spanish santo bust, a nineteenth-century painted crucifix with vivid stigmata, and a seventeenth-century Byzantine St. John the Baptist. iv. A painting of Johann von Schönenberg, the archbishop-elector who orchestrated and presided over the bloody Trier witch trials. Below him is a dramatic portrait of Girolamo Savonarola, known for burning books and destroying what he considered "immoral" art. v. Details of the Johann von Schönenberg painting, dated 1582.

ARCHBISHOP-ELECTOR JOHANN VAN SCHÖNENBERG ORCHESTRATED AND PRESIDED OVER THE BLOODY TRIER WITCH TRIALS.

claw-foot bathtubs; and the original Victorian decorative brass towel holders. And I must admit, a lovely little surprise was the discovery of a servant's bell."

Furnishing a home of this size and being true to the period is always challenging; Vasilios's plight was no exception. "The cumbersome, heavy, intricately carved, ornate furniture was sometimes a logistical nightmare to move (without damaging) into and through the house. Another issue was the home's decorative plaster; although in rather good shape, bringing it back to its celebrated wonder was challenging. Fortunately, I meticulously restored the original decorative plaster and ornate crown moldings to their original glory."

In addition to the sweat equity Vasilios has put into the home to get it to where it is today, he has scoured the world to find just the right home decor. "My most significant furniture finds are the ten-foot-long, tufted, high-back Victorian sofa; a heavily carved baroque armoire; and antique Gothic dining room table with mythologically themed carving. Carefully curated are my paintings, especially a work of art of considerable size depicting Mephistopheles that was once owned by the renowned magician Harry Blackstone Senior."

As one moves through life, different pieces move in and out of being the most favorable. "I can't select a favorite piece; as I revisit the entire collection, my favorites change depending on what research I am engaged in. Sometimes I am captivated by a book, a painting, an occult piece, or a medieval torture relic; I tend to favor the darker historical relics. In fact, they all call my name and want me to favor them."

An early-eighteenth-century framed
reliquary of an undetermined pope.
The piece appears to be accented
with human bone fragments.

For Vasilios, the same is true for specific rooms in his home. "For years, my favorite room undoubtedly was the Collections Room; however, that has evolved, and now the room I am most drawn to is my study. I spend countless hours here, mostly researching and taking pause to look around and appreciate the relics and books I've brought back from my travels. I find the most inspiration from that room, becoming lost in my books or taking in the beauty of my baroque paintings."

Like most homeowners, Vasilios is always searching for the next great piece. "Right now, most significantly, it's seventeenth-century paintings, especially with the iconography of martyrdom, hellish scenes, historical torture, alchemy, and beheadings. I have managed to secure two paintings, one entitled *Burned at the Stake*.

"My holy grail of portrait paintings is not a common subject matter and was something I wanted to add to the collection: a portrait that

> **I FIND MORE PLEASURE IN COLLECTING PIECES IF I IMMERSE MYSELF IN THE RESEARCH AND HISTORY.**

reflects the brutality associated with the abuse of religious power.

"Hence two of my favorite paintings: one depicting Johann van Schönenberg, the archbishop-elector who orchestrated and presided over the bloody Trier witch trials. These trials resulted in the torture and execution of over three hundred people.

"The other came through an arduous search to find a piece pertaining to Savonarola. I acquired this significant painting with a finely detailed execution of his iconic profile. It is painted on bone; Savonarola was the monk responsible for the Florentine bonfire of the vanities. He destroyed many beautiful art pieces and was hanged and burned at the stake.

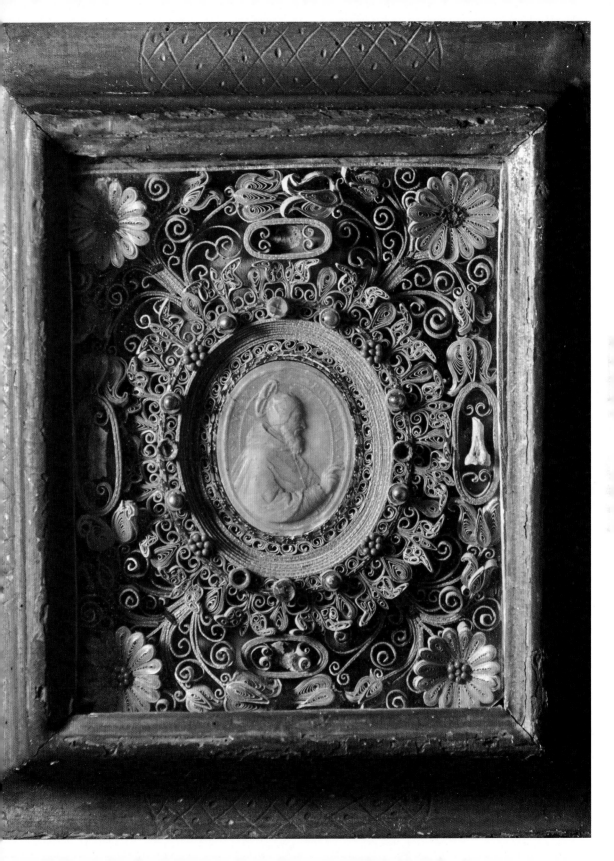

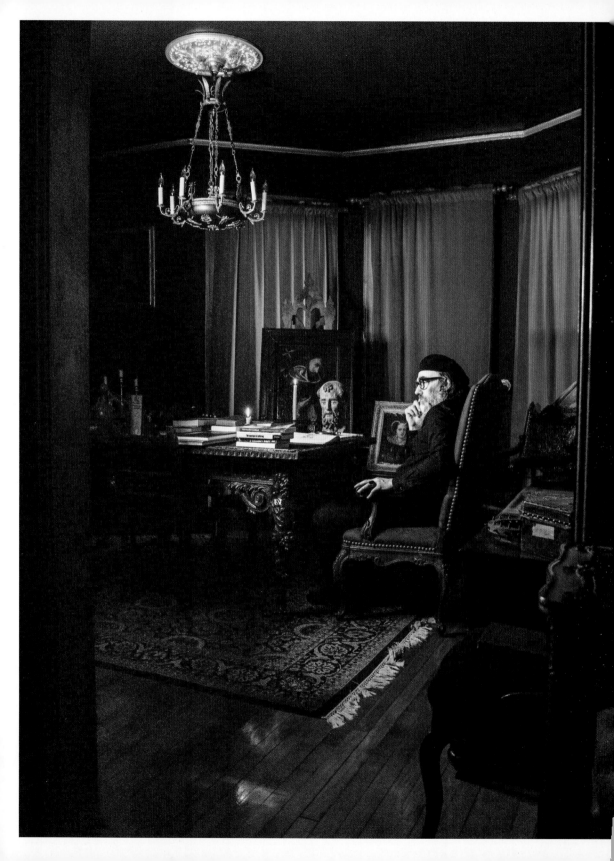

SOMETIMES I AM CAPTIVATED BY A BOOK, A PAINTING, AN OCCULT PIECE, OR A MEDIEVAL TORTURE RELIC; I TEND TO FAVOR THE DARKER HISTORICAL RELICS.

"These two pieces reflect my passion for theology, art, and macabre history. I recently traveled to Italy and visited the monastery where Savonarola lived, as well as the location where he was burned in Florence. I find more pleasure in collecting pieces if I immerse myself in the research and history."

With pieces coming from around the world and many representing some of the darker elements of a culture, Vasilios believes, "There are many pieces in my collection that are very disturbing and have a distinct energy, especially my medieval relics of torture. The dark, dense energy is palpable and casts a shadow of death that many can also sense. I'm not compelled to sell them; I've just made peace with them and the unsettling experiences they embody, especially the Dutch executioner's beheading axe from the 1500s.

"I wouldn't say my home is haunted; however, it has significant energy, often attributed to the pieces I collect and the stories they tell me about their past."

Vasilios is a historian and curator of his collection and finds himself in relentless pursuit of his next discovery, whether it be art, antiquarian books, or dark supernatural relics. "My passion for utilizing primary sources will lead me to these dark and arcane treasures."

✣

i. A sixteenth-century strappado, also known as a corda, was used as a form of torture: the victim's hands were tied behind their back and the victim was suspended by a rope and the strappado wheel. In front is an eighteenth-century execution permit from Rome given to the religious brothers of the Catholic church, which allowed them to pray for the souls of the executed. ii. A mysterious Roman bust. iii. The bones of a victim who was tortured on the "breaking wheel," also known as the Wheel of Catherine. iv. A supernatural archaeological relic of the sixteenth century: a vampire femur bone and a killing stake. v. A nineteenth-century plaster cast death mask impression from the corpse of a guillotine victim, accompanied by the original handwritten letter that states the time, date, and location of the execution for this particular victim. vi. Left to right: a seventeenth-century santos sculpture; an eighteenth-century legal notice of execution; limb bones that were shattered by the breaking wheel; a seventeenth-century gallows noose; a seventeenth-century painting depicting "Bamburg the Witch Burner"; a sixteenth-century witch gag; a sixteenth-century French strappado wheel; and an eighteenth-century execution permit from Rome that was given to the religious brothers of the Catholic church to pray for the executed, whose damned souls were in purgatory. vii. These cloak clasps and buttons are believed to have belonged to the notorious German executioner Franz Schmidt. He performed more than three hundred and sixty executions over his forty-five-year career during the mid-1500s. viii. A large Mephistopheles oil on canvas obtained from the former collection of the famous magician Harry Blackstone Sr., painted circa the 1900s.

i.

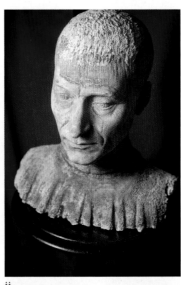

ii.

iii.

iv.

v.

i.

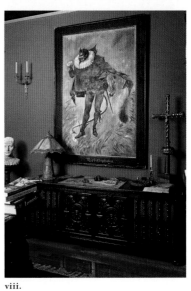

viii.

CONCLUSION

Everyone featured in the pages of this book has a passion for Gothic decor. However, based on their unique interpretations of what constitutes a Gothic home, we have seen that an attempt to place each of these homeowners in the same pine box would be erroneous.

If you had the privilege that I was granted of being so graciously welcomed into these homes and being offered the grand hospitality I was shown, you would never come to the assumption that these people, who choose to surround themselves with the macabre, are anything but some of the kindest and most knowledgeable individuals who have ever traded in their vintage cookie jar for a real human skull.

I am sure this confirmed what some readers already knew. And for others, I hope this book was a breath of fresh air among a miasma of corpse gas. For those who took these pages as an eye-opening experience, we hope it gave you the inspiration to stick your Gothic inhibitions in a sarcophagus and make the leap to turn your home decor dreams—or nightmares—into a reality.

LEFT: From the home of Giano Del Bufalo.

ACKNOWLEDGMENTS

I would like to thank Dan Howell for lending his talent as one of the main photographic contributors to this book and all my previous books, but also for being the person who came up with the concept for *The Art of Gothic Living*.

I would also like to acknowledge all the photographers: J.Ph Baudey, Jesse Korman, Erica Payne, Gianluca Santi, Lorenzo Vanzetti, Anjella Roessler, and Alexis Ziemiski, who spent countless hours creating the perfect photos.

I would like to thank the tremendously talented team at my publisher, Union Square & Co., led by Kate Zimmermann, who acquired this book and shepherded it through the entire process. Thanks to designer Stacy Forte, photography director Jennifer Halper, project editor Kristin Mandaglio, and production manager Shadi Nasr, as well. I would also like to thank my agent, Lee Sobel, who shopped the project until he found the perfect publisher with Union Square & Co.

And, of course, I would like to acknowledge my family, who were a constant source of encouragement through the good times and the bad.

PHOTOGRAPHY CREDITS

Front cover: Gianluca Santi

ii: Anjella Roessler

iv: J.Ph Baudey

vi: Dan Howell

Introduction, clockwise from left: Alexis Ziemski (skeleton); Dan Howell (chair); J.Ph Baudey (death mask and bear); Dan Howell (shelf)

202: Lorenzo Vanzetti

Back cover: Alexis Ziemski

HOMES

Bashian: Jesse Korman

Cohn: Dan Howell

Delaney: Anjella Roessler

Del Bufalo: Gianluca Santi and Lorenzo Vanzetti

Fahenstock: Dan Howell

Freeman: Dan Howell

Hodge: Erica Payne

Holmberg: Dan Howell

Johnson: Alexis Ziemski

Marini: Dan Howell

McKinley: J.Ph Baudey

Michelson: Dan Howell

Morgan: Dan Howell

Walacavage: Dan Howell; Prop Stylist: Jodi Rice

Vasilios: Dan Howell and Alexis Ziemski

INDEX

UNION
SQUARE
& CO.

NEW YORK

ISBN 978-1-4549-5109-4
ISBN 978-1-4549-5110-0 (e-book)

Library of Congress Control Number: 2023944895

For information about custom editions, special sales, and premium purchases, please contact specialsales@unionsquareandco.com.

Printed in India

2 4 6 8 10 9 7 5 3 1

unionsquareandco.com

Editor: Kate Zimmermann
Designer: Stacy Wakefield Forte
Project Editor: Kristin Mandaglio
Production Manager: Shadi Nasr
Photography Director: Jennifer Halper
Copy Editor: Kalista Johnston
Proofreader: Lori Paximadis
Indexer: JS Editorial, LLC

Photography credits appear on page 205